PERFORMATIVITY

AND

PERFORMANCE

ESSAYS FROM
THE ENGLISH INSTITUTE

Since 1944, the English Institute has present-
ed work by distinguished scholars in English
and American literatures, foreign literatures,
and related fields. A volume of papers select-
ed for the meeting is published annually.

Also available in the series from Routledge:

Comparative American Identities:
Race, Sex, and Nationality in the
Modern Text
Edited by Hortense J. Spillers

English Inside and Out:
The Places of Literary Criticism
Edited with an Introduction by
Susan Gubar and Jonathan Kamholtz

Borders, Boundaries, and Frames:
Essays on Cultural Criticism and
Cultural Theory
Edited with an Introduction by
Mae Henderson

ROUTLEDGE

NEW YORK

LONDON

PERFORMATIVITY

AND

PERFORMANCE

Edited with an Introduction by

ANDREW PARKER AND

EVE KOSOFSKY SEDGWICK

Published in 1995 by

Routledge
29 West 35th Street
New York, NY 10001

Published in Great Britain in 1995 by

Routledge
11 New Fetter Lane
London EC4P 4EE

Library of Congress Cataloging-in-Publication Data

 Performativity and performance / edited with an introduction by Andrew Parker and Eve Kosofsky Sedgwick.
 p. cm.
 Papers presented at the English Institute, 1993.
 Includes bibliographical references.
 Contents: The unhappy performative / Timothy Gould — Culture and performance in the circum-Atlantic world / Joseph Roach — Writing the absent potential : drama, performance, and the canon of African-American literature / Sandra L. Richards — Traumatic awakenings / Cathy Caruth — Katharsis : the ancient problem / Andrew Ford — The play of conscience / Stephen Orgel — The shudder of catharsis in twentieth-century performance / Elin Diamond — Performativity and spatial distinction : the end of AIDS epidemiology / Cindy Patton — Burning acts / Judith Butler.
 ISBN 0-415-91054-4. ISBN 0-415-91055-2 (pbk.)
 1. Speech acts (Linguistics) 2. Performance. I. Parker, Andrew. II. Sedgwick, Eve Kosofsky. III. English Institute.
P95.55.P47 1995 94-23046
401'.41—dc20 CIP

CONTENTS

ACKNOWLEDGMENTS

We would like to thank all the participants in the 1993 meeting of the English Institute, where these papers were originally delivered. The topic of performativity and performance emerged from a conversation with Elizabeth Young and Ken Wissoker. Besides the authors represented in this book—whose promptness, patience, care, and good cheer we have tremendously appreciated—those who contributed most to the conference included Kwame Anthony Appiah, John Brenkman, Lydia Alix Fillingham, Coppélia Kahn, Suzanne Marcus, Jeffrey Masten, Scott Malcomson, Karen Newman, Peter Stallybrass, and the many responsive listeners, questioners, and discussants who annually give the English Institute its point. We are particularly grateful to Harvard University and to the nationwide roster of colleges and universities whose subventions enable the Institute's work to continue. And our biggest thanks belong to Katie Kent, who kindly, resourcefully, and brainily did all the various research, telephone, computer, and other tasks that have made this book happen.

PERFORMATIVITY

AND

PERFORMANCE

ANDREW PARKER
EVE KOSOFSKY SEDGWICK

INTRODUCTION

PERFORMATIVITY

AND

PERFORMANCE

WHEN IS SAYING something doing something? And how is saying something doing something? If they aren't coeval with language itself, these questions certainly go as far back, even in European thought, as—take your pick—Genesis, Plato, Aristotle. Proximally, posed explicitly by the 1962 publication of the British philosopher J. L. Austin's *How to Do Things with Words*, they have resonated through the theoretical writings of the past three decades in a carnivalesque echolalia of what might be described as extraordinarily productive cross-purposes. One of the most fecund, as well as the most under-articulated, of such crossings has been the oblique intersection between performativity and the loose cluster of theatrical practices, relations, and traditions known as performance. The English Institute conference at which these essays were presented was an attempt, at a moment full of possibilities, to take stock of the uses, implications, reimagined histories, and new affordances of the performativities that are emerging from this conjunction.

That these issues reverberated through what has been, historically, a conference on English literature is only one of the many signs of theoretical convergence that has, of late, pushed performativity onto center stage. A term whose specifically Austinian valences have been renewed

in the work of Jacques Derrida and Judith Butler, performativity has enabled a powerful appreciation of the ways that identities are constructed iteratively through complex citational processes.[1] If one consequence of this appreciation has been a heightened willingness to credit a performative dimension in all ritual, ceremonial, scripted behaviors, another would be the acknowledgment that philosophical essays themselves surely count as one such performative instance.[2] The irony is that, while philosophy has begun to shed some of its anti-theatrical prejudices, theater studies have been attempting, meanwhile, to take themselves out of (the) theater. Reimagining itself over the course of the past decade as the wider field of performance studies, the discipline has moved well beyond the classical ontology of the black box model to embrace a myriad of performance practices, ranging from stage to festival and everything in between: film, photography, television, computer simulation, music, "performance art," political demonstrations, health care, cooking, fashion, shamanistic ritual. . . .[3]

Given these divergent developments, it makes abundant sense that performativity's recent history has been marked by cross-purposes. For while philosophy and theater now share "performative" as a common lexical item, the term has hardly come to mean "the same thing" for each.[4] Indeed, the stretch between theatrical and deconstructive meanings of "performative" seems to span the polarities of, at either extreme, the *extroversion* of the actor, the *introversion* of the signifier. Michael Fried's opposition between theatricality and absorption seems custom-made for this paradox about "performativity": in its deconstructive sense, performativity signals absorption; in the vicinity of the stage, however, the performative is the theatrical.[5] But in another range of usages, a text like Lyotard's *The Postmodern Condition* uses "performativity" to mean an extreme of something like *efficiency*—postmodern representation as a form of capitalist efficiency—while, again, the deconstructive "performativity" of Paul de Man or J. Hillis Miller seems to be characterized by the *dis*linkage precisely of cause and effect between the signifier and the world.[6] At the same time, it's worth keeping in mind that even in deconstruction, more can be said of performative speech-acts than that they are ontologically dislinked or introversively

nonreferential. Following on de Man's demonstration of "a radical estrangement between the meaning and the performance of any text" (298), one might want to dwell not so much on the nonreference of the performative, but rather on (what de Man calls) its necessarily "aberrant" relation to its own reference—the torsion, the mutual perversion, as one might say, of reference and performativity.

Significantly, perversion had already made a cameo appearance in *How to Do Things with Words* in a passage where the philosophical and theatrical meanings of performative actually do establish contact with each other.[7] After provisionally distinguishing in his first lecture constatives from performatives—statements that merely describe some state of affairs from utterances that accomplish, in their very enunciation, an action that generates effects—Austin proceeded to isolate a special property of the latter: that if something goes wrong in the performance of a performative, "the utterance is then, we may say, not indeed false but in general *unhappy*" (14). Such "infelicity," Austin extrapolated, "is an ill to which *all* acts are heir which have the general character of ritual or ceremonial, all *conventional* acts" (18–19). But if illness was understood here as intrinsic to and thus constitutive of the structure of performatives—a performative utterance is one, as it were, that always may get sick—elsewhere Austin imposed a kind of quarantine in his decision to focus exclusively, in his "more general account" of speech acts, on those that are "issued in ordinary circumstances":

> [A] performative utterance will, for example, be *in a peculiar way* hollow or void if said by an actor on the stage, or if introduced in a poem, or spoken in soliloquy. This applies in a similar manner to any and every utterance—a sea-change in special circumstances. Language in such circumstances is in special ways— intelligibly—used not seriously, but in ways *parasitic* upon its normal use—ways which fall under the doctrine of the *etiolations* of language. All this we are *excluding* from consideration. (22)

This passage, of course, forms the heart of Derrida's reading of Austin in "Signature Event Context": where Austin sought to purge from his analysis of "ordinary circumstances" a range of predicates he

associated narrowly with theater, Derrida argued that these very predicates condition from the start the possibility of any and all performatives. "For, finally," asked Derrida, "is not what Austin excludes as anomalous, exceptional, 'nonserious,' that is, *citation* (on the stage, in a poem, or in a soliloquy), the determined modification of a general citationality—or rather, a general iterability—without which there would not even be a 'successful' performative?" (*Margins,* 325). Where Austin, then, seemed intent on separating the actor's citational practices from ordinary speech-act performances, Derrida regarded both as structured by a generalized iterability, a pervasive theatricality common to stage and world alike.

Much, of course, has long since been made of Austin's parasite, which has gone on to enjoy a distinguished career in literary theory and criticism. And Derrida's notion of a generalized iterability has played a significant role in the emergence of the newly expanded performance studies. Yet what, to our knowledge, has been underappreciated (even, apparently, by Derrida) is the nature of the perversion which, for Austin, needs to be expelled as it threatens to blur the difference between theater and world. After all these years, in other words, we finally looked up "etiolation" and its cognates in our handy Merriam-Webster, and were surprised to discover the following range of definitions:

> **etiolate** (vt): 1) to bleach and alter or weaken the natural development of (a green plant) by excluding sunlight; 2) to make pale and sickly <remembering how drink hardens the skin and how drugs etiolate it—Jean Stafford>; 3) to rob of natural vigor, to prevent or inhibit the full physical, emotional, or mental growth of (as by sheltering or pampering) <the shade of Poets' walk, a green tunnel that has etiolated so many . . . poets—Cyril Connolly>
>
> **etiolated** (adj): 1) grown in absence of sunlight, blanched; lacking in vigor or natural exuberance, lacking in strength of feeling or appetites, effete <etiolated poetry>
>
> **etiolation** (n): 1) the act, process or result of growing a plant in darkness; 2) the loss or lessening of natural vigor, overrefinement of thought or emotional sensibilities: decadence

etiology (n): a science or doctrine of causation or of the demonstration of caus-
es; 2) all the factors that contribute to the occurrence of a disease or abnormal
condition

What's so surprising, in a thinker otherwise strongly resistant to moral-
ism, is to discover the pervasiveness with which the excluded theatrical
is hereby linked with the perverted, the artificial, the unnatural, the
abnormal, the decadent, the effete, the diseased. We seem, with Austinian
"etiolation," to be transported not just to the horticultural laboratory,
but back to a very different scene: the Gay 1890s of Oscar Wilde.
Striking that, even for the dandyish Austin, theatricality would be insep-
arable from a normatively homophobic thematics of the "peculiar,"
"anomalous, exceptional, 'nonserious.'"

If the performative has thus been from its inception already infect-
ed with queerness, the situation has hardly changed substantially today.
The question of when and how is saying something doing something
echoed, to take one frighteningly apt example, throughout C-SPAN's
coverage of the debates surrounding the Pentagon's 1993 "don't ask,
don't tell, don't pursue" policy on lesbians and gay men in the U.S.
military. The premise of the new policy is:

Sexual orientation will not be a bar to service unless manifested by homosexual
conduct. The military will discharge members who engage in homosexual conduct,
defined as a homosexual act, a statement that the member is homosexual or bisex-
ual, or a marriage or attempted marriage to someone of the same gender.[8]

"Act," "conduct," and "statement" pursue their coercively incoherent
dance on the ground of identity, of "orientation." Since the unveiling
of the policy, all branches of government have been constrained to
philosophize endlessly about what kind of statement can constitute
"homosexual conduct," as opposed to orientation, and hence trigger an
investigation aimed at punishment or separation. Performativity—as
any reader of Austin will recognize—lives in the examples. Here is an
example of a U.S. Congressman imitating J. L. Austin:

Representative Ike Skelton, a Missouri Democrat who heads the House [Armed Services
Military Forces and Personnel] subcommittee, asked [the Joint Chiefs of Staff] for
reactions to four situations: a private says he is gay; a private says he thinks he is
gay; an entire unit announces at 6:30 A.M. muster that they are all gay; a private
frequents a gay [bar] every Friday night, reads gay magazines and marches in gay
parades. He asked what would happen in each situation under the new policy.'

Such highly detailed interrogations of the relation of *speech* to *act* are
occurring in the space of a relatively recent interrogation of the rela-
tion of *act* to *identity*. "Sexual orientation will not be a bar to service
unless manifested by homosexual conduct"—contrast these fine dis-
criminations with the flat formulation that alone defined the issue until
1993: "Homosexuality is incompatible with military service." In response
to many different interests, the monolith of "homosexuality" has dif-
fracted into several different elements that evoke competing claims for
legitimation or censure. Unlikely as the influence may seem, the new
policy is clearly founded in a debased popularization of Foucauldian
and post-Foucauldian work in the history of sexuality. Probably through
the work of legal scholars involved in gay/lesbian advocacy, the queer
theorists' central distinction between same-sex sexual *acts* and histor-
ically contingent gay/lesbian *identities* has suddenly become a staple of
public discourse from Presidential announcements to the call-in shows
(assuming it's possible at this point to distinguish between the two).
Yet the popularization of this analytic tool has occurred through an
assimilation of it to such highly phobic formulations as the Christian
one, "Hate the sin but love the sinner." (Was it for this that the careful
scholarship of the past decade has traced out the living and dialecti-
cal linkages and gaps between same-sex acts and queer and queer-loving
identities?—all of which need to be nurtured and affirmed if any are
to flourish.)

 A variety of critiques of agency, as well, have begun to put inter-
pretive pressure on the relations between the individual and the group as
those are embodied, negotiated, or even ruptured by potent acts of speech
or silence. Viewed through the lenses of a postmodern deconstruction
of agency, Austin can be seen to have tacitly performed two radical

condensations: of the complex producing and underwriting relations on the "hither" side of the utterance, and of the no-less-constitutive negotiations that comprise its uptake. Bringing these sites under the scrutiny of the performative hypothesis, Austin makes it possible to see how much more unpacking is necessary than he himself has performed. To begin with, Austin tends to treat the speaker as if s/he were all but coextensive—at least, continuous—with the power by which the individual speech act is initiated and authorized and may be enforced. (In the most extreme example, he seems to suggest that war is what happens when individual citizens declare war! [40, 156].) "Actions can only be performed by persons," he writes, "and obviously in our cases [of explicit performatives] the utterer must be the performer" (60). Foucauldian, Marxist, deconstructive, psychoanalytic, and other recent theoretical projects have battered at the self-evidence of that "obviously"—though in post-Foucauldian theory, in particular, it seems clear that the leverage for such a critique is available precisely in the space opened up by the Austinian interest in provisionally distinguishing what is being said from the fact of the saying of it.[10]

If Austin's work finds new ways to make a deconstruction of *the performer* both necessary and possible, it is even more suggestive about the "thither" side of the speech-act, the complex process (or, with a more postmodernist inflection, the complex space) of uptake. Austin's rather bland invocation of "the proper context" (in which a person's saying something is to count as doing something) has opened, under pressure of recent theory, onto a populous and contested scene in which the role of silent or implied witnesses, for example, or the quality and structuration of the bonds that unite auditors or link them to speakers, bears as much explanatory weight as do the particular speech acts of supposed individual speech agents. Differing crucially (as, say, theater differs from film?) from a more familiar, psychoanalytically founded interrogation of *the gaze*, this interrogation of the space of reception involves more contradictions and discontinuities than any available account of interpellation can so far do justice to; but interpellation may be among the most useful terms for beginning such an analysis. (In the Congressional hearings on "don't ask, don't tell," a

lively question was this: if a drill sergeant motivates a bunch of recruits by yelling "Faggots!" at them, is it permissible for a recruit to raise his hand and respond, "Yes, sir"?) It is in this theoretical surround that the link between performativity and performance in the theatrical sense has become, at last, something more than a pun or an unexamined axiom: it emerges, as in many of the essays collected here, as an active question.)

The most classic Austinian examples (those unceasing invocations of the first person singular present indicative active) open up newly to such approaches. "I dare you," for instance, gets classified cursorily, along with "defy," "protest," "challenge," in Austin's baggy category of the behabitives, which "include the notion of reaction to other people's behavior and fortunes and of attitudes and expressions of attitudes to someone else's past conduct or imminent conduct" (160–161). But to do justice to the performative force of "I dare you," as opposed to its arguably *constative* function of expressing "attitudes," requires a disimpaction of the scene, as well as the act, of utterance. To begin with, while "I dare you" ostensibly involves only a singular first and a singular second person, it effectually depends as well on the tacit requisition of a third person plural, a "they" of witness—whether or not literally present. In daring you to perform some foolhardy act (or else expose yourself as, shall we say, a wuss), "I" (hypothetically singular) necessarily invoke a consensus of the eyes of others. It is these eyes through which you risk being seen as a wuss; by the same token, it is *as* people who share with me a contempt for wussiness that these others are interpellated, with or without their consent, by the act I have performed in daring you.

Now, these people, supposing them real and present, may or may not in fact have any interest in sanctioning against wussiness. They might, indeed, themselves be wussy and proud of it. They may wish actively to oppose a social order based on contempt for wussitude. They may simply, for one reason or another, not identify with my contempt for wusses. Alternatively they may be skeptical of my own standing in the ongoing war on wussiness—they may be unwilling to leave the work of its arbitration to me; may wonder if I harbor

wussish tendencies myself, perhaps revealed in my unresting need to test the w-quotient of others. For that matter, you yourself, the person dared, may share with them any of these skeptical attitudes on the subject; and may additionally doubt, or be uninterested in, *their* authority to classify you as wuss or better.

Thus, "I dare you" invokes the presumption, but *only* the presumption, of a consensus between speaker and witnesses, and to some extent between all of them and the addressee. The presumption is embodied in the lack of a formulaic negative response to being dared, or to being interpellated as witness to a dare. The fascinating and powerful class of negative performatives—disavowal, renunciation, repudiation, "count me out"—is marked, in almost every instance, by the asymmetrical property of being much less prone to becoming conventional than the positive performatives. Negative performatives tend to have a high threshold. (Thus Dante speaks of refusal—even refusal through cowardice—as something "great.")[11] It requires little presence of mind to find the comfortable formula "I dare you," but a good deal more for the dragooned witness to disinterpellate with, "Don't do it on my account."

Nonetheless such feats are possible, are made possible by the utterance itself; and to that extent it is necessary to understand any instance of "I dare you" as constituting a crisis quite as much as it constitutes a discrete act. For in daring you, in undertaking through any given iteration to reinscribe a set of presumptive valuations more deeply, and thereby to establish more firmly my own authority to wield them, I place under stress the consensual nature both of those valuations and of my own authority. To have my dare greeted with a witnesses' chorus of "Don't do it on our account" would radically alter the social, the political, the interlocutory (I-you-they) space of our encounter. So, in a different way, would your calmly accomplishing the dare and coming back to me, before the same witnesses, with the expectation of my accomplishing it in turn.

Or let us join Austin in reverting to his first and most influential, arguably the founding, example of the explicit performative: "'I do (sc. take this woman to be my lawful wedded wife)'—as uttered in

the course of the marriage ceremony" (5). As one of us has recently written, in a discussion of specifically *queer* performativity:

> Austin keeps going back to that formula "first person singular present indicative active" . . . and the marriage example makes me wonder about the apparently natural way the first-person speaking, acting, and pointing subject gets constituted in marriage through a confident appeal to state authority, through the calm interpellation of others present as "witnesses," and through the logic of the (heterosexual) supplement whereby individual subjective agency is guaranteed by the welding into a cross-gender dyad. The subject of "I do" is an "I" only insofar as he or she assents in becoming part of a sanctioned, cross-gender "we" so constituted in the presence of a "they"; and the I "does," or has agency in the matter, only by ritually mystifying its overidentification with the powers (for which no pronoun obtains) of state and church.
>
> The marriage example, self-evidently, will strike a queer reader at some more oblique angle or angles. Persons who self-identify as queer will be those whose subjectivity is lodged in refusals or deflections of (or by) the logic of the heterosexual supplement; in far less simple associations attaching to state authority; in far less complacent relation to the witness of others. The emergence of the first person, of the singular, of the active, and of the indicative are all questions rather than presumptions, for queer performativity.[12]

Austin-like, the obliquity of queer reception needs and struggles to explicitate the relations on the thither side of "I do." Any queer who's struggled to articulate to friends or family why we love them, but just *don't want to be at their wedding*, knows it from the inside, the dynamic of compulsory witness that the marriage ceremony invokes. Compulsory witness not just in the sense that you aren't allowed to absent yourself, but in the way that a much fuller meaning of "witness" (a fuller one than Austin ever treats) gets activated in this prototypical performative. It is the constitution of a community of witness that makes the marriage; the silence of witness (we don't speak now, we forever hold our peace) that permits it; the bare, negative, potent but undiscretionary speech act of our physical presence—maybe even *especially* the presence of those people whom the institution of

marriage defines itself by excluding—that ratifies and recruits the legit-
imacy of its privilege.

And to attend, as we have been here, to the role of witness in con-
stituting the space of the speech-act: where does that get us but to the
topic of marriage itself *as* theater—marriage as a kind of fourth wall
or invisible proscenium arch that moves through the world (a hetero-
sexual couple secure in their right to hold hands in the street), continually
reorienting around itself the surrounding relations of visibility and spec-
tatorship, of the tacit and the explicit, of the possibility or impossibility
of a given person's articulating a given enunciatory position? Marriage
isn't always hell, but it is true that *le mariage, c'est les autres*: like a play,
marriage exists in and for the eyes of others. One of the most inerad-
icable folk-beliefs of the married seems to be that it is no matter-of-fact
thing, but rather a great privilege, for anyone else to behold a wedding
or a married couple or to be privy to their secrets—including oppres-
sive or abusive secrets, but also the showy open secret of the "happy
marriage." Like the most conventional definition of a play, marriage is
constituted as a spectacle that denies its audience the ability either to
look away from it or equally to intervene in it.

And the epistemology of marital relation continues to be pro-
foundly warped by the force field of the marital proscenium. Acquiring
worldly wisdom consists in, among other things, building up a usable
repertoire of apothegms along the lines of: don't expect to be forgiv-
en *ever* if you say to your friend X, "I'm glad you two have broken up;
I never liked the way Y treated you anyway" and your friend and Y
then get back together, however briefly. But also: don't expect to know
what's happening or going to happen between X and Y on the basis
of what your friend tells you is going on, or even on the basis of lovey-
dovey or scarifying scenes which may be getting staged in one way or
another "for your benefit." (Not, of course, that any actual benefit
accrues to you from them.)

Think of all the Victorian novels whose sexual plot climaxes, not
in the moment of adultery, but in the moment when the proscenium
arch of the marriage is, however excruciatingly, displaced: when the
fact of a marriage's unhappiness ceases to be a pseudosecret or an open

secret, and becomes a bond of mutuality with someone outside the marriage; when a woman says or intimates something about "her marriage" to a friend or lover that she would not say to her husband. These tend to be the most wracking and epistemologically the "biggest" moments of the marriage novel. Such a text, then, also constitutes an exploration of the possible grounds and performative potential of refusals, fractures, warpings of the proscenium of marital witness.

The entire plot of *The Golden Bowl*, for instance, is structured by an extraordinary aria uttered by Charlotte Stant to Prince Amerigo, her ex-lover, when she has persuaded him to spend an afternoon alone with her on the eve of his marriage to another woman:

> "I don't care what you make of it, and I don't ask anything whatever of you—anything but this. I want to have said it—that's all; I want not to have failed to say it. To see you once and be with you, to be as we are now and as we used to be, for one small hour—or say for two—that's what I have had for weeks in my head. I mean, of course, to get it *before*—before what you're going to do. . . . This is what I've got. This is what I shall always have. This is what I should have missed, of course," she pursued, "if you had chosen to make me miss it. . . . I had to take the risk. Well, you're all I could have hoped. That's what I was to have said. I didn't want simply to get my time with you, but I wanted you to know. I wanted you"—she kept it up, slowly, softly, with a small tremor of voice, but without the least failure of sense or sequence—"I wanted you to understand. I wanted you, that is, to hear. I don't care, I think, whether you understand or not. If I ask nothing of you I don't—I mayn't—ask even so much as that. What you may think of me—that doesn't in the least matter. What I want is that it shall always be with you—so that you'll never be able quite to get rid of it—that I *did*. I won't say that *you* did—you may make as little of that as you like. But that I was here with you where we are and we are—I just saying this. . . . That's all."[13]

The ostentatious circularity of Charlotte's performative utterance ("I want to have said it—that's all; I want not to have failed to say it. . . . that I was here with you where we are and *as* we are—I just saying this") puts it in a complicated relation to the performative utterance of the marriage vow. Charlotte here forestalls and displaces the Prince's

marriage vow, but without at all preventing it. Her performative is so repetitious and insistent because she can't just fill in the blanks of some preexisting performative convention, but rather must move elaborately athwart it, in creating a nonce one. She parodies certain features of the marriage vow—in particular the slippery inexplicitness with which, in each case, an act of utterance makes the claim both to represent and to subsume a narrative of unspecified sexual acts. ("I *did* [it]. . . . I won't say that *you* did [it].") She also makes the most of a certain pathos ("I don't ask anything whatever of you") in her distance from the presumptuous logic of the heterosexual supplement: the agency of her "I" exactly *isn't* to be guaranteed by another echoing "I do" that will constitute it retroactively within a stable "we." But this insisted-upon isolation of the unguaranteed "I" also entails a barely implicit threat of sexual blackmail ("*I won't say* [right now] that you did [it]"). Furthermore, Charlotte places herself firmly in a Gothic tradition (think of *The Monk* or *Frankenstein* or *Daniel Deronda*) where variants on the marriage vow function as maledictions or curses, moving diagonally through time, not preventing marriage but poisoning it, prospectively, retroactively, through some unexpected adhesion of literalness to the supposed-to-be-mobile performative signifier. With this speech, Charlotte Stant has done what she *can* do—and it's a lot—to install her own "I" as a kind of permanent shunt across the marriage proscenium, mining the threshold of who can or must or can't or mayn't regard the drama of whose life; which "I"'s are or are not to be constituted as and by the "we" that means and doesn't mean the power of the state.[14]

Arguably, it's the aptitude of the explicit performative for mobilizing and epitomizing such transformative effects on interlocutory space that makes it almost irresistible—in the face of a lot of discouragement from Austin himself—to associate it with theatrical performance. And to associate it, by the same token, with political activism, or with ritual.[15] But that association also seems to throw off center a conventional definition of theater. In particular, it challenges any definition of theater according to which the relation between theatrical speakers and the words they speak would have to be seen as fixed in advance, as definitionally consistent. Not—to say the

obvious—that every instance (or even many instances) of theatrical performance can allow actors the discretionary choice that "real people" are supposed to have over what words may issue from our mouths. But if a spatialized, postmodernist performative analysis like the present one can demonstrate any one thing, surely it is how contingent and radically *heterogeneous*, as well as how contestable, must be the relations between any subject and any utterance.

The essays in this volume demonstrate the extraordinary productivity of this new refusal to take any aspect of performative relations as definitionally settled. The essays approach the conjunction of performance with performativity from different beginning points. Three of them work explicitly within Austin's legacy. Timothy Gould's "The Unhappy Performative" is the most sustained as a reading of Austin, finding a myriad of ways of pushing back against what have been the premature foreclosings of Austinian questions in deconstructive literary criticism and in speech-act philosophy. Suggesting that the theatrical is more closely associated with Austin's description of the constative function of language rather than (as most readers have assumed) with its performative function, Gould mobilizes a reading of *Antigone* to dramatize the promise of opening up conceptual space between Austin's categories of illocution and perlocution. In "Burning Acts," Judith Butler suggests a reorientation of a key Austinian question, "asking . . . what it might mean for a word 'to do' a thing, where the doing is less instrumental than it is transitive." Taking as her central example a racist cross burning as considered by the U.S. Supreme Court, Butler exposes the consequences of various legal models' blindness to the performative dimensions of what the Court has chosen to frame as a merely constative conveyance of ideas. "Epidemiology as performative," in comparison with the constatation of a tradition of tropical medicine, is the subject of Cindy Patton's "Performativity and Spatial Distinction: The End of AIDS Epidemiology." In discussing both AIDS medicine and AIDS activism, Patton identifies and offers tools for undoing a history of "overemphasis on the actant/subject and . . . relative lack of consideration of the stage of context or field of the performance or performative act."

Indeed, part of the unfulfilled promise of a focus on performativity is that it might permit more nuanced understandings of the relations between what have been blandly, confidently distinguished as "text" and "context." In different ways, the essays by Sandra L. Richards and Joseph Roach illuminate the structuring effects of what Austin calls "uptake" in the performances they consider. In "Writing the Absent Potential: Drama, Performance, and the Canon of African-American Literature," Richards discusses the surprising problem that performance genres have posed for the academic framing of African-American literature; her discussion of the performance history of *Color Struck* and *Ma Rainey's Black Bottom* links the consequent devaluation of performance itself to the devaluation within this literature of women's viewpoints and voices. Roach, too, contributes to the redefinition and reanimation of the space of performance in "Culture and Performance in the Circum-Atlantic World," where he braids together themes of embodiment, surrogation, and collective memory in Afro-Euro-American history to culminate in a bravura reading of a New Orleans jazz funeral.

A millennia-old way of posing the question of embodiment and surrogation is the Aristotelian notion of catharsis, which in the essays of Andrew Ford, Stephen Orgel, and Elin Diamond opens onto a remarkably Austinian-sounding series of meditations on how saying something, at particular critical moments in the West, has been signally a way of doing something. In "*Katharsis*: The Ancient Problem," Andrew Ford concludes his reading of the *Poetics* and related texts by Aristotle by suggesting that the purpose of Aristotle's appeal to catharsis was "to delimit the field of the theorist," thereby making possible a theatrical formalism that would constitute something called literature as purged of the "irrationality" of its performance. Stephen Orgel brings catharsis up to the Renaissance in "The Play of Conscience," which puts into question, through a reading of Massinger's play *The Roman Actor*, who is to be purged by drama, of what they are to be purged, and what purgation itself was thought to be, in the double historical context of Renaissance classicism. Elin Diamond's essay, "The Shudder of Catharsis in Twentieth-Century Performance," takes as its texts a series of women's performances, from Eleanora Duse to Karen

Finley, that are also performances of femininity. Diamond makes graphic why the problematic of catharsis lives on in contemporary performance, given the connections it articulates and continually dislocates between seeing and feeling, between word and body.

Other sets of dislocations—between vision and knowledge, fantasy and reality, space and time, wakefulness and death—form the subject of Cathy Caruth's essay, "Traumatic Awakenings," which reconsiders Freud's and Lacan's now-classic analyses of "The Dream of the Burning Child." Describing traumatic experience as a performance "that contains within itself its own difference," Caruth suggests that trauma undermines the classical dramaturgy that an Oedipalizing dream theory has long since sought to uphold; reconceived here as inaugurating an ethical relation to the real, trauma imposes itself, Caruth concludes, as a persistent, irreducible problem *for* psychonanalytic thinking—forming, in so doing, its opening to the future.

The force of these essays, taken together, is, we believe, to transform the interdisciplinary performativity/performance conversation in powerfully new and usefully unpredictable ways. The essays all begin at a point far beyond the pre-Derridean project of definitively segregating constatation from performativity, and theatrical speech from "ordinary language." Vastly more important is the confident way that they move beyond recent work—itself highly significant—whose generally tacit assumption has been that the most interesting questions to bring to performativity/performance are epistemological ones. In contrast, these essays strikingly refrain from looking to performativity/performance for a demonstration of whether or not there are essential truths or identities, and how we could, or why we couldn't, know them. As a certain stress has been lifted momentarily from the issues that surround *being something*, an excitingly charged and spacious stage seems to open up for explorations of that even older, even newer question, of how saying something can be doing something.

NOTES

1. Jacques Derrida, "Signature Event Context," in *Margins of Philosophy*, trans. Alan Bass (Chicago, 1982); Judith Butler, *Gender Trouble: Feminism and the Subversion of Identity* (New York, 1990), and *Bodies that Matter: On the Discursive Limits of "Sex"* (New York, 1993).

2. An exemplary instance of this acknowledgment would be Shoshan Felman, *The Literary Speech Act*, trans. Catherine Porter (Ithaca, 1983), which undertakes both a speech-act reading of *Don Juan* and a theatrical reading of Austin.

3. Among the many texts that reflect this transformation, see Sue-Ellen Case, ed., *Performing Feminisms* (Baltimore, 1990); Richard Schechner, *Between Theater and Anthropology* (Philadelphia, 1985); Michael Taussig, *Mimesis and Alterity* (New York, 1993); and Victor Turner, *The Anthropology of Performance* (Baltimore, 1985). See the Bibliography in this volume for a fuller listing of important works on performance and performativity. On the ontological distinctions that circumscribe traditional notions of theatrical space, see Philippe Lacoue-Labarthe, "Theatrum Analyticum," *Glyph* 2 (1977), pp. 122–143, and Geoffrey Bennington, *Lyotard: Writing the Event* (New York, 1988): "A theatre involves three limits or divisions or closures. First, the outside walls of the building itself. The 'real world' is outside, the theatre inside. . . . Within the theatre comes a second limit or division, separating the stage from the audience, marking off the place observed and the place from which it is observed. . . . A third essential limit separates the stage from the wings or back-stage" (pp. 10–11).

4. For an extension of this discussion, see Eve Kosofsky Sedgwick, "Queer Performativity: Henry James's *The Art of the Novel*," *GLQ* 1 (1993), p. 2, from which the remainder of this paragraph is taken.

5. Michael Fried, *Absorption and Theatricality: Painting and Beholder in the Age of Diderot* (Berkeley, 1980).

6. Jean-François Lyotard, *The Postmodern Condition: A Report on Knowledge*, trans. Geoff Bennington and Brian Massumi (Minneapolis, 1984); J. Hillis Miller, *Tropes, Parables, Performatives: Essays on Twentieth-Century Literature* (Durham, 1991); Paul de Man, *Allegories of Reading: Figural Language in Rousseau, Nietzsche, Rilke, and Proust* (New Haven, 1979).

7. J. L. Austin, *How to Do Things with Words* (Cambridge, MA, 1975).

8. "Text of Pentagon's New Policy Guidelines on Homosexuals in the Military," *New York Times* (July 20, 1993), p. A16 (national edition), emphasis added.

9. Eric Schmitt, "New Gay Policy Emerges as a Cousin of Status Quo," *New York Times* (July 22, 1993), p. A14 (national edition).

10. Foucault writes, for instance, about sexuality:

> The central issue . . . is not to determine whether one says yes or no to sex, whether one formulates prohibitions or permissions, whether

one asserts its importance or denies its effects . . . ; but to account for the fact that it is spoken about. . . . What is at issue, briefly, is the overall "discursive fact."

(*The History of Sexuality, Vol. 1: An Introduction*, tr. Robert Hurley [New York, 1978]).

The Foucauldian move is not, of course, identical to Austin's distinction between the (true or false) constatation of an utterance, and its performative force—a deemphasis of yes versus no—is not the same as a deemphasis of true versus false. The two moves are congruently structured, however; they invoke and reward very similar interpretive skills. We might say that both Austin and Foucault train readers to identify and perform the kind of figure/ground reversals analyzed by the Gestalt psychology of the first half of this century. Austin for instance, abandoning the attempt to distinguish between some utterances that are intrinsically performative and others that are intrinsically constative, finally offers a substitute account, applicable to any utterance, that is couched in terms (such as the curious intransitive verb "to abstract") of perception and attention: "With the constative utterance, we abstract from the illocutionary . . . aspects of the speech act, and we concentrate on the locutionary. . . . With the performative utterance, we attend as much as possible to the illocutionary force of the utterance, and abstract from the dimension of correspondence with facts" (pp. 145–146).

11. "*Il gran rifiuto*," in the *Inferno*, III, 60. See also Cavafy's poem, "Che fece . . . il gran rifiuto," in Edmund Keeley and Philip Sherrard, trs., George Savidis, ed., *C.P. Cavafy: Collected Poems*, revised ed. (Princeton, 1992), p. 12.

12. "Queer Performativity: Henry James's *The Art of the Novel*," pp. 3–4.

13. Henry James, *The Golden Bowl* (Harmondsworth, Middlesex, 1980), pp. 93–94.

14. Since writing the above paragraphs, I have been doing more work on the same issues and passages, arriving at a further and somewhat different formulation. In a forthcoming essay, "Around the Performative," I'll suggest that it would be useful to understand language like Charlotte Stant's, not under the rubric of the performative proper, but under a new rubric, that of *the periperformative*. Periperformatives are utterances, not themselves proper performatives, that explicitly allude to explicitly performative utterances. The force of this concept, as I'll hope to show, involves its ability to spatialize a neighborhood of language around or touching the performative (as opposed to the emphasis on temporality in post-Derridean discussions of the performative); thus, the spatial emphasis that underlies the present discussion of performativity and performance will, as I hope, be more explicitly grounded and further developed.—EKS

15. Judith Butler, for example, discusses "the convergence of theatrical work with theatrical activism" in *Bodies that Matter*, p. 233.

TIMOTHY GOULD

THE UNHAPPY PERFORMATIVE

I WANT TO RECOVER some of the significance and provocation in J. L. Austin's efforts to distinguish between performative and constative utterances, and in his companion efforts to fix our attention on the illocutionary forces of our words.[1] I will then turn to consider some passages in Sophocles's *Antigone*, moments in which we may test our sharpened sense of exposure to the performative utterance against a drama which enacts a kind of conflict of performatives. Beyond the specific issue of the performative utterances, the *Antigone* discovers for us a kind of struggle over the various authorities and mutual authorizations of language and the political.

I note that my project requires that I begin by decoupling the term "performative" from the constellation of "performance" and "performativity." This may seem perverse or even ungrateful, since it is, at least on the surface, a certain manner of linking these terms that has produced so much fruitful work.[2] I am still not prepared to assess whether this particular linkage of the terms is one of the causes of the energy and insight that has so strikingly altered the contours of the discussion, or whether the linkage is one of its more spectacular side effects. In any case, my separation of these terms is only provisional.

The reason it seems to me necessary to begin in this way is not because there are no interesting links between Austin's work on performatives and various ideas of performance, but because, in the last two decades, Austin's specific philosophical point in isolating the performative has gotten obscured. When the force of Austin's project is brought into the open, the connection to various ideas of performance and theatricality resurfaces with a still greater pertinence. Some idea of the dramatic conditions of the performative utterance is implied in my discussion of the *Antigone*. And already, in the third section of this essay, I will be suggesting that a certain idea of the theatricality of human speech shows within the philosopher's ideal of the constative utterance conceived as a pure description.

I.

Austin's contrast between the constative and the performative utterance may be glimpsed in the difference between my saying, "Pat Schroeder will be reelected in 1996," and my saying, "I bet you a bottle of your favorite Scotch that Pat Schroeder will be reelected in 1996." The first remark is a kind of statement, however provocative it might prove to be in some contexts (or in some parts of Colorado). The second remark constitutes, in itself, the offer of a bet, at least when it is uttered in the appropriate circumstances. Most especially, Austin wished to emphasize that the performative utterance, "I bet you" and so on, was not a description of some action, inner or outer, prior or posterior, occurring *elsewhere* than in the utterance itself. To say those words in those circumstances *is* to offer the bet: the action in question lies in the act of uttering those words in those circumstances.

However intriguing such a distinction might prove, it can also seem quite simple and even simple-minded. It seems easy enough to characterize it as a distinction between saying something and doing something, or perhaps between merely stating something and actually performing an action with your words. Hence, we have Austin's list of classic, explicit performatives: "I give and bequeath my watch to my brother"; "I christen this ship the Daniel Ortega"; "I do" (namely, "take you to be

my lawfully wedded wife"); "I advise you" (for example, "of your right to remain silent"); "I dare you" (for example, "to tell that joke about the polar bears"); "I do request that you keep your seat belt fastened while you are in your seat" (5–9). Finally, it is worth mentioning "I resign," and "I quit." These utterances are both explicit performatives. They may be usefully contrasted with "Take this job and shove it," which, however satisfying to perform or to contemplate performing, is not in fact a performative. To repeat: in each case of what Austin will come to call an *explicit* performative, the act that is accomplished in the words (for instance, offering to bet, bequeathing, baptizing, marrying, advising, daring you, resigning) is not an act occurring otherwise than in the words themselves. Austin insisted that the utterance does not refer to some inward, invisible act, for which the words would then be taken as the outward and visible—but still descriptive—sign (9).

The sacramental, or rather antisacramental, ring to the words "outward and visible sign" is Austin's, and it is deliberate. This side of his work on performatives is related to his consistent, if not exactly systematic, efforts to combat a whole sheaf of false pictures of the relation between the "inside" and "outside" of human expression. These efforts have received less attention than they deserve. Their immediate relevance is this: we cannot—or ought not to—reduce my offer to bet you a fifth of Scotch to an outer description of an inner state of mind, for instance, to a description of my willingness to engage you in the activity of betting. Austin equally insists that we cannot reduce our ability to identify the action performed in a performative utterance to a matter of calculating the effects on some audience, real or imagined.

To recover the force and significance of Austin's distinction, Austin himself suggests that it is necessary to isolate the performative from the statement proper, as classically conceived, with which it at least appears to share a grammatical category and a form. In particular (though this can seem too obvious to mention), the explicit performative shares with the constative utterance the grammatical form of a "statement."[3] Austin evidently imagined that the philosophical effort to "fasten on" the distinctness of the performative (and to grasp the related distinctness of the illocutionary forces of our words) would

have to overcome what Austin later characterizes as a tendency to elide this very distinctness (122–123). *Why* the performative utterance and the illocutionary force should be so difficult to keep in view is hard to say precisely, but it clearly has something to do with the sway of what Austin calls the Descriptive Fallacy—the assumption that Austin's analyses were designed to oppose. If Austin is right about the nature and importance of this fallacy, it makes a certain kind of sense that the assumption that he is resisting should itself have certain powers of resistance and obfuscation at its disposal.

Austin's initial formulation of the Descriptive Fallacy runs like this:

> It was for too long the assumption of philosophers that the business of a "statement" can only be to "describe" some state of affairs, or to "state some fact," which it must do either truly or falsely. (I)

Sometimes he makes it explicit that, when he isolates what philosophers take to be the "business" of a statement, he is isolating what philosophers have generally taken to be the interesting or even the fundamental work of language. Austin seems well aware that a shift in what philosophers take to be of philosophical interest is a shift with fundamental and far-reaching consequences. Austin certainly thought of his efforts to rearouse and rearrange our interest in acts of speech to be revolutionary in their implications for philosophy. He is, however, exceedingly causal both about the immediate form of his provocation to philosophy and also about the new directions of investigation that his work proposes and illuminates.

I list, without argument, a number of Austin's claims and (as I believe) insights about this fallacy: 1) He is very clear, if not always very explicit, that this assumption is, in general, unconsciously held (12). 2) He suggests that, when engaged in, as we used to say, "doing philosophy," it is quite natural to find yourself in the grip of this assumption. Furthermore 3) for Austin, philosophy contains a kind of melodramatic condensation of the sins of ordinary thought. Austin sometimes thinks of philosophy as a kind of scapegoat, most useful,

perhaps, for driving out exactly those condensed versions of our daily errors and lapses (2). Therefore, finally 4) certain versions of the Descriptive Fallacy are more widespread than we might have thought. Certainly, the fallacy in question does not vanish merely upon the adoption of a terminology of speech-acts—not even when the terminology was specifically designed to repudiate that fallacy.

Austin's way of combating the regime of the descriptive and the constative was to use his isolation and mapping of the performative utterance to render first visible, and then salient, the dimension of human utterance that he called the dimension of happiness and unhappiness. His maps and classifications of unhappiness were meant to oppose the philosophers' fixation on their favorite form of utterance, the statement—the linguistic entity capable of being true or (as Austin joked) at least false. It is the ideal of "the statement" that forms the main link between the Descriptive Fallacy and the true/false dichotomy—a dichotomy which is all but inevitably invoked by those in the grip of the Descriptive Fallacy. The idea that the business of language shows up in a form of utterance that is, in a sense, designed to be true or false has its counterpart in a philosopher's picture of the world—a world in which the (interesting) conditions are to be thought of as "facts," to which our (interesting) utterances must correspond (or fail to).

Austin's strategy for combating these pictures begins with his tracing, in virtuoso and almost comic detail, the parallels between the dimension of our assessment of statements (their correspondence to the facts) and the dimension in which we assess what he called the happiness and unhappiness of our performative utterances. His goal was not to substitute performance and its various effects for truth and its various consequences. His strategy was rather to drag the fetish of true and false into the same swamp of assessment and judgment in which we find the dimension of happiness and unhappiness that afflicts our performative utterances. The comic combination of confidence and provisionality in his classificational schemes was not merely designed to shake our confidence in the true/false dichotomy. It was intended to seduce us away from the reassurances of that dichotomy

into a larger appreciation of the common miseries of utterance—whether constative *or* performative. Delivering us from the old fetishism of the true and the false would, by the same act, deliver us over to what the fetish was perhaps designed to conceal: a more homely, less manageable, and hence more uncanny region—a region in which our utterances find (or fail to find) their various relations to the world and its other inhabitants.

2.

Before going on with some of the consequences of Austin's strategy, I want at least to point to a significant source of resistance to my way of reading Austin. Some of this resistance may be due to the fact that the "fallacy" that Austin isolates in the Descriptive Fallacy seems so blindingly obvious to literary critics and theoreticians that it does not seem worthwhile to dwell on it. The danger here lies in the possibility that, in going on to "apply" Austin's terminology of performative and constative to problems of ostensibly greater theoretical interest, the primary force of Austin's critique will be lost. This danger has, I believe, been repeatedly realized, and the assumptions that Austin was combating have frequently persisted in the very terms that were meant to undo those assumptions.

In any event, the homely region of uncanniness that is intended, according to my reading of Austin, to emerge in our appreciation of the Unhappy Performative will fail to emerge—and my reading will accordingly run aground—to the extent that it cannot dislodge a particular, competing interpretation of Austin's distinction. According to this reading, which still seems to predominate in literary-theoretical circles, a performative utterance is to be characterized as a kind of verbal performance or artifact, and hence it is to be assessed by its effectiveness with an audience (whether real or implicit or constructed). A performative utterance is correlatively also to be characterized as essentially "nonreferential," where nonreferential is taken to mean "not related to facts or previously existing situations."

An extreme version of this can be found in J. Hillis Miller's recent *Tropes, Parables, Performatives*. He writes, for instance:

> A parable does not so much passively name something as make something happen.
> . . . A true performative brings something into existence that has no basis except
> in the words, as when I sign a check and turn an almost worthless piece of paper
> into whatever value I have inscribed on the check.[4]

And later:

> Human performatives . . . can never be the object of an epistemological act . . .
> [but] are always from beginning to end baseless positings.[5]

Miller accepts a radical split between statements (or descriptions) which are subject to "verification" (or recognition), and other forms of utterance. These latter forms of utterance are called "performatives" by Miller, apparently because they *do* something (or posit something). And also apparently because such utterances *do* something, they are, for Miller, not subject to verification, and not grounded in what he calls "extralinguistic" reality. Finally, they are evidently *therefore* not subject to acts of knowledge or recognition. It is hard to find a more perfect summary of the persistence of logical positivist assumptions about verification as the guarantor of linguistic sense and knowability. And it is accordingly also hard to find a better instance of what Austin is opposing in our thinking about language.

Behind a reading like Miller's—and his reading is hardly unique—there lie the intricate and powerful readings advanced by Derrida and de Man. I cite one proposition from within Derrida's complex intimation of a "Nietzschean" strain in Austin's lectures: Austin strove, according to Derrida, to "free the analysis of the performative from the authority of the value of truth, from the opposition true/false, at least in its classical form, and to substitute for it at times the value of force, of difference of force. . . ."[6] Derrida speaks as if the difference of force—which is also the difference of the performative from the constative—could be reduced to the fact that, as Derrida puts it, a performative "produces or

transforms a situation."[7] Whatever the initial philosophical affinity that Derrida may have sensed in Austin's critique of the Descriptive Fallacy and the associated fetish of the true and the false, Derrida's line of thinking ends by submerging the power of Austin's critique within some other current of thought. That this other current of thought is powerful in its own right is a fact that only underscores the difficulties of deploying the results of a critique outside the specific branching of philosophical tradition towards which the critique is directed.[8]

In lieu of a more explicit demonstration that Derrida's reading would lead us to muffle one of the primary aims of Austin's project, I cite a passage from Stanley Cavell's reading of Derrida's encounter with Austin:

> Austin's "substitution" of force for truth is not meant as a revelation of truth as illusion or as the will to power,[9] but rather as demonstrating that what may be called the value of truth—call it an adequation of language and reality, or a discovery of reality—is as essential to performative as to constative utterance. So that an aporia in the way of distinguishing between performatives and constatives is as much to Austin's philosophical liking as to his classificatory dismay.[10]

The dimension of unhappiness which constitutes the medium in which we make and appreciate the performative is equally the medium within which we make our claims upon the true and the false. At the same time, such unhappiness is the common affliction of both sorts of utterances. (I do not imagine that Derrida needs to disagree with this.) If Austin's analysis is to point to the region of swampiness that the performatives share with constatives (and thus do its work of defetishizing truth and falsity with a wider variety of oppositions and judgments), we must keep in view a more complex structure than this interpretation of performative allows. Above all, we need a greater appreciation of the relation between the "inner" structure or grammar of the performative and the "outer" act that is performed. It would also be useful if we had a clearer picture of the tendency to characterize (or rather to reduce) this relationship to a relation between an "inner" cause and an "outer" consequence.

3.

Supposing that we have dislodged, at least for the time being, this tena-cious reinterpretation of the "force" of speech-acts in terms of their "effects" on an audience, I want to focus on a couple of places in Austin's analysis that we are now in a better position to appreciate. A major part of my point in trying to recapture the radicalness of Austin's work is to locate something of his power of diagnosis. At least to my mind, part of this power of diagnosis is that Austin has discerned a new wrinkle in philosophy's old obsession with theater and theatri-cality. In Austin's view, I suggest, it is the statement—the constative utterance—which philosophers tend to construe as something that is "right to say in all circumstances, for any purpose, to any audience, &c." (146). This phrase is explicitly said to characterize the philoso-pher's "ideal" of language. Austin's remark comes at a point when he is turning back from his discussion of illocutionary forces to recon-sider his initial distinction. If the point itself is made almost casually, it could hardly be placed at a critical moment of his lectures:

> What then finally is left of the distinction of the performative and constative utter-ance? Really we may say that what we had in mind here was this . . .
>
> a) . . . we abstract from the illocutionary (let alone the perlocutionary) aspects of the speech act, and we concentrate on the locutionary; moreover, we use an over-simplified notion of correspondence with the facts—over-simplified because essentially it brings in the illocutionary aspect. This is the ideal of what would be right to say in all circumstances, for any purpose, to any audience, &c. . . . Perhaps it is some-times realized.
>
> b) With the performative utterance, we attend as much as possible to the illo-cutionary force of the utterance, and abstract from the dimension of correspondence with facts. (145–146)

Once again, it is the statement that becomes, for philosophers, the ideal bearer of the capacity for being true or false—hence the guar-antor of linguistic meaningfulness. Within this ideal, Austin discerns the wish, or the fantasy, that a "statement" is always dramatically or

rhetorically "correct." A statement (so goes the philosopher's wish) not only makes logical or grammatical sense, but it is just the sort of production that is appropriate for all occasions and all audiences. It is, one supposes, preferable that the statement be true. But even when false, a statement is doing its job of making sense. Therefore, in this philosophical daydream, it makes sense to say it. The sense and reference of an utterance are supposed to guarantee its human relevance. Austin is clear that this intimation of automatic relevance is not something that philosophers in the Anglo-American tradition are inclined to dwell upon.

In Austin's diagnosis, the philosopher ends up craving a certain descriptive enforcing of sense and relevance. In his almost offhand depiction of an almost casual wish for such enforcement, I suggest that Austin presents the philosopher as a condensed type of human tyranny. In particular, the classical regime of philosophy shares the tyrant's wish to reduce the options of acceptable human speech. An utterance is either acceptable—in which case, its sense and relevance can be enforced—or else it can be reduced to some previously defined forms of the unacceptable. The philosopher's condemnation of certain forms of utterance as "nonsense" is an image of the tyrant's wish for more violent forms of the segregating and suppressing of human expression. (No doubt, the tyrant has instruments other than language at his disposal, and no doubt he has needs and desires other than that of maintaining a regime of linguistic propriety.) I will shortly be at least implicitly exploring something more of this "philosophical image" of tyranny, through a kind of analogy with Creon's twisting together of performative and descriptive acts of stigmatizing.[11]

4.

I want to bring out an aspect of illocutionary force which is, for the most part, only latent in Austin's analysis: I will call this aspect illocutionary suspense or perlocutionary delay. In lieu of a detailed analysis of the locutionary, illocutionary, and perlocutionary forces of our utterances, I will offer a few examples to bear in mind.

The locutionary act of saying, for instance, the words "I'm sorry" may have the illocutionary force of an apology. It might also have the force of a confession, or a provocation, or even a kind of oblique accusation. We must further distinguish between understanding that the words had the force of an apology and the fact that the apology was *accepted*. When the former occurs, then Austin says that what he calls "uptake" has been secured. The latter, on the other hand, is that sort of thing that Austin calls the perlocutionary force or effect of the utterance. Such effects might include mollifying, or indeed, further irritating the offended party. Similarly, someone says the words, "The new general manager of the orchestra in Rochester is planning to cut musicians' salaries by thirty-three percent." This may have, in some circumstances, the illocutionary force of a warning or, in other circumstances, the force of a threat. And it may, for instance, have the perlocutionary effect of alarming the oboist, at the same time that it has the perlocutionary effect of outraging the trumpet player and of galvanizing the percussionist.

Austin's point is not to celebrate the sheer pleasures of linguistic diversity (much less, of linguistic "undecidability"). He is, rather, emphasizing the possibility of our coming to comprehend the illocutionary force of an utterance before the full battery of "effects" has been discharged. This side of what I am calling the gap is what Austin mobilizes against the positivists and against what he knew of pragmatism (145). That an utterance had the force of a question (or of a warning or of advice) requires that certain effects (the "uptake") be secured—and perhaps that certain other effects (the perlocutions) be desired. But the meaning and the illocutionary force of the utterance are not therefore to be construed as identical to the fact that an utterance has certain effects or consequences. The perlocutionary consequences (alarm, influence, perplexity, resolve, and so on) may not be forthcoming. More crucially, the possibility of illocutionary uptake is not sensibly to be conceived of as the effect of a cause. It is no more usefully to be thought of as the effect of a cause than my opening with pawn to king four is "caused" by my having moved a small piece of carved, white wood four centimeters to the north. However exactly we come to

conceive of this relation between illocutionary utterance and its uptake, it is evidently less like the causal relation and more like the conventional or grammatical or logical relation between a move in a chess game and the movement of a piece of wood.

Now a further aspect of this analysis becomes relevant: when I say something that has the illocutionary force of, for example, advising you to consult a lawyer before you testify to the committee, I am normally intending (or wishing) that my illocutionary act of advice will have the perlocutionary effect of, for example, actually influencing you. Or if I scold you about the condition of the lawn, I intend this illocutionary act to have the perlocutionary effect of shaming you. And even if I do something with a sort of constative aspect—for example, describing to you the health care situation in American cities—I may want to have the perlocutionary effect of outraging you.

Austin's analysis of the illocutionary force of our utterances insists on the fact that we can sometimes—even, perhaps, as a rule—understand that what he called illocutionary uptake has occurred, *prior to* the occurrence of any perlocutionary effects or consequences. One of Austin's most crucial points is that an utterance needs a certain kind of sequel (he calls it "uptake") in order to count as (in order to *be*) that particular illocutionary utterance, with just that force (116–118). This does not mean that an illocutionary utterance is just equivalent to saying some words which have a certain effect. And, emphatically, the fact that the intended illocutionary act has been happily performed does not mean that the act in question has had its desired effect.[12]

It seems to me that a kind of gap opens up between the possibility of uptake (which is necessary for the happiness of the illocutionary utterance) and the successful achievement of the desired perlocutionary effect. I have successfully advised you—but I have not (or not yet) succeeded in influencing you. I offer to bet you a bottle of Scotch that Pat Schroeder is going to win in '96, but you say, "That's a sucker's bet, no deal." I say, in front of witnesses, "I am giving you this watch in return for your many and faithful services," and you say, "Forget it." I

say something that we both know amounts to an effort to threaten you, and you react by being mildly amused, not in the least alarmed.

In countless instances, this sort of gap opens between the happiness and coherence of my illocutionary act and, on the other hand, the field of desired perlocutionary effects onto which I launched my utterance. I will dub this gap "illocutionary suspense" or "perlocutionary delay."[13] I am not arguing here for the existence of this suspense or delay. I am suggesting that, if we do come to appreciate the existence of such suspense or delay, it will alter our sense of exposure to language and its "operations." Here, again, I am hinting at a kind of analogy between this exposure to the timing or temporality of our utterances and the workings of language in *Antigone*.

Apart from the gain in bringing something of this gap in our acts of speech into the light, there is a further gain in recognizing the forces that prevent us from appreciating this gap or delay. There is, after all, a humanly comprehensible wish for the rightness and appropriateness of our speech—and for the fact that, ideally, the appropriate act of speech will reach all the way out into the world, to secure its appropriate perlocutionary effects. I am, in a sense, dwelling upon another face of one of Austin's primary points. Austin, for good reason, emphasizes the fact that we can sometimes know (and indeed sometimes cannot avoid knowing) of this coherence and "happiness" of our illocutionary acts *before* we know if these acts are to reach all the way to the impact we desire for them.[14]

5.

It does not take a very long story to get from the classical obsessions of Western philosophy to the central issues of *Antigone*. In various ways, both Hegel and Heidegger take this work to be a crucial source for their sense of the relation of philosophy to tragedy, to language, and to the ethos of the political. Hegel uses Antigone's relationship to her brother as a means of characterizing the moment at which the natural but circumscribed life of the family is broken up and translated into the opposing ethical "moments" of the individual and the universal that

continue to disrupt our lives.[15] Heidegger's centrally located remarks about the play address, and indeed associate, the uncanny power of language and the world-creating aegis of the *polis*. (As far as I know, he manages to accomplish this without ever addressing the special circumstances of Antigone, nor the fact that the play depicts her clash with an apparently legitimate authority.) While I do not propose to enter into a general account of the peculiar attraction that this play has held for philosophers, it has seemed increasingly, if sometimes obscurely, important to me to place Austin's vision of language in some proximity to the world of the *Antigone*.

It must be admitted, however, that Austin can seem an unpromising figure for such a juxtaposition. Some of the steps that I propose to take would not, I suppose, have been congenial to Austin. As Cavell points out, Austin does make a crucial and emphatic reference to the *Hippolytus* (9–10).[16] And he does speak, in "A Plea for Excuses," of having the "grace to be torn between . . . simply disparate ideals."[17] But I do not imagine that it would be especially to Austin's liking if I go on to suggest a parallel between Greek tragedy and the relation of our ordinary expressions to our ordinary situations.

I am not at the moment worrying about Austin's famous remarks about the "etiolation" of speech in poetry or on the stage.[18] Cavell has pointed to a link between Austin's refusal of seriousness to the threat of skepticism and the oddness of Austin's manner in bracketing theater, poetry, and quotation as lying in the realm of the "non-serious."[19] If Cavell is right that these gestures go together at some quite fundamental level in Austin's work, then it can seem as if Austin had fashioned a sort of working agreement with his vision of language. On the side' of philosophy, we are to follow him in refusing to take seriously the skeptical possibility that our words might go exactly nowhere. To put it another way, we are to regard as prejudicial from the outset the vision of our words as mere signs, awaiting our private assignments of significance, in hope of some sort of public assessment of their possible usefulness in communication.

But if he refuses—for instance, as banal or jejune or otherwise not worth our while—the skeptical vision of language as a collection

of initially unemployed and potentially unemployable signs, so it seems that there are other places of "linguistic" perplexity that he is not inclined to pursue. If Walt Whitman is seriously inciting that eagle to fly, or if Emily Dickinson is seriously writing a letter to the world that never wrote to her—these are acts of incitement and provocation that Austin is not about to tangle with (104). The process of keeping philosophy from tyrannizing over language may sometimes end up keeping philosophy not only at home but indoors and perhaps, in some sense, grounded.

However fruitful Austin's pact with language proved to be, I am not content with some of its conditions. In pushing his vision of language towards my own sense of our exposure to language in the *Antigone*, I am fairly self-consciously trying to draw Austin's investigations out of doors. Or rather, I am allowing my considerations of Austin's diagnosis of the regime of the Descriptive Fallacy to be drawn towards another region of conflict that expresses itself in something like linguistic terms.

I am not claiming that there is some position from which we may compare philosophy's treatment of language with that of the tragic poet. That would be to suggest that there are well-known alternative routes to this familiar phenomenon of language, and that we are capable of taking such routes independent of either philosophy or poetic drama.[20] This suggests, further, that the knowledge that is thus arrived at could be used as a kind of standard to measure, as it were, the accuracy or adequacy of philosophy or drama to the phenomenon of language. In exposing the vision of a particular philosopher to the vision of a particular work, I mean rather to be drawing us out of such a comfortable sense of our access to language. In particular, I am suggesting that one way in which we begin to experience language as a phenomenon is by being pulled between the poles of philosophical thinking (or fantasizing) about language and the enactment of certain dramatic exposures to the language of political authority. This tension is an important part of what I want to derive from my juxtaposition of Austin's systematic refusal of philosophy's wish for a guarantee of sense and relevance with the *Antigone*'s exposure of language and the realm of the political.

6.

Antigone is the principal character in our culture—equalled, perhaps only by Cordelia, Coriolanus, and Bartleby the Scrivener—who is defined, and who defines herself, in a speech-act of refusal. The physical act of sprinkling some moistened dirt on her dead brother is almost nothing, the movements becoming the merest of traces by which she is to be apprehended. These movements—along with the actual physical touching of her brother's abandoned body—come to assume the greatest importance to Antigone. But, for us, these dark, uncanny, off-stage actions are primarily the occasions within which she voices her resistance. She proclaims—and thereby performs—the fact of her action, proclaiming it most completely in her refusal to deny it: "I say I did it; I do not disavow it" (487).[21]

More than this, her speech act of simultaneous avowal and disobedience occurs in the absence of any clearly recognizable political or social position that would enable the members of the city-state—the *polis*—to make any straightforward sense of the politics of her act. As a woman represented within a Greek city-state—even though she is a member of the royal family—she is without any obvious public place within the *polis*. We could say either that she is too far outside or that she is too far inside the social order for her words to make much sense as mere human utterance. When she appears for the second time as an apprehended criminal, the chorus—who have just finished chanting their ode to the uncanny wonder of the human being—can only characterize her as a *daimon*. In this context, the word means not so much that she is a spirit or that she is "demonic," but that she is a kind of portent, a sign from the gods. She is, however, an all but unreadable sign. In part for the very intensity of her relation to language and signification, and for the consequent difficulties she presents to the city's capacity for interpreting her, I am holding back from regarding the clash of Antigone and Creon as a clash of language. In a sense, it is precisely this unreadability in the human realm that makes her into such a sign.

Hegel, Hölderlin, and Heidegger are surely no longer alone in finding the element of language to be essential to our grasp of the

political conflict in *Antigone*. Indeed, they suggest it is essential to grasp-
ing the very nature of the political. In the first place, there is a clash
between the promulgation of a command and the refusal of its author-
ity. (That it is a promulgation, a public declaration of a command, and
not merely the command itself that is in question receives confirma-
tion from the fact that Creon makes a point of asking her whether she
knew of the decree [ll. 446–447]). Creon's announcement about
Polyneices was clearly a kind of performative:

> I here proclaim to the city that this man
> shall no one honor with a grave and none shall mourn.

(ll. 222–223)

The peculiar shape of Creon's performative proclamation is, first, that
it is intended to have the force of a stigmatizing, descriptive fiat: it is
not merely a performative declaration that Polyneices is hereby dis-
honored by the state. Creon, speaking in a passive, impersonal mode,
actually tries to smother the very possibility of any residual private
feeling or murmuring on behalf of Polyneices. The Greek is closer
to saying: "It is proclaimed that . . . ," henceforth this man shall be
known as a traitor, and as without honor, shameful. Secondly, Creon's
performance interdicts the normal Greek comportment towards the
dead—which would have comprised acts of honoring and mourning.
Creon has thus intertwined performative and descriptive forces, as if
he would use speech to interdict the power of speech itself. He thus
guarantees that any utterance and any feeling on behalf of Polyneices
will be taken as rebellion. More than this: he has made sure that it will
be rebellion. Creon's performance helps to create the ground for a
deeper and more radical disobedience to the state than had yet been
possible. Antigone's utterances do not clash with Creon's merely or
purely as performatives. In fact, she often speaks as though she were
describing something. She presents herself as offering a conclusion,
based on a knowledge of events and utterances that most mortals do
not take themselves to possess directly:

> It was, to me, not Zeus that made that proclamation;
>
> nor did Justice, who lives with those below, enact
>
> such laws as that, for mankind. I did not deem
>
> your proclamation had such power to enable
>
> One who will someday die to override
>
> the gods' unwritten and unfailing laws. . . .
>
> *They* are not of today and yesterday;
>
> They live forever; none knows from what time or place they first were.
>
> These are the laws whose penalties I would not
>
> incur from the gods, through fear of any man's temper.

<div align="right">(ll. 494–501; trans. modified)</div>

Antigone's great speech should not be taken as some obvious piece of "normal" civil disobedience, nor even perhaps as some historically recognizable mode of political revolt.

As the ground of her resistance, she claims to be—I suppose she is—in touch not only with the knowledge of the "unwritten and unfailing" laws of Zeus and of the underworld, but with the unknowable place of their origin. At any rate, she claims to be in touch with the fact that no one can know of this origin, hence she claims to know something of the measure that the immortal life of these laws establishes for human lives and human laws. More practically speaking, she claims to be able to calculate the various penalties attached to disobedience towards each realm, along with the gains of the appropriate obedience. Thus she presents to us, as well as to the chorus, something of an unearthly character—a mode of being between realms.

7.

If Antigone dramatizes not merely resistance by means of words, but speech as an effort to find a ground of resistance that goes beyond any humanly or historically situated speech, it is Creon whose tragic exposure reveals something more human about language—if, perhaps, the revelation is no less uncanny than Antigone's. I want to single out a couple of moments of Creon's peculiar relationship with speech.

Creon comes on, announcing his edict forbidding the burial of
Polyneices to the Chorus (Antigone had, somehow, already known of
it). Both the chorus and Creon agree that their meeting, at least in
principle, has something to do with the function of giving counsel or
advice. Creon goes so far as to say that the soliciting of counsel and
the prosecuting of the affairs of the state are the means by which a
man becomes known to the city, to others:

> It is impossible to know any man—
> I mean his soul, intelligence, and judgment—
> until he shows his skill in rule and law.
> I think that a man, the supreme ruler of a whole city,
> if he does not reach for the best counsel for her,
> but through some fear, keeps his tongue under lock and key,
> him I judge the worst of any.
>
> (ll. 194–206, trans. modified)

This means that the ruler's mind and character must become open to
public view. It also means (I am suggesting) not only that the ruler
becomes open to the city through the medium of the language of his
decrees and that of the counsel he receives, but conversely, that the
ruler himself becomes exposed to the medium of language. We are
now used to thinking of language and knowledge as political phe-
nomena: for this particular tragedy, it is equally true that the political
realm is experienced as a realm of language and knowledge.

A further piece of Creon's position emerges in the same speech:

> I have always judged so; and anyone thinking
> another man more a friend than his own country;
> I rate him nowhere. For my part, God is my witness,
> who sees all, always, I would not be silent
> if I saw ruin, not safety, on the way
>
> (ll. 207–211, trans. modified)

The mix of self-justification with the seeds of self-destruction is not unfamiliar in tragedy (Greek or otherwise), nor perhaps in contemporary political predicaments. What seems more specific to Creon is the mixture of authorizing the Chorus as a public giver of counsel and, on the other hand, the promulgation of a view that makes any public counsel of, for instance, moderation akin to disloyalty.

Creon creates a public space in which the illocutionary force of advice must remain open, for that openness is part of how he has defined and occupied the role of ruler.[22] But his view of loyalty and language insures that sensible citizens will keep quiet. So he himself—on his own account of how we become known to each other—must remain unknown. At least, he must remain unknown until the "counsel" finally reaches its perlocutionary consequences. These consequences render him as passive in the face of the words of Tiresias and the Chorus at the end of the play as he is the active promulgator of edicts at the beginning.

Perhaps nothing, not even ghosts, is harder for a modern audience to take than the fact of prophets and prophecy. This may be a reason that critics and philosophers have not been inclined to look at this moment to further our understanding of Creon's relation to language. Yet when Creon finally yields to his knowledge of Tiresias' powers of prophecy, he is at once yielding to the necessity that was foretold, and at the same time yielding to the one who foretold it. And this means that Creon learns the openness of listening to the speech of others— which is to say, he learns of his exposure to language—only by yielding to it. Such speech is from the beginning what he, as a ruler, claimed to need. And such speech is from the beginning what he, as a ruler, proscribed as unthinkable. The inexorable taking effect of the speech of others is part of the workings of this tragedy.

> My mind is all bewildered. To yield is terrible [*deinon*].
> But by opposition to destroy my very being
> with a self-destructive curse must also be reckoned
> in what is terrible [*deinon*].

(ll. 1168–1171, trans. modified)

I note that Creon apprehends both sides of his dilemma as exposing him to what he apprehends as *deinon*. His bewilderment lies not merely in the terrible whirl of alternatives, but in the fact that, whether he is subjected to the language of necessity or to the necessity which that language expresses, he is exposed to what he calls *deinon*, the "terrible." This word runs a range of meanings, from the terrible, to the wonderful, to the uncanny, as Heidegger insisted we bear in mind.

Even given that a preponderance of the play's force is passing through this moment of Creon's yielding, we may still feel that his predicament possesses a strong similarity to the difficulties of having to admit that he made a mistake. This may be a hard or a wrenching thing to do (as the various translators struggle to say) but it is scarcely in itself a tragedy. Indeed, it can have more than an edge of the comical to it. It is not the point of this essay to establish, once and for all, the differences between tragic resolution and the pains of advice not taken, or taken too late. I have been trying, rather, to advance a kind of analogy between Creon's sense of the uncanny horror in yielding to speech and, on the other side, a potential uncanniness in what I am calling the illocutionary suspense of our utterances. I would like this analogy to end up as more than an analogy. But, at the moment, I will settle for pointing out that—whatever the relationship between these forms of language—philosophy has proven itself all too adept at domesticating both sorts of uncanniness.

I do not imagine that the mere recognition of what I have been calling perlocutionary delay is liable to make philosophy better able to think about tragedy. I do, however, take it that to suppress the gap of perlocutionary delay will make it all but impossible to think about the differences that might occur within this gap. To think about tragedy, philosophers—from Socrates to Derrida and Cavell—have had to be willing to think about comedy, perhaps even to allow their prose the risks of the comical and the banal.

To push the various analogies between dramatic conflict and philosophy's antagonism towards itself one step further, I will offer a little parable of philosophy's oscillating estrangement from and engagement with language and politics. It seems to me that philosophers, at least

since Hegel, have wanted to identify the powers and ironies of philosophy with Antigone's immense capacity to resist the rulers of the earth and, perhaps, especially their power to set the terms by which they regulate our lives. On the other hand, there are those who would now be inclined to describe philosophy as occupying—or anyway wishing to occupy—the position of Creon.

I have gone so far as to suggest implicitly a certain analogy between philosophy's addiction to the Descriptive Fallacy and Creon's unfortunate efforts to enforce not only what is said and done, but the sense and meaning (even perhaps the reference) of what is said and done. Austin, I have suggested, shows philosophy as shadowing Creon's wish, as I said before, to reduce the options of speech to the "acceptable" or to the previously defined forms of the unacceptable. I have been suggesting, only somewhat obliquely, that Austin's account of philosophy's fantasy of an all-purpose, hypertheatrical Constative, is also a condensed fantasy of a certain philosophical form of tyranny. It is perhaps a less violent version of the philosopher's perennial wish that philosophy should be king—or at least that what makes sense in philosophy should be the rule of sense and nonsense in the world.

Knowing that the fantasies of philosophy die hard, I do not imagine that reading Austin and the *Antigone* will by itself provide the occasion for overcoming them. Opposing that vision of philosophy, and even trusting that my sympathies will continue to remain with Antigone, I would nevertheless be committing an act of hubris (or of Heideggerian violence) to envisage a philosophical mood or method that was somehow in tune with Antigone's speech, and with her other sublimities. So I close with a touchstone for a more earthbound methodology—a better measure or fantasy of finding my way in philosophy. Repeating, but with a twist, what others have tried to tell his father Creon, Haemon (who is betrothed to Antigone) speaks for those whose tongues have been tied up with fear:

> Your face is terrible [deinon] to a simple citizen
> It frightens him from words you dislike to hear.
> But what I can hear, in the dark, are things like these:

The city mourns for this girl; they think she is dying most wrongly and most
undeservedly. . . .
Surely what she merits is golden honor, is it not?
That's the dark rumor that spreads in secret.

(ll. 744–755)

In the face of the uncanniness and terror in our various positions and
performances, and perhaps especially in the face of the uncanny ability
of social power to cloak itself as the natural language of the world, phi-
losophy could still learn to imitate Haemon's ability to listen for the
murmuring of incommensurable loyalties. As a mode of human rea-
sonableness, philosophy must somehow maintain its capacity to hear and
to articulate the rules and positions that constitute a realm of meaning
and culture—a place of possible utterance. But that possibility of utter-
ance will always also contain the possibility of a certain tyranny of sense,
a tyranny that tries to dictate to us the "business" of language.

Within this tension between the possibility of sense and the pos-
sibility of the tyranny of sense, I would have philosophy learn to keep
up the habit and the loyalty that allows it to hear the rumors of honor
and grief and shame—rumors that, from whatever fearfulness or other
interdiction, have not yet found their voice. Giving voice to such rumors
of honor or mourning might, at best, become part of the actual efforts
to honor and to mourn. And if mourning requires some kind of pub-
lic space of expression and acceptance, then philosophy's role in
preserving our openness to language might again prove indispensable.
Philosophy cannot, any more than any other form of utterance (per-
formative or constative), create the condition of its own reception, the
happiness of its own performances. But perhaps if it stopped trying
to enforce its vision of its audience and of its subjects, it would give
itself more room for its own forms of speech—and hence for its own
forms of listening.

NOTES

1. The primary source for Austin's investigations of the performative utterance is his *How to Do Things with Words*, 2nd ed., ed. Marina Sbisa and J. O. Urmson (Cambridge, MA, 1975). Further references will be cited in the text. The book was constructed posthumously from Austin's notes for the William James Lectures, delivered at Harvard University in 1955. See also his "Performative Utterances," "A Plea for Excuses," "Other Minds," "How to Talk—Some Simple Says," and "Pretending," all of which were published in his lifetime and are collected in his *Philosophical Papers*, 3rd ed., ed. J.O. Urmson and G. J. Warnock (Oxford, 1979). Encouragement and specific suggestions concerning various drafts of this essay have come from a gratifying range of friends and other interested parties. I want to thank especially Nancy Bauer, Stanley Cavell, Ted Cohen, Maria de Santis, Daniel Herwitz, Andrew Parker, Eve Sedgwick, Garrett Stewart and Kathleen Whalen. Less recent conversations with Stanley Bates and Josh Wilner made it seem worth persisting in my efforts to negotiate among (let us call them) the Anglo-American and the Franco-German traditions of thinking about language. Chris Devlin offered skillful editorial suggestions at the last stages of revision.

2. See especially Eve Kosofsky Sedgwick, "Socratic Raptures, Socratic Ruptures: Notes Toward Queer Performativity," in *English Inside and Out: The Places of Literary Criticism*, edited with an Introduction by Susan Gubar and Jonathan Kamholtz (New York, 1993), pp. 122–136, and also material now gathered in the introduction to this volume. Thinking about her material on Henry James led me, fairly directly, to my formulations about the significance of illocutionary suspense. I plan to pursue the connections between these projects in another essay. See also Judith Butler, *Gender Trouble: Feminism and the Subversion of Identity* (New York, 1990), and her essay entitled "Critically Queer," *GLQ* 1:1 (1993), pp. 17–32, which picks up some of Sedgwick's themes about Austin. It was Sedgwick's conjunction of "performance" and "performativity," along with her faithful instigations, which produced the occasion which brought my investigations to their present shape.

3. The importance of the fact that the explicit performative shares with the constative the grammatical form of a "statement" is often overlooked or minimized. (See Austin, pp. 3–5.) One thing that is emphasized by this commonality of form is that it requires an act of speech to "make a statement" as much as it requires an act of speech to make a bet or advise you of your rights. In both cases, a sentence of a certain form gets used to perform an act. Ultimately, Austin is insisting on the primacy of the *act* of speech in both the performative and the constative utterance. He is not challenging the possibility of making "statements" (whether true or false); he is challenging the philosophical tendency to take the form of the "statement" or the "proposition" as the linguistic-ontological category that is fundamental for philosophers. This tendency goes with a tendency to take the

statement as an "entity" that is logically or metaphysically independent of the various acts of making a statement. (See Austin, pp. 1, 139.)

4. J. Hillis Miller, *Tropes, Parables, Performatives: Essays on Twentieth-Century Literature* (Durham, 1991), p. 139.

5. Miller, p. 145. In this passage, Miller contrasts the act of "positing" (*Ersetzen*) in the performative of utterance with an act of *Erkennen*, presumably to be translated as "knowledge" or "recognition." This terminology seems to derive from Paul de Man's reading of Nietzsche's reading of Descartes and the epistemological tradition of Western philosophy. (See, for instance, de Man, *Allegories of Reading* [New Haven, 1979], pp. 119–124.) Hillis Miller measures what he calls the "human performative" of "I now pronounce you husband and wife" against God's *fiat lux* (pp. 139 and 145). Since this confuses the notion of the performative with the imperative form of "Let there be light," it is difficult to see how this discussion can be applied to Austin's work. It is probably worth pursuing the fact that God does not deal in performatives.

6. Jacques Derrida, "Signature, Event, Context." I cite the version published in *Margins of Philosophy,* trans. Alan Bass (Chicago, 1982), p. 322.

7. Derrida, p. 321.

8. Timothy Gould, "Aftermaths of the Modern: The Exclusions of Philosophy in Richard Rorty, Jacques Derrida and Stanley Cavell," in *After the Future: Postmodern Times and Places*, ed. Gary Shapiro (Albany, 1990), pp. 135–153. I do not suppose that my essay is immune to the difficulties that it describes.

9. Nor, I might add, is Austin very interested in that other, oft-cited, Nietzschean trope, namely, that of truth as a mobile army of metaphors and metonymies.

10. Stanley Cavell, *A Pitch of Philosophy* (Cambridge, 1994), p. 80. See especially Chapter 2, "Counter-Philosophy and the Pawn of Voice." I am grateful to Cavell for a typescript of these investigations, as well as for reading an earlier draft of this essay and offering a series of usable suggestions.

11. This is also the place, it seems to me, of the deepest affinity of my project with Judith Butler's analysis of the discursive formations and constructions of gender in *Gender Trouble*. In the longer set of investigations, of which this essay is the second installment to be published, I characterize one aspect of Butler's vision of the social as a realm that secretes the scarifying and stigmatizing names of things and people and categories. This secretion works as if by nature—or as if by magic. It now seems sometimes as if our various tyrannical regimes, whether social or philosophical, have shrunk back from explicit acts of speech, whether performative or constative. Perhaps they have even shrunk back from proclaiming themselves in words at all. Hence Butler's efforts to render audible the linguistic aspect or performance of the social becomes, if not quite a step in the right direction (since we do not know where that might be), at least a step away from our paralysis.

12. Discussion of this and other related matters concerning Austin are to be found in Ted Cohen's "Illocutions and Perlocutions," *Foundations of Language* 9 (1973). A good deal of my understanding of what I am going to call illocutionary suspense has emerged from my reflections on this essay and on discussions with Cohen about Austin and other matters.

13. I am leaving open the feature of my account that allows for something of an echo of the phenomena of deferred action—of *Nachträglichkeit*. In my choice of the term "delay," there is also a bit of a nod to Derrida's emphasizing of "deferral" in his variations on the theme of *différance*.

14. This knowability of an illocutionary act—even of its limited happiness—is what is most directly denied when Hillis Miller asserts that a performative is not "verifiable."

15. Hegel, *Phenomenology of Mind*, trans. J. B. Baillie, 2nd ed. (London, 1949), pp. 474–478.

16. See Cavell, *A Pitch of Philosophy*.

17. Austin, *Papers*, p. 203.

18. See, for instance, Austin, *How to Do Things with Words*, pp. 9, 22, 104.

19. Cavell, *A Pitch of Philosophy*. These are among the key passages that Derrida seized upon in "Signature, Event, Context," thereby influencing at least a generation of Austin's readers.

20. Or indeed of other forms of literature and inquiry.

21. My quotations, except where indicated, follow the language and the line numberings of *Sophocles I*, trans. with an introduction by David Grene (Chicago, 1991). I have, however, frequently modified his translation, at the cost of some of his fluency.

 I first encountered the *Antigone* in the language of the previous translator in the Chicago series, Elizabeth Wyckoff. I owe her a debt for a version of the linguistic power of this play that was, apparently, ineradicable. More recently, I have used, to the best of my abilities, the Greek edition contained in the Loeb Classical Library, with a translation by F. Storrs, first printed in 1912. Part of the final impetus to write out some of this material came from Joan V. O'Brien, *Bilingual Selections for Sophocles' Antigone: An Introduction to the Text for the Greekless Reader* (Carbondale, 1977).

22. In this play, "counsel," and a word for "speech" that is used as a synonym for counsel, are thematic.

JOSEPH ROACH

2

CULTURE AND PERFORMANCE
IN THE CIRCUM-ATLANTIC WORLD

T HE REAL MAGIC happens," says Anna Deavere Smith, "when the word hits your breath."[1] Those who have seen her performances will understand the validity of this statement as a description of her work. In this essay, I want to explore its resonant implications for professors of the discipline that might still be called English: in the study of language and culture, literature is not enough. My theme today is the interdependence of performance and collective memory. It emerges from a project that would recast the category of literature, as a repository of texts, in relation to what my colleague Ngugi wa Thiong'o calls "orature," the range of cultural forms invested in speech, gesture, song, dance, storytelling, proverbs, customs, rites, and rituals. Ngugi defined orature indirectly when he said of the singer: "He is a sweet singer when everybody joins in. The sweet songs last longer, too." As Kwame Anthony Appiah notes, "there are many devices for supporting the transmission of a complex and nuanced body of practice and belief without writing."[2] This continuing dialogue between literature and orature, however, does not accept a schematized opposition between literacy and orality as transcendent categories; rather, it rests upon the conviction that these modes of communication have produced one another interactively over time,

The white man who made the pencil also made the eraser.

—Yoruba Proverb

and that their historic operations may be usefully examined under the rubric of performance.

The concept of performance engages "The Politics of Theater" through its implicit critique of the culturally coded meaning of the word *theater*. Derived from the Greek word for seeing and sight, *theater*, like *theory*, is a limiting term for a certain kind of spectatorial participation in a certain kind of event. *Performance*, by contrast, though it frequently makes reference to theatricality as the most fecund metaphor for the social dimensions of cultural production, embraces a much wider range of human behaviors. Such behaviors may include what Michel de Certeau calls "the practice of everyday life," in which the role of spectator expands into that of participant.[3] De Certeau's "practice" has itself enlarged into an open-ended category marked "performative." As the Editor's Note to a recent issue of *PMLA* ("Special Topic: Performance") observes: "What once was an event has become a critical category, now applied to everything from a play to a war to a meal. The performative . . . is a cultural act, a critical perspective, a political intervention."[4]

From the perspective of the interdiscipline—or the postdiscipline—of performance studies, poised on the cusp of the arts and human sciences, moving between anthropology and theater, the term *performance* may be more precisely delineated as what Richard Schechner calls the "restoration of behavior." "Restored behavior" or "twice-behaved behavior" is that which can be repeated, rehearsed, and above all *recreated*.[5] But therein lies an anomaly that evokes Anna Deavere Smith's "magic." The paradox of the restoration of behavior resides in the phenomenon of repetition itself: no action or sequence of actions may be performed exactly the same way twice; they must be reinvented or recreated at each appearance. In this improvisatory behavioral space, memory reveals itself as imagination.

Variations on the theme of "repetition with a difference" may be discerned, of course, in a range of poststructuralist positions. Most pertinent to my concerns today, the African-American tradition of "signifyin(g)," as explained by Henry Louis Gates, Jr., with reference to Jelly Roll Morton's stomp variation on Scott Joplin's rag, and applied as "repetition with revision" to Yoruba ritual by Margaret Thompson

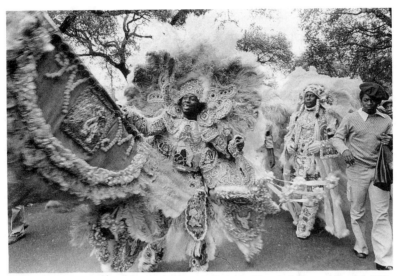

Big Chief Bo Dollis, Wild Magnolias Mardi Gras Indian Tribe, at "Hercules" Gateman Funeral, 1979.
Photo: Michael P. Smith

Drewal,[6] illuminates the theoretical possibilities of restored behavior, not merely as the recapitulation, but as the transformation of experience through the renewal of its cultural forms. In this sense, performance offers itself as a governing concept for literature and orature alike.

Thus understood, performance highlights a distinction between social memory and history as different forms of cultural transmission across time: memory requires collective participation, whether at theatrical events, shamanic rituals, or Olympic opening ceremonies; history entails the critical (and apparently solitary) interpretation of written records. Both also function as forms of forgetting: cultures select what they transmit through memory and history. The persistence of collective memory through restored behavior, however, represents an alternative and potentially contestatory form of knowledge—bodily knowledge, habit, custom. The academic preoccupation with textual knowledge—whereby a culture continually refers itself to its archives—tends to discredit memory in the name of history.[7] In fact, both forms of cultural transmission have their distinctive efficacies: textual knowledge, for instance, though it travels apparently intact through space and

time, obviously lacks the vitality of kinesthetic awareness that characterizes the participatory enactments of memory. Knowledge of such memories comes more readily to the observer-participant, who has danced the dance or joined the procession, than it does to the reader. At the same time, the diachronous relations of such performances can quite readily disappear from critical consciousness, transforming memory into the most volatile forms of nostalgia.

Both history and memory participate in the production of restored behavior, circulating in performance genres as diverse as street carnivals, intelligence testing (which measures "performance"), postoperative therapies for breast prostheses, slave auctions, and operas. The study of restored behaviors in their diachronous dimension, however, is a relatively new field of research, organizing itself around what I call "genealogies of performance." Genealogies of performance "document the historical transmission and dissemination of cultural practices through collective representations."[8] For this formulation, I am indebted to Jonathan Arac's definition, revising Nietzsche and Foucault, of a "critical genealogy," which "aims to excavate the past that is necessary to account for how we got here and the past that is useful for conceiving alternatives to our present condition."[9] Genealogies of performance approach literature as a repository of the restored behaviors of the past. They excavate the lineage of restored behaviors still at least partially visible in contemporary culture, in effect "writing the history of the present."[10] But they intensify when they treat performances of cultural self-declaration in the face of encounter and exchange—the performance of culture in the moment of its most acute reflexivity, when it attempts to explain and to justify itself to others. For this reason, my argument, as my title indicates, is geographically located in broad hemispheric vortices as well as local sites, and this location itself requires some explanation.

I began with the Yoruban proverb, itself a powerfully compact mnemonic conveyance, to emphasize the indispensability of African diasporic and Native American memories to my account of culture and performance. I insist on the term *circum*-Atlantic, as opposed to *trans*-Atlantic, to underscore the compelling truth of Paul Gilroy's observation:

"A new structure of cultural exchange has been built up across the imperial networks which once played host to the triangular trade of sugar, slaves and capital."[11] The creation of those imperial networks, which was one of the most vastly consequential undertakings of the early modern period in Europe or of any other time in human history, required modernization of the European economy predicated on the genocidal exploitation of West African and American peoples. What compels me in restating this fact of history is a claim I want to make about the creation of the triangle of exchange between Northern Europe, Africa, and the Americas: the vast scale of the project—and the scope of the contact between cultures it required—limited the degree to which it could be eradicated from the memory of those who had the deepest motivation and the surest means to forget it; but it also fostered complex and ingenious schemes to displace, refashion, and transfer those persistent memories into representations more amenable to those who most frequently wielded the pencil and the eraser. In that sense, the creation of the circum-Atlantic world is a monumental study in the pleasures and torments of incomplete forgetting.

Historians have attended to the shift of decisive trade and power rivalries from the Mediterranean world to the Atlantic, which occurred in the late seventeenth and early eighteenth centuries, especially in the years leading up to and immediately following the Treaty of Utrecht in 1713.[12] The rivalry between Britain and France, particularly their struggle to dominate the slave economies in the West Indies and North America, shaped the cultural formations I am addressing here and the performances by which they are memorialized. The cultural politics of the odyssey from Mediterranean to Atlantic made it an epic story, living on the tips of many tongues.[13] As Homer and the tragic dramatists recorded and celebrated what they saw as the enormous, epochal shift of cultural and political gravity from the Asiatic world to the Mycenaean, as Virgil immortalized the similar movement out from the Aegean into the larger world of *mare nostrum*, so the poets, dramatists, and storytellers of the early modern period could once again poetically witness a transfer of the imperial vortex from its historic locus.

Africa plays a hinge-role in turning the Mediterranean-centered consciousness of European memory into an Atlantic-centered one, and not only because African labor produced the addictive substances (sugar, coffee, tobacco, and—most insidiously—sugar and chocolate in combination) that revolutionized the world economy.[14] The scope of that role largely disappears from history until fairly recent times: Africa leaves its historic traces amid the incomplete erasures, beneath the superscriptions, and within the layered palimpsests of more-or-less systematic cultural misrecognition. But diasporic Africa also leaves much more than historic traces; it regenerates the living enactments of memory through orature—and more recently through literature, which now links the perimeter of the circum-Atlantic world (American, Caribbean, African) with lyrics, narratives, and dramas of world-historical prominence.

I will focus here on a particular kind of performance—the funeral, as it is both represented in literature and enacted through orature. On the one hand, customs of death and burial, changing slowly over time, serve as grist for the mill of the *annalistes*: historical practices so conservative that even over the *longue durée* they look like structures. On the other hand, funerals can easily and often do become sites for the enunciation and contestation of topical issues. They are also characterized by the conditions of specificity that, according to ethnographer Barbara Kirshenblatt-Gimblett, attract investigators to such sites: "performance-oriented approaches to culture place a premium on the particularities of human action, on language as spoken and ritual as performed."[15]

In establishing the genealogy of circum-Atlantic performance genres, multimedia events prove the most promising, perhaps because their varied sensory modalities provide different kinds of memories. The funeral frequently combines music, poetry, dramatic action, and spectacle in a form that resembles opera, a coincidence that Wagner was neither the first nor last composer to exploit. The operatic mode of performance unites literature and orature, especially in the baroque *opera seria*, which delegated many of its vocal effects to the singers' improvisations. The most celebrated passage in early English opera,

for instance, is the final aria sung by Dido, Queen of Carthage, in Henry Purcell's *Dido and Aeneas*, which is followed by a chorus that describes the obsequies performed to commemorate her death. This enactment of Mediterranean encounter, rupture, and dynastic establishment premiered in an amateur performance at a girls' school in 1689, the same year that James II involuntarily turned his interest in the Royal Africa Company, founded by brother Charles in 1672, over to its ambitious investors and sailed away.[16] There has been informed speculation about the local political allegory of *Dido and Aeneas* relating to the royal succession and Williamite policy,[17] but my genealogical reading is circum-Atlantic in scope.

The libretto of *Dido* is by Nahum Tate, better remembered for his improvements to *King Lear*. In fact, a number of Tate's works for the stage derive directly or indirectly from the materials in Geoffrey of Monmouth's *Historia Regum Britanniae*, a narrative from which he grafted some details onto the fourth book of Virgil's *Aeneid* to produce the *Dido* libretto. In the 1670s, Tate had begun a play on the Dido and Aeneas story, but he decided to adapt the plot to fit the epic voyages of the legendary Trojan Brutus, Aeneas's grandson (or greatgrandson in some versions). In this play, called *Brutus of Alba; or, the Enchanted Lovers* (1678), the hero loves and leaves the Queen of Syracuse as Aeneas abandons the Queen of Carthage: the grandfather sails away to found Rome; the grandson, according to Tate's dramatization of Geoffrey of Monmouth's account of the oral tradition, sails away to found Britain.

Moving from the Mediterranean world to the Atlantic, this mythic reiteration of origins, an evocation of collective memory, hinges on the narrative of abandonment, a public performance of forgetting. In the score's most stunning moment of musical declamation, which prepares for the death of the forsaken queen and the observances performed over her body, Tate gave Purcell a deceptively simple line to set. As Aeneas sets sail for Rome and empire, Dido's last words seem to speak for the victims of transoceanic ambitions:

Remember me, but ah! forget my fate.[18]

Dido pleads that she may be remembered as a woman, even as the most pertinent events of her story are erased, a sentiment that more appositely expresses the agenda of the departing Trojans. Dryden's translation of Virgil catches the drama of this decisive moment:

> Dire auguries from hence the Trojans draw;
> Till neither fires nor shining shores they saw.
> Now seas and skies their prospect only bound;
> An empty space above, a floating field around.[19]

As Aeneas casts a parting look back to the rising pillar of smoke, his ambivalence fuses memory and forgetting into one gesture. In that gesture, he enacts the historic tendency of Europeans, when reminded, to recall only emotions of deep love for the peoples whose cultures they have left in flames, emotions predicated on the sublime vanity that their early departure would not have been celebrated locally as deliverance.

The key to the genealogy of performance derived from this moment of a Restoration opera, however, rests on the musical setting for the text. The ground bass accompaniment for the vocal line of Dido's lament is a chaconne. This form became widely popular in Europe at the beginning of the seventeenth century, first in Spain, as a dance in triple meter with erotic connotations, then in France, as a more stately court dance, associated especially with weddings. Purcell came to know it from the French. The only agreement about the origin of what the Spanish call the *chacona* and the Italians *ciaccona*, however, is that it was not European, and that it drove women crazy. Spaniards attributed it to the Indians of Peru or perhaps the West Indies, where it gave its name to a mythical island, a utopia also called Cucuña (or in English "Cockaigne"). Beauchamps, the French dancing master, confidently traced the chaconne to Africa.[20]

Whatever the precise history of the chaconne across four continents, the very confusions about its points of origin suggest its emergence out of an early version of what James Clifford describes as the "creolized 'interculture'" of the Caribbean.[21] Its assimilation into the musical life of a finishing school for daughters of English

merchants suggests the invisible domestication and consumption of the Atlantic triangle's vast cultural produce, which, like sugar, its textures effaced, metamorphosed from brown syrup into white powder, until only the sweetness remained. That Dido's final lament, stately threnody that it is, derives its cadences and musical style from a forgotten Native American or African form, lends an eerily doubled meaning to the queen's invocation of memory as her lover sails boldly away from the coast of Africa, bound for amnesia.

The cultural appropriation that plays itself out along the routes of the circum-Atlantic triangle—conjoining and resegregating Europeans, Africans, and Native Americans—appears most emphatically where the genealogy of performance encompasses what I call surrogation, the theatrical principle of substitution of one persona for another. The triangular relationship of white, red, and black peoples seems both to threaten and accelerate the process of surrogation, which requires the elimination or the abjection of the third party.

The impetus of circum-Atlantic contact to performative self-definition through cultural surrogation produced diverse effects at various sites along the oceanic rim. In a recent study of the role of theatricality in the early cultural history of the United States, for instance, *Declaring Independence: Jefferson, Natural Language, and the Culture of Performance*, Jay Fliegelman begins with the significant but neglected fact that the Declaration of Independence was just that—a document written to be spoken aloud as oratory. He goes on to document generally the elocutionary dimension of Anglo-American self-invention, which emerged in relationship to Native Americans, on one hand, and Africans, on the other. Thomas Jefferson identified the supposedly transparent Anglo-Americans with the "natural eloquence" of Indian orators. When he was accused of inventing the words of the Shawnee chief Logan's great speech in *Notes on the State of Virginia*, Jefferson replied that its authorship was immaterial because, in any case, "it would still have been American."[22] This same desideratum disqualified Africans from political expression, however, because the supposed uniformity and fixity of their color allegedly rendered them inscrutable behind what Thomas Jefferson called "that immovable veil of black which covers all the emotions."[23]

Like theatrical doubling, surrogation operates in two modes. In the first mode, one actor stands in for another (as in the film trade's "stunt double" or "body double") so that, in effect, two actors share one mask. In the second mode of doubling, one actor plays more than one role—two (or more) masks appear on one actor. In the doubling of Logan, Jefferson casts himself as stand-in for the Shawnee chief: two actors wear the one mask coded "American." By contrast, in the doubling accomplished by blackfaced minstrelsy, one actor wears two distinct masks—the mask of blackness on the surface and the mask of whiteness underneath, which the printed programs for minstrel shows ostentatiously feature in portraits of the performers out of makeup, acting white.[24] In the first case, the surrogated original, the Native American, disappears into white speech. In the second, the doubled African American remains ventriloquized. In both cases, Anglo-American self-definition occurs in performances that feature the obligatory disappearance or captive presence of circum-Atlantic cohabitants.

Performances of encounter, however, do not belong to Europeans by right of manifest destiny. Circum-Atlantic contact and cultural exchange between Native Americans and Africans have produced performance traditions in the Caribbean and, on its northernmost rim, in Louisiana, that flourish today, though their rich meanings depend on relationships forged in colonial times. My work on performance genealogies began when I first learned about the Mardi Gras Indian "tribes" of New Orleans, African Americans who parade as Native Americans (in gorgeous, fantastical, hand-sewn costumes) and therefore reenact at carnival time the historical sense of the shared experience of peoples from two continents.[25]

The persistent power of surrogation in the performance of such cultural and ethnic difference resides, I believe, in the social liminality of the designated performers. According to Victor Turner, the temporary liminality of the performer in "social dramas" (such as rites of passage) creates conditions of reflexivity, of cultural self-consciousness, or in Turner's own words, "a limited area of transparency in the otherwise opaque surface of regular, uneventful social life."[26] At

the limit of the boundaries of a culture, performers are paradoxically "at once the distillation and typification of its corporate identity."[27]

From this perspective, the funerals of actors provide particularly promising sites for performance genealogies, because they involve a figure whose performance of both liminality and surrogation was all in a day's work. In any funeral, the liminal body of the deceased literally performs the limits of the community called into being by the need to mark its passing. United around a corpse that is no longer inside but not yet outside its boundaries, the community reflects upon the constructedness, the permeability, and not infrequently the violence of its borders.[28]

Liminality helps to explain why transvestism, for instance, seems historically constitutive of performance, a prior urgency to which the theater provides an epiphenomenal elaboration or publicity. Marjorie Garber's insightful account of the funeral of Laurence Olivier ("a transvestite Olivier") as the surrogated burial of Shakespeare in Westminster Abbey ("only this time, much more satisfyingly, *with* a body") focuses on the uses of liminality in the creation of memory: "That impossible event in literary history, a state funeral for the poet-playwright who defines Western culture, doing him appropriate homage—an event long-thwarted by the galling absence of certainty about his identity and whereabouts—had now at last taken place."[29] While I warmly embrace this analysis of the meaning of the event, I argue that it was hardly the first of such rituals, but rather one repetition among many in a genealogy of performance that dates from at least 1710. In such obsequies, the dead actor stood in for the Bard, who stood in for the imagined community, summoned into illusory fullness of being by the performance of what it thought it was not. Unlike the anxious atmosphere of homophobia and misogyny that produced the transvestite liminality necessary to Olivier's apotheosis as a surrogated double, however, the sacred monsters of earlier times were produced by "playing off" the circum-Atlantic world's obsession with race.

In a somber, even haunting *Tatler* number (May 4, 1710), Richard Steele recounts his evening walk to the cloisters of Westminster Abbey, there to attend the interment of the remains of Thomas Betterton, the most celebrated actor of that age. As Steele stands in the lengthening

shadows of the burial place of English kings, awaiting the corpse of a stage player, he reflects on the kindred significance of two kinds of performance: first, the public rites and obsequies accorded to the venerated dead; second, the expressive power and the didactic gravity of the stage. "There is no Human Invention," he concludes, "so aptly calculated for the forming a Free-born people as that of a Theatre."[30] In the civic-minded, Augustan language of liberal moral instruction, Steele's eulogy sets forth the principal argument that I am trying to make about the stimulus of restored behavior to the production of cultural memory in the crucible of human difference along the circum-Atlantic rim.

Betterton's funeral in 1710 marked the end of a fifty-year career (some have called it a "reign") on the London stage. In that time, he played over 183 roles in every genre, 131 of which he created.[31] Contemporaries took pride in Betterton's link to Shakespeare through bodily memory across the gulf of the Interregnum: the actor learned the physical business and intonations of some roles from Davenant, who claimed to have learned them from Taylor, whom Shakespeare supposedly coached in person. In an age that had a low opinion of actors and actresses on principle, Betterton's burial in Westminster Abbey was momentous. When Steele surveyed the entirety of the English Roscius's career, however, he chose one special role from the 183 to demonstrate the defining power of theatrical performance in "the forming of a Free-born people":

> I have hardly a Notion that any Performer of Antiquity could surpass the Action of Mr. *Betterton* on any of the Occasions in which he has appeared on our Stage. The wonderful Agony which he appeared in, when he examined the Circumstances of the Handkerchief in *Othello*; the Mixture of Love that intruded upon his Mind upon the innocent Answers *Desdemona* makes, betrayed in his Gesture such a Variety and Vicissitude of Passions, as would admonish a Man to be afraid of his own Heart, and perfectly convince him, that it is to stab it, to admit that worst of Daggers, Jealousy. Whoever reads in his Closet this admirable Scene, will find that he cannot, except he has as warm an Imagination as *Shakespeare* himself, find any but dry, incoherent, and broken Sentences: but a Reader that has seen *Betterton* act it, observes there could not be a Word added; that longer Speech had been unnatural, nay impossible,

in *Othello's* Circumstances. The charming Passage in the same Tragedy, where he tells the Manner of winning the Affection of his Mistress, was urged with so moving and graceful and Energy, that while I walked in the Cloysters [of Westminster Abbey], I thought of him with the same Concern as if I waited for the Remains of a Person who had in real Life done all that I had seen him represent.[32]

Betterton, paragon of Anglo orature, vessel of its collective memory, thus doubles Shakespeare in Steele's vision of "forming a Free-born people," but he does so wearing blackface, just as Thomas Jefferson did it in war paint, and Lord Olivier more recently played it in drag.

In circum-Atlantic terms, canon formation in European culture parallels the spiritual principle to which bell hooks, in her essay on "Black Indians," attributes the deep affinity of African and Native American peoples: "that the dead stay among us so that we will not forget."[33] This principle animates the deeply moving account by Kwame Anthony Appiah of the funeral of his father, in whose house, we are made to understand, were many mansions: "Only something so particular as a single life—as my father's life, encapsulated in the complex pattern of social and personal relations around his coffin—could capture the multiplicity of our lives in the postcolonial world."[34] Around the Atlantic rim today, this principle of memory and identity still provokes intercultural struggles over the possession of the dead by the living. These struggles take many forms, of which the most remarkable are those in which the participatory techniques of orature—people speaking in one another's voices—predominate.

Last year in New Orleans, Joe August, the rhythm and blues pioneer known as "Mr. Google Eyes," was buried "with music." To be buried with music in New Orleans means that the ordinary service will be followed by what the death notices call a "traditional Jazz Funeral." Jazz funerals represent festive occasions in the community—no disrespect for the dead intended. As Willie Pajaud, trumpeter for the Eureka Brass Band, put it: "I'd rather play a funeral than eat a turkey dinner."[35] Well-known and esteemed local musicians, black or white, will likely receive such a send off, and Joe August, who recorded "Poppa Stoppa's Be-Bop Blues" for Coleman Records, and "No Wine, No

Women" and "Rough and Rocky Road" for Columbia, who also wrote one of Johnny Ace's biggest hits, "Please Forgive Me," and who founded the activist agency Blacks That Give a Damn, qualified on both counts.[36] Before the Olympia Brass Band led the way to the cemetery, Malcolm Rebennack, better known as Dr. John, the white jazz celebrity, eulogized Joe August thus: "it is with great pride that we carry the message of the blues that you instilled in us as children."[37]

The festive procession of the Jazz Funeral then followed, and Joe August's remains were escorted towards the cemetery by a crowd of mourners, following the elegant grand marshall (or "Nelson") and the band, in a restoration of behavior that participants trace to West Africa, a recreated diasporic memory.[38] Gwendolyn Midlo Hall, in her magisterial *Africans in Colonial Louisiana*, documents the discrete pattern whereby the French imported slaves from one area of West Africa. Following the Treaty of Utrecht in 1713, the French slavers evaded the British domination of the West Indian slave trade (and eschewed the British practice of mixing together African peoples from different language groups and cultures) by concentrating on Mandekan-speaking peoples from Senegambia. One consequence of this French policy was a cohesion and continuity in Louisiana slave society that enabled it to retain performance-rich African traditions relatively intact, including celebrations of death founded on religious belief in the participation of ancestral spirits in the world of the present. After the suppression of the great slave revolt of 1795, for instance, "festivals of the dead," held in defiance of the authorities, honored the executed freedom fighters.[39]

In opposition to the official voice of history, which, like Aeneas looking back on the pillar of smoke, has tended to emphasize the cultural annihilations of the diaspora, the voice of collective memory, which derives from performance, speaks of the stubborn reinventiveness of restored behavior. Funerals offer an occasion for the playing out of what James C. Scott, in *Domination and the Arts of Resistance*, calls "hidden transcripts."[40] Translating Scott's terms to the history of Afrocentric funeral rites in Louisiana, "festivals of the dead" became a vehicle for the covert expression of officially discouraged solidarity masked by publicly permissible expressions of mourning. The fact of

broad participation itself, then, may silently resist the dominant public transcript by affirming the rites of collective memory. When the French naturalist Claude C. Robin visited New Orleans at the time of the sale of Louisiana to the United States, he remarked: "I have noticed especially in the city that the funerals of white people are only attended by a few, those of colored people are attended by a crowd, and mulattoes, quadroons married to white people, do not disdain attending the funeral of a black."[41] Such a performance event opens up, with its formal repetitions, a space for play. Its genius for participation resides in the very expandability of the procession: marchers with very different connections to the deceased (or perhaps no connections at all) join together on the occasion to make connections with one another. In 1962, Richard Allen, an observer of the revelers in the most joyous part of a Jazz Funeral (after the body is "cut loose" and sent on its way), noted: "At least two boys and two women dancing with partners of opposite sex and color."[42] In the midst of this extraordinary Afrocentric ritual, however, in the very space it has created for memory as improvisation, the process of circum-Atlantic surrogation unfolds. Dr. John, who eulogized Joe August, is a white man who takes his stage name from the formidable, nineteenth-century New Orleans Voodoo, alias Bayou John, who intimidated slaves and slaveholders alike. Malcolm Rebennack spoke the eulogy under his own name as a carrier of the "message of blues," instilled in him by Joe August, but he records and performs under the assumed name of Dr. John, who claimed that he was a Senegalese Prince, whose face was scarified in the African manner, and whose voice, it was said, could be heard from two miles away.[43] Perhaps it can be heard across surprising expanses of time as well.

In 1960, Joe August, who got his stage name for the way he once looked at a waitress, was arrested and charged under Louisiana's antimiscegenation law. Although the charges were eventually dropped, his career, as his obituary put it, "slowed." The state of liminality, like the State of Louisiana, both of which ethnographers find so rich in cultural expressiveness, can be very hard on the people who are actually trying to live there. In relation to southern protocols of ocular circumspection between the races, the adoption of "Mr. Google Eyes"

as a stage name proved a tactless choice. Joe August cut his last record in 1963, nearly thirty years before his death.[44]

Like the fate of the chaconne in the seventeenth century, the contributions of other cultures to Western forms tend to become disembodied as "influences," distancing them from their original contexts (and from the likelihood of a contract for their initiators). This form of reversed ventriloquism permeates circum-Atlantic performance, of which American popular culture is now the most ubiquitous and fungible nectar. The voice of African-American rhythm and blues carries awesomely over time and distance, through its cadences, its intonations, its accompaniment, and even its gestures. Elvis Presley, like Dr. John, inverted the doubling pattern of minstrelsy—black music pours from a white face—and this surrogation has begotten others. It seems to me that the degree to which this voice haunts American memory, the degree to which it promotes obsessive attempts at simulation and impersonation, derives from its ghostly power to insinuate memory between the lines, in spaces between the words, in the intonation and placements by which they are shaped, in the silences by which they are deepened or contradicted. By such means, the dead remain among the living. This is the purview of orature, where poetry travels on the tips of tongues and memory flourishes as the opportunity to participate.

Yet, as I hope I have demonstrated, such memories haunt literature—the libretto of *Dido and Aeneas*, a *Tatler* paper—as pervasively, if not as overtly, as they inhabit orature. At the outset, I identified performance as the transformation of experience through the renewal of its cultural forms. I want to conclude with the possibility that the study of performance might assist in the ongoing renovation of the discipline of English—not simply as an additive to the coverage model of specialties in period and genre, but as a transformative force, revising the place of literature in relation to other cultural forms. In my own work I have tried to recognize that poems, essays, and plays are not simply texts—a recognition that is particularly difficult to achieve when virtually all phenomena, from cityscapes to Madonna videos, are read as texts. Rather, literary texts participate in a world system, the relationship of whose parts are obscured by the conditions of their local production and often

ignored by a discipline that devalues any form of production except the textual—with the bizarre exception of conference papers.

Although theories of colonial and postcolonial discourse have done a great deal to liberate the field from the confines of its academic insularity, the relation of a text to its colonial or postcolonial context is most frequently presented as a process in which the insular text is constituted by its opposition to a racial or cultural Other. But that formulation reduces the Other to a role of simple instrumentality in a process that is effective only to the extent that it erases its instrument. Genealogies of performance, however, resist such erasures by taking into account the give and take of transmissions, posted in the past, arriving in the present, delivered by living messengers, speaking in tongues not entirely their own. Orature is an art of listening as well as speaking; improvisation is an art of collective memory as well as invention; repetition is an art of recreation as well as restoration. Texts may obscure what performance tends to reveal: memory challenges history in the construction of circum-Atlantic cultures, and it revises the yet unwritten epic of their fabulous cocreation.

NOTES

1. Anna Deavere Smith, interviewed by John Lahr, quoted in "Under the Skin," *The New Yorker* (June 28, 1993), p. 92.

2. Ngugi wa Thiong'o, interviewed by Bettye J. Parker, *Critical Perspectives on Ngugi wa Thiong'o*, ed. G. D. Killam (Washington: Three Continents Press, 1984), p. 61; Kwame Anthony Appiah, *In My Father's House: Africa in the Philosophy of Culture* (New York and Oxford, 1992), p. 132.

3. Michel de Certeau, *The Practice of Everyday Life*, trans. Stephen F. Rendall (Berkeley and Los Angeles, 1984), pp. 91–110.

4. John W. Kronik, "Editor's Note," *PMLA* 107 (1992), p. 425.

5. Richard Schechner, *Between Theater and Anthropology* (Philadelphia, 1985), pp. 35–116.

6. Henry Louis Gates, Jr., *The Signifying Monkey: A Theory of Afro-American Literary Criticism* (New York, 1988), pp. 63–88; Margaret Thompson Drewal, *Yoruba Ritual: Performers, Play, Agency* (Bloomington, 1992), pp. 4–5.

7. For the material in this paragraph, I am variously indebted to John J. MacAloon, *Rite, Drama, Festival, Spectacle: Rehearsals Toward a Theory of Cultural Performance*

(Philadelphia, 1984); Paul Connerton, *How Societies Remember* (New York, 1989); and Maurice Halbwachs, *On Collective Memory*, ed. Lewis A. Coser (Chicago and London, 1992).

8. Joseph Roach, "Slave Spectacles and Tragic Octoroons: A Cultural Genealogy of Antebellum Performance," *Theatre Survey* 33 (1992), p. 169.

9. Jonathan Arac, *Critical Genealogies: Historical Situations for Postmodern Literary Studies* (New York, 1987), p. 2.

10. Michel Foucault, *Discipline and Punish: The Birth of the Prison*, trans. Alan Sheridan (New York, 1979), p. 31.

11. Paul Gilroy, *'There Ain't No Black in the Union Jack': The Cultural Politics of Race and Nation* (Chicago, 1987), p. 157.

12. J. S. Bromley, *The New Cambridge Modern History*, Vol. VI, *The Rise of Great Britain and Russia* (Cambridge, 1971), p. 571; for a view of the larger context, see Fernand Braudel, *The Mediterranean and the Mediterranean World in the Age of Philip II*, 2 vols. (New York, 1972–73).

13. See Paul Zumthor, *Oral Poetry: An Introduction*, trans. Kathryn Murphy-Judy (Minneapolis, 1990).

14. See Sidney Mintz, *Sweetness and Power: The Place of Sugar in Modern History* (New York, 1985).

15. Barbara Kirshenblatt-Gimblett, "Objects of Ethnography," in *The Poetics and Politics of Museum Display*, ed. Ivan Karp and Steven D. Lavine (Washington and London, 1991), p. 430.

16. Angus Calder, *Revolutionary Empire: The Rise of the English-Speaking Empires from the Fifteenth Century to the 1780s* (New York, 1981), p. 347.

17. For several commentaries, see Curtis Price's critical edition, *Dido and Aeneas, an Opera* (New York and London, 1986).

18. Henry Purcell and Nahum Tate, *Dido and Aeneas* (1689; facs. rpt. Boosey & Hawkes, n.d.), p. 8.

19. John Dryden, *Virgil: The Aeneid Translated by John Dryden* (New York, 1944), p. 126.

20. Thomas Walker, "Ciaccona and Passacaglia: Remarks on Their Origin and Early History," *Journal of the American Musicological Society* 21 (1968), pp. 300–320.

21. James Clifford, *The Predicament of Culture: Twentieth-Century Ethnography, Literature and Art* (Cambridge, MA and London, 1988), p. 15.

22. Chief Logan, quoted in Jay Fliegelman, *Declaring Independence: Jefferson, Natural Language, and the Culture of Performance* (Stanford, 1993), p. 98.

23. Thomas Jefferson, quoted in Fliegelman, p. 192.

24. Eric Lott, "Love and Theft: The Racial Unconscious of Blackface Minstrelsy," *Representations* 39 (1992), pp. 23–50.

25. Joseph Roach, "Mardi Gras Indians and Others: Genealogies of American Performance," *Theatre Journal* 44 (1992), pp. 461–483; see Judith Bettelheim and John W. Nunley, *Caribbean Festival Arts: Each and Every Bit of Difference* (St. Louis, 1988).

26. Victor Turner, *Schism and Continuity: A Study of Ndembu Village Life* (Manchester, 1957), p. 93.

27. Victor Turner, *Celebration: Studies in Festivity and Ritual* (Washington, DC, 1982), p. 16.

28. See Richard Huntington and Peter Metcalf, *Celebrations of Death: The Anthropology of Mortuary Ritual* (Cambridge and New York, 1979).

29. Marjorie Garber, *Vested Interests: Cross-Dressing and Cultural Anxiety* (New York, 1993), p. 33.

30. Richard Steele, *The Tatler*, ed. Donald F. Bond (Oxford, 1987), II, p. 423.

31. Judith Milhous, "An Annotated Census of Thomas Betterton's Roles, 1659–1710," *Theatre Notebook* 29 (1975), Part I, pp. 33–45; Part II, pp. 85–94.

32. Steele, II, 423–424.

33. bell hooks, *Black Looks: Race and Representation* (Boston, 1993), p. 180.

34. Appiah, p. 191.

35. Willie Pajaud: in file, Funeral and Music: General, William Ransom Hogan Jazz Archive, Tulane University.

36. Joseph Charles Augustus, Obituary, *New Orleans Times-Picayune* (October 12, 1992) p. B8, Hogan Jazz Archive.

37. Malcolm Rebennack (Dr. John): in Joseph August, "Mr. Google Eyes," Memorial Service Program, Hogan Jazz Archive.

38. See Jack Vincent Buerkle and Danny Barker, *Bourbon Street Black: The New Orleans Black Jazzman* (New York: Oxford, 1973), and William J. Schafer and Richard B. Allen, *Brass Bands and New Orleans Jazz* (Baton Rouge and London, 1977); "Nelson" could also be used as a verb to describe the distinctive motion of the grand marshall (see Archie Carey: in file, Funeral and Music: Grand Marshall, Hogan Jazz Archive).

39. Gwendolyn Midlo Hall, *Africans in Colonial Louisiana: The Development of Afro-Creole Culture in the Eighteenth Century* (Baton Rouge and London, 1992), pp. 50, 372.

40. James C. Scott, *Domination and the Arts of Resistance: Hidden Transcripts* (New Haven and London, 1990).

41. Claude C. Robin, *Voyage to Louisiana*, trans. Stuart O. Landry (New Orleans, 1966), p. 248.

42. Richard Allen: in file, Funeral and Music: Local, Hogan Jazz Archive.

43. Robert Tallant, *Voodoo in New Orleans* (1946; rpt. Gretna, Louisiana, 1983), pp. 33–36.

44. Joe August, Obituary.

3

SANDRA L. RICHARDS

WRITING

THE ABSENT

POTENTIAL

DRAMA,

PERFORMANCE,

AND THE CANON OF

AFRICAN-AMERICAN

LITERATURE

WHEN ONE REVIEWS anthologies of African-American literature and criticism, it would seem as though drama is not a species of literature, for seldom is it included. Consider, for example, Baker and Redmond's *Afro-American Literary Study in the 1990's*, where the editors rightly celebrate the creation of a community of scholars advancing the production of knowledge concerning African-American literature. Acknowledging that they have presented an incomplete research agenda, they assert, "Drama and other genres of expression, for example, form no part of our consideration. Our statements and exchanges are, rather, tentative statements of what we think *is* [italics theirs] the state of Afro-American literary study at the moment. . . ."[1] Similarly, Cheryl A. Wall's edited collection of conference presentations, *Changing Our Own Words: Essays on Criticism, Theory and Writing By Black Women* offers no discussion of drama.[2] Henry Louis Gates, Jr., adopts a different stance: two of the seventeen critical readings offered in *Reading Black, Reading Feminist* address playwrights, and the *Norton Anthology of African American Literature* project that he is directing may include five plays among its selections.[3] Yet none of the proposed plays were written prior to 1959, leading one to conclude that, for his team

of anthologizers, an African-American theater worthy of study begins only with Lorraine Hansberry.

This neglect represents a curious state of affairs. The critical tradition within African American literature locates "authentic" cultural expression on the terrain of the folk, but the folk have articulated their presence most brilliantly in those realms with which literature is uncomfortable, namely in arenas centered in performance. I want to engage one of the fundamental challenges constituted by the folk insistence upon the importance of performance and the literary inheritance of a written, hence seemingly stable text. I will argue that in confronting this challenge, one must write the absent potential into criticism; that is, in addition to analysis of the written text, one must offer informed accounts of the latent intertexts likely to be produced in performance, increasing and complicating meaning. Though this assertion may seem to threaten the critical enterprise by introducing too many speculative variables, though it may for some confirm the rationale for regarding drama as a disreputable member of the family of literature, I contend otherwise. The genre of drama, with its component of embodiment through performance, simply spotlights issues of meaning, particularly those related to reader response, implicit in other branches of the clan.

II

I imagine that my colleagues in African-American literature might initially offer two responses to my charge of indifference. They might remind me that a similar situation exists within the field of Western literature and drama. Certainly, Jonas Barish argued along those lines in his *The Antitheatrical Prejudice*, and more recently, Susan Harris Smith, in an extensive review of the field, asserted that between 1954 and the publication of her article in 1989, no essay on American drama had appeared in *PMLA*.[4] The list of explanations for this devalued status is long Smith argues

In part because of a culturally dominant Puritan distaste for and suspicion of the theatre, in part because of a persistent, unwavering allegiance to European models,

slavish Anglophilia, and a predilection for heightened language cemented by the New
Critics, in part because of a suspicion of populist, leftist, and realist art, and in part
because of the dominance of prose and poetry in the hierarchy of genres studied
in university literature courses, American drama has been shelved out of sight.[5]

The British critic C. W. E. Bigsby advances another reason:

The critic approaching theatre encounters or generates a series of resistances. The
text has already been violated by others in the process of its transmission. It offers
itself as a product of those violations. Of course all literary texts suffer similar
assault. . . . But in the case of theatre, the director, actor, designer, lighting engi-
neer is him or herself a critic whose interpretative strategies leave their mark. . . .
There is a worrying instability, the sense that other unacknowledged collaborators
may be implicated in those texts. . . . The question of authorship becomes
disturbingly problematic.[6]

Continuing in language that is less provocative in its imagery, Bigsby
also notes,

And drama does differ radically from the novel and poem in the degree of incom-
pletion necessary to its survival. It is not simply that the written work exists to be
amplified, . . . it is that the text announces and displays its necessary incomple-
tions—necessary because the text has to allow for the impress of performance and
the interaction of the audience.[7]

The concern for textual purity captured in Bigsby's imagery may
not be shared by critics of African-American literature, given a histo-
ry of what Houston Baker and George Lamming before him termed
commercial deportation and the economics of slavery.[8] Instead, my
colleagues may, with some validity, object that rather than looking over
the fence wistfully at the wide expanse of Euro-American literary pro-
duction, or at the more circumscribed but nonetheless flourishing area
devoted to African-American literature, I should survey the grounds
of dramatic criticism, and identify those texts instructive to their study
of literature. Within that patch devoted to African-American theater,
cultivation is varied: as I myself have noted, in an essay on African-

American women playwrights and the American dramatic canon,[9] since 1985 four anthologies comprising more than twenty plays written by women have been published. Add to that the reissue of *Center Stage*, a collection of plays written in the 1970s and 80s; James Hatch's new collection, *The Roots of African American Drama*, an anthology of plays written prior to 1940; and William Branch's two collections of contemporary works, *Black Thunder* and *Crosswinds*; as well as the publication of individual texts by authors such as August Wilson, George C. Wolfe, or Adrienne Kennedy, and it would seem that African-American playwrights are being produced and published in fairly respectable numbers.[10] If one looks to that area of the yard where criticism grows, one will discover uneven cultivation: the last five years have seen the publication of five books, four of which survey a group of playwrights or genre.[11] The posthumous publication of Larry Neal's essays, *Visions of a Liberated Future*, along with Amiri Baraka's autobiography, is making easier the reassessment currently underway of the Black Arts Movement.[12] Certainly, the anthology of essays examining Adrienne Kennedy's dramaturgy, *Intersecting Boundaries*, is a long overdue bright spot, as should be the pending University of Iowa collection on August Wilson.[13] But even though *Black American Literature Forum* devoted an issue to the intersection of church and theater in 1991, no multiple-subject, multiauthored collection of criticism has been published since Errol Hill's *The Theater of Black Americans* (1980).[14] Whereas those of you who are in literature—should I say literature proper?—have displayed your collective production of knowledge and of a diverse, intellectual community through the publication of conference proceedings, we in black theater have not.

A simple explanation for this failure is that fewer academics enter the field. A more complicated one relates to the ambiguous position that theater and drama departments generally occupy in the academy. Given the evanescence of theater, and its insistence upon subjectivity as part of its methodological approach, academics from other disciplines all too often view the scholarly validity of drama departments with varying degrees of skepticism; that ambiguity reproduces itself within departments as a contentious divide between practitioners and

scholars, such that each group jostles to privilege its mode of activity, and the insights of one often do not inform those of the other.[15] Actors, designers, and technicians find some of their most gratifying validation in the responses of the theatergoing public, while scholars obtain important rewards from appointments and promotions committees comfortable reviewing written texts.

Contrary to the binarism that often separates theater faculties, many of the small number of black Ph.D.s regularly combine production with scholarship. While this practice can make for more astute criticism, the time-intensive nature of production virtually guarantees the more immediate result of a smaller collective output, as measured by the conventional standards of academic publication. Furthermore, given our analytical training in dramatic literature, our written criticism often appears to be uninformed by our theatrical practices. Like many of our colleagues writing dramatic criticism of the Western canon, we have learned to share literary analysts' preoccupation with permanence, choosing for the most part to focus upon meanings lodged in the alleged purity of the written word, "uncompromised" by theatrical interpreters or audiences.[16]

III

Criticism of African-American literature from the days of DuBois and Locke on through to Baraka, Baker, and Gates has placed considerable emphasis on the folk; indeed, as Kimberly Benston has observed, "evocation of the vernacular as a criterion of Afro-American theoretical discourse has become almost *de rigeur*. . . ."[17] Yet the folk often seem to function in these accounts like laborers, producing the raw materials which the more skilled—and more highly regarded— artisans finish off as literature or as criticism within which the folk would be hard-pressed to recognize representations of themselves. Thus, for example, Locke's New Negroes separate the dialect motive from the "broken phonetics of speech," fusing it instead with "modernistic styles of expression"; they will bring a "[P]roper understanding and full appreciation to the Spirituals," so that "[T]he emotional

intuition which has made him [the Negro] cling to this folk music" will eventually be superseded by a recognition of their "true musical and technical values."[18] Amiri Baraka, as a leading architect of the Black Arts Movement, proclaims that he functions as "the raised consciousness of the people," fashioning a theater that will reveal to them their victimage and thereby force revolutionary change.[19] Or, Houston Baker mightily melds Michel Foucault, Fredric Jameson, Hayden White, and a host of other venerable European fathers with Blues ingenuity into such a daunting mix that it leaves many of us dazzled, wondering how the resultant theory is indeed vernacular: in whose language or systems of thought should such a theory be registered? To whom is it addressed? One answer, I suppose, comes from Henry Louis Gates's observation, "[W]e [critics] write, it seems to me, primarily for other critics of literature."[20]

But because I see myself in part as a critic working in theatre, as a person whose directing constitutes a critical praxis addressed to a nonprofessional audience, and whose subsequent writing to an academic audience is partially shaped by those experiences, I would like to suggest that we pay more attention to one site where the anonymous folk occasionally meet the identified craftsperson or artist. In that world of performed drama, one has an individually authored, partially recuperable text in which the imprint of the vernacular may remain strongly palpable. In so doing, we must recognize that the category of "folk" is too often left vague. By the term "folk" I mean non-middle-class or middle-class-oriented black people, the masses of working, underemployed, or unemployed people who do not share the aspirations of the bourgeois, American mainstream. This category is not static: the "folk" who in the 1920s were conceptualized as predominantly rural, uneducated, and removed from modernizing social tendencies obviously do not exhibit the same profile in the 1990s. While they are still the "drylongso," or ordinary people, at the bottom of American socioeconomic structures, while they may remain deeply skeptical of middle-class values of propriety, they also participate in the mainstream, in the sense that Baudrillard, Auslander, and others have argued that no one escapes the reaches of global commodification.[21] Therefore, issues of folk

authenticity or purity become untenable in today's culture, if indeed they were valid concerns in the 1920s, during the growth of the folk drama/little theater movement.

IV

What aesthetic elements found in artistic modes patronized by the folk might be relevant to a discussion of the absent potential in black drama? Consider the theater criticism of Theophilus Lewis, a postal worker who, for much of the 1920s, wrote reviews for A. Philip Randolph's socialist periodical *The Messenger*; as Nellie McKay has argued, his trenchant criticism merits further systematic study.[22] A 1923 viewing of the musical *The Sheik of Harlem* at the Lafayette Theater prompted the observation that the raw material was tawdry and contained an overabundance of funny men whose antics were unrelated to the plot.[23] Although the frothy side of Harlem life was "mirrored with absolute fidelity," Lewis also noted that the community's foibles and vices were

> sprayed with an acid bath of mordant humor that stings and soothes at the same time. When the lash of irony bites a little too deep for a laugh to efface the pain as it occasionally does, the stronger palliative of Mr. Heywood's wistful tunes is applied until the hurt is healed.[24]

In 1924 he saw a Mamie Smith revue. Terming her a "competent blues shouter," he added, "... she knows how to bring out acid humor without which a blues song bears too close a resemblance to a spiritual."[25]

Acerbic humor, obviously, was not the only technique in the repertoire of blues singers, for as Daphne Duval Harrison writes retrospectively about Ma Rainey,

> Rainey sometimes took everyday situations and created an outrageously funny picture. A fine example is "Those Dogs of Mine," a mournful, draggy blues about the aching corns on her feet. Every line is so funny that one can just see this fat woman tiptoeing ever so carefully to avoid another twinge of pain. In each of her blues, regardless of whether she presented the dilemma with wry humor, sardonic irony,

or mocking sadism, the message is clear—"I am pained," "My sense of worth is threatened," "I'm lonely, I need love."[26]

And, one might be tempted to add, "I survived, and in singing surmount this pain."

This mixture of seemingly oppositional elements also features in Albert Murray's analysis of black musicians, whom he likens to poets or priests engaged in the existential process of "confronting, acknowledging and contending with the infernal absurdities and ever-impending frustrations inherent in the nature of all existence by *playing with the possibilities that are also there*."[27] John Gennari, in reviewing the ideological historiography of jazz criticism, highlights the presumed binarism of tradition versus innovation; he notes,

> The central role in jazz performance of the improvised solo both puts a premium on individual style and makes it necessary for soloists constantly to seek fresh approaches to familiar material. By *modifying* timbre, *reworking* phrasing, *adjusting* dynamics, *rethinking* harmonic and rhythmic relationships, and *reinventing* melodies, jazz improvisers constantly seek to establish difference—to distinguish their voices from those of other performers, and to mark each performance as a distinct statement within their own oeuvre.[28]

Certainly, this description recalls what Gates has described as African-American literature's characteristic of "repetition with a difference."[29] Furthermore, Gennari notes that formulating and writing analytic accounts of jazz are hampered by the fact that "the most fundamental and enduring article of faith in jazz . . . [is] that its truth is located in its live performance aesthetic, its multitextual, non-recordable qualities of emotional expressiveness and response."[30]

These same preferences for juxtaposed oppositions and the creative dynamic of live performance are evident in the practices of the black church, which folklorist Gerald L. Davis argues is "fundamental to understanding African-American performance, particularly language-based performance."[31] Seeking to identify the analytic standards by which congregants evaluate the effectiveness of the performed

African-American sermon, Davis isolates three categories that are actively manipulated by all present, namely the expectation of potency and emotion as generating motives in African-American performance; the organization of sensual perceptions into a systematic and codified series of expressive responses; and

> [T]he balance, in the performance of African-American folklore events and systems, between tradition (customary, habitual, and dynamic usage of folk ideas in performance) as a structural framework and contemporaneity . . . [as] a shaping force internal to the . . . event.[32]

While the pairing traditional/contemporary or, for that matter, sacred/secular, seem to be "contrapositional sets," they are, so he contends, "synchronous polarities."[33]

These examples from various performative practices supported by the folk argue that a central principle of this aesthetic is the juxtaposition in performance of radical differences, oftentimes understood as binary oppositions, that generate deep emotional responses from those assembled, challenging them to imagine some interpretive resolution.[34] Attention to this principle offers a guide to reconfiguring the analysis of African-American drama; obviously, it also has implications for other genres of African-American literature closely related to the oral. Not only should we analyze what is "there" on the page, that is, scrutinize those meanings we produce based upon the multiple discourses in which we and the script are embedded, but we also need to imagine and to write into critical discourse how these interpretations imply contradictory positions that are likely to result from the materiality of theater, that is, from the semiotics of movement, tones, silences, costumes, and spatial arrangements onstage, as well as from the reactions of spectators in the auditorium. Such an approach destabilizes interpretation and the critic's privileged, generative role in that process. It brings the spectator (or reader) more into the foreground and gestures towards the folk custom of collaborative, artistic production. And it offers a model of community that is significant for nontheatrical activity, for the audience is recognized under this frame-

work as both homogeneous and diverse, in some senses solidified by sharing a particular performance event, yet segmented by its production of a variety of meanings.[35]

V

I would like to illustrate my contention by utilizing portions of two plays, Zora Neale Hurston's *Color Struck* and August Wilson's *Ma Rainey's Black Bottom*. I have chosen Hurston because her nondramatic texts have generated considerable attention in American, African-American, and women's literature courses, and because her efforts to craft a new definition of theater, based in a black folk tradition, problematize questions concerning intended audiences and the production of meaning. Wilson is an important test case because, given the volubility of his characters, his symbolically rich descriptions of character and setting that sometimes are not dramatized in the dialogue given them, and his evident interest in myth and Morrisonesque reach, his texts seem to be eminently "present" in much the same way as is a novel.

Possibly Hurston's first play, *Color Struck* won second place in the *Opportunity* contest for best dramas in 1925.[36] Although the play was not produced,[37] it is nevertheless instructive to engage questions of what a production might have looked like and how it might have been received, in order to generate a fuller analysis of the intertexts with which the playwright is working and to more accurately chart the history of African-American attempts to construct a theater that would be "true" to black culture and necessarily interact with a larger, American culture. Note that I am not alone in arguing the importance of an unproduced drama. Henry Louis Gates, Jr. and the late George Bass adopted a similar stance in relation to the Hurston-Hughes text, *Mule Bone*; their subsequent theatrical production raised some of the same intertextual issues, discussed here, concerning representations of the folk.

Briefly stated, the plot prominently features a cakewalk contest, yet it centers around a woman who is so traumatized by her dark skin

color that she alienates her dance partner and later hastens the death of her child. At first glance, the text appears to be a curious or unsuccessful blend of two genres popular during the 1920s, namely the "folk" drama and the "propaganda" or "race" play, for the dance numbers, that presumably constitute a significant segment of the action onstage and yet are largely absent from the page, seem to locate the script within the realm of light entertainment, while the subject of intraracial prejudice is shown to have tragic consequences that militate for social change. But when, within a critical analysis of *Color Struck*, one begins to foreground the fact of actors' bodies which are visible to particular audiences, this sense of a bifurcated text shifts.[38] Additionally, this foregrounding spotlights different issues of cultural literacy both within the confines of an individual's study and of a public auditorium.

Color Struck opens with a minimalistic representation of a Jim Crow railroad car in which a group of Jacksonville black people is riding in order to compete in a statewide cakewalk contest. Stage directions suggest that, already in high spirits, the men and women show off their finery to each other and engage in verbal bantering designed to exercise wit as much as to test out and advance romantic liaisons. Three characters stand out from the mass of what appears to be a kind of social club in which everyone's personal business is known: Effie, a skillful dancer who has decided to participate in the contest, despite an argument with and subsequent absence of her dance partner and boyfriend; and the couple John and Emmaline, who are expected to win the cake for Jacksonville, and who are also continually fighting about Emmaline's fears of being displaced by a light-skinned woman. Encouraged to "limber up," the couple and Effie offer dances that tease the appetite of their colleagues as well as that of the spectators.

What are some of the semiotics of theater that are merely hinted at on the written page and exhibit this juxtaposition of contradictions? First of all, Hurston states that the action occurs in a Jim Crow railroad car. For possible spectators who shared the class background of the semiurban, working-class characters onstage, for African-American readers of *Opportunity* magazine which awarded a prize to the play, the indignities of travelling Jim Crow were well known, so that it

would be immediately understood that this frivolity is happening with-
in a circumscribed space of racism. Implicit behind the laughter is a
painful reality that these characters have chosen to ignore temporari-
ly; it is one that has challenged but not stifled their creative impulses.

But in that Hurston herself and architects of the Harlem
Renaissance like DuBois, Johnson, and Locke wanted to speak to white
Americans, too, the text must encounter intertwined discourses that,
on the one hand, denigrate the body as the site of the irrational, and
posit black people solely as bodies and thus as negative signifiers on the
scale of civilization, or that on the other hand, celebrate black people
as delightful examples of the primitive who unself-consciously provide
salvational models for white sophisticates, chafing at the stultifying mate-
rialism and positivism of American culture. Hence, for viewers shaped
by these discourses, the Jim Crow context is probably not visible, and
the first three scenes appear as belonging to the minstrel show repre-
sentation of black folks as singin' and dancin' without a care in the
world. Similarly, were one to revive this script for a contemporary audi-
ence, the context of discrimination, signalled presumably by the set,
might not read for many—both black and white—who are ignorant
of American history. Thus, the implicit tension of opposites collapses.

As with the description of the set, Hurston's comments regarding
the dances are deceptively simple in their notation but critical in their
potential, performative impact. She supplies such information as, "John
and Emma . . . 'parade' up and down the aisle—," "Effie swings into
the pas-me-la . . . ," or later,

> The contestants, mostly girls, take the floor. There is no music except the clapping
> of hands and the shouts of "Parse-me-lah" in time with the hand-clapping.[39]

In dancing, the performers enact a history that has been preserved
and taught to younger generations kinesthetically. But its particulars
might be unacceptable to some of Hurston's integration-oriented
contemporaries and indecipherable to present-day theatergoers, for
according to such authorities as Marshall and Jean Stearns or Lynne
Emery, the pas-me-la and cakewalk are dances that have their origins

in plantation life, when slaves would dance for their own amusement as well as that of their owners.[40] As Emery notes,

> The Cake-Walk . . . was originally a kind of shuffling movement which evolved into a smooth walking step with the body held erect. The backward sway was added, and as the dance became more of a satire on the dance of the white plantation owners, the movement became a prancing strut. [Tom] Fletcher reported that the inclusion of women in shows such as *The Creole Show* "made possible all sorts of improvisations in the Walk, and the original was soon changed into a grotesque dance."[41]

As this description indicates, these plantation dances changed over time; indeed, given the tent shows, carnivals, gillies, and small minstrel shows that were performed throughout the South, it is likely that the traffic of borrowings worked in two directions, with performers appropriating movements from the "folk" they encountered on tour, and the "folk" embellishing upon what they had seen onstage at their own social events. The most celebrated cakewalkers of the decade immediately preceding Hurston's play were the musical comedy team of Bert Williams and George Walker. They had, in fact, further popularized the dance—and added to their own notoriety—by challenging the Rockefellers to a dance contest; thus, for portions of Hurston's potential audience in 1925, this dance was also part of an urban environment. But, as indicated by Hurston and Hughes's allegations in such essays as "My People! My People" and "The Negro Artist and the Racial Mountain," a significant portion of the potential pool of middle-class, African-American arts supporters wanted to escape the race entirely. Art proponents like Alain Locke or Frederick Koch of the Carolina Playmakers tended to conceptually locate "the folk" in an earlier historical framework that had only a tangential, inspirational relationship to a modern, urban, and capitalist environment.[42] An ability to read the body in performance would have demonstrated to a 1925 audience that in certain respects, the distance between the supposedly uncultured rural folk and urban sophisticates was minimal, and that through the language of dance as well as that of music, the former were helping to reconfigure urban

culture on terms that were not entirely inimical to their value system.
A scholarly knowledge of the history referenced in Hurston's short
descriptions of "stage business" subverts the distinction between folk
and race or propaganda plays inherited from Locke, DuBois, Johnson,
et al. It contributes to the contemporary critique of Renaissance the-
oreticians' construction of the New Negro, and affects the ways in
which we position ourselves as intellectuals continuing the tradition of
theorizing a black vernacular.[43]

Another materiality requiring specific discussion in a written crit-
ical analysis relates to skin color. For the reader, Emma's intensely hostile
reactions to light-skinned Negroes seem unwarranted because her
partner continually seeks to reassure her of his affections, and no one
makes disparaging remarks about her skin color. But because the body
onstage, through its carriage, gestures, and spatial relationships to other
bodies, resonates with social history, the viewing experience is con-
siderably different. Spectators see a woman described as "black" in the
company of a boyfriend said to be "light brown-skinned," competing
against a single female who is described as "a mulatto girl." Many, at
the first sight of these bodies, will utilize their own socialization to
read onto the performers the American racial discourse privileging
whiteness. Dependent on the extent to which the lead actress possesses
other Negroid features in addition to dark skin coloring, "black" can
easily signify a lack of physical desirability. Undoubtedly, some of
Hurston's hypothetical 1925 audience would have made such an equa-
tion, though *Messenger* critic Theophilus Lewis's complaints against the
persistent casting of "high yaller" chorines suggest that other specta-
tors would have appreciated the privileging of dark-skinned beauty
implicit in such casting of the lead. Though Hurston does not indi-
cate the skin colors of other characters, a director might choose to
surround the actress playing Emmaline with mainly lighter-complex-
ioned women in order to semiotically allude to these understood social
prejudices, and thereby add validity to her fears. For a contemporary,
post-Black-is-Beautiful audience, response to the issue of skin color
is, obviously, going to be considerably more varied: while intraracial
prejudice remains a provocative issue among African Americans, our

communities also seem to tolerate more diversity, so that in fact, a kind of deliberate construction of a fantastic, hybrid African diasporic and Euro-American identity is often on display. While Emmaline's decision years later to delay obtaining medical help for her mulatto daughter is reprehensible, the ease with which one comes to that assessment, the empathy granted her dilemma, is very much shaped by the specifics of casting. The consequence of these considerations of spectator response is that a determination of the genre of this text is unstable: some may receive the text as distanced, lodged in an earlier period of racial discourse, while for others it may continue to function as an instance of social protest.

Scene III is a critical scene in this short play, for its power lies largely in what is absent from the printed page. Occurring in the dance hall, it juxtaposes the happy dance contestants and the increasingly paranoid Emmaline, who has decided not to compete rather than to risk subjecting herself to a prejudicial slur. Hurston's stage directions, like those of most playwrights, are virtually a shorthand: she states that Emmaline stares at the "gay" scene before she "creeps" over to a seat along the wall and remains "motionless"; that the couples—particularly John and the biracial woman Effie—"strut" and "prance"; and that over a seven-to-nine-minute period, the "fervor of the spectators grows until all are taking part in some way. . . . At curtain they have reached frenzy."[44] What we as readers must imagine, what the director and performers must strive to suggest, is the physical-psychological momentum of dance that gradually envelopes all the characters in the construction of community, coupled with the inverse process by which Emmaline isolates herself and further internalizes a sense of racial inferiority. Seemingly, her disintegration must almost become a dance, in the sense of a series of choreographed gestures that achieve a power to momentarily disrupt the spectacle of the cakewalk, so that viewers apprehend both joy and despair. Lewis's comments about the acid humor of good musical comedy, and Murray's, about jazz musicians playing both the absurdities and possibilities of existence, argue that it is the director's and actors' responsibility to represent both emotions as persuasively as possible. Spectators are the ones who decide whether one emotion finally predominates.

Given this potential interlock in performance of competing energies, one has a text that again generically rejects the binarism of folk versus propaganda/race play and Esu-like, hints at the possibility of some confounding third category. As I have argued with traditionally grounded, African theatrical performances, the critical determination of category is flexible, dependent not so much on formal or written structuring elements as upon the dynamic triangulation between these formal elements, performers, and spectators.[45]

VI

Like Eugene O'Neill before him, August Wilson writes dramas that gesture toward the novel in offering allusive, contextual descriptions that structure readers' responses in ways that dialogue and dramatic action alone would find difficult to accomplish. In addition, because he works within the genre of dramatic realism that posits a cause-and-effect explanation of behavior, it would seem as though his scripts are quite "present" on the page, containing few moments where the kind of theatrical shorthand found in a Hurston stage description, for example, has the power to complicate apparent meaning. But analysis from a director's perspective, that must account for bodies in space, can raise questions about the absent potential of dramatic realism within an African-American cultural tradition, and returns us to Bigsby's comments about the textual incompleteness that drama shamelessly displays.

A case in point is Wilson's *Ma Rainey's Black Bottom*. Set in a Chicago recording studio in 1927, it examines the socioeconomic relations that govern black cultural production in the United States. At the outset, Wilson tells the reader:

It is hard to define this music. . . . This music is called blues. The men and women who make this music have learned it from the narrow crooked streets of East St. Louis, or the city's [Chicago's] Southside, and the Alabama or Mississippi roots have been strangled by the northern manners and customs of free men of definite and sincere worth. . . . Thus, they are laid open to be consumed by it; . . . its vision and

prayer, which would instruct and allow them to reconnect, to reassemble and gird up
for the next battle in which they would be both victim and the ten thousand slain.[46]

The reader is thus alerted that the ensuing drama will concern issues of
identity, though when enacted, it understandably takes quite a bit longer
for an audience to sense what is at stake. However, for me as director, a
question that goes unnoticed by virtue of reading the text without imag-
ining its embodiment in space, a question that a literary-oriented criticism
has left largely unaddressed, is this: why is the play called _Ma Rainey's_
Black Bottom? The obvious answers are, of course, that Ma is the head
of this fictional band of musicians, and that the historical figure around
whom this drama revolves did indeed record a song with such a title.
But they are insufficient when one realizes that Ma is one of the least
visible characters in the play, and that the celebrated storyteller August
Wilson has given her no particular story to relate.

Now certainly the tactic of delaying her entry onstage, while hav-
ing everyone else wonder when she will arrive, increases spectators'
interest; the actress has been scripted a wonderful performance chal-
lenge, for she must exude so much presence as to warrant all the
anticipation. But although it is possible, as critic Sandra Shannon has
argued, to interpret this delay as a metaphor for the delayed justice that
African Americans have historically experienced in the United States,
it is also the case, as Shannon notes, that Ma's entry interrupts the fas-
cinating stories the men are telling downstairs in the rehearsal room.[47]
Thus, if Ma is to occupy the space of importance that the title sug-
gests, she must engage in action whose significance seems to equal that
of the men. She fulfills this dramaturgic obligation through her bat-
tles with virtually all of the men with whom she comes in contact:
the white policeman who believes she has stolen a car and assaulted a
cab driver; the producers who are eager to record her voice but will
not give her such minimal luxuries as a heated studio and a Coca-
Cola; the ambitious trumpeter, Levee, who wants to supplant Ma's
authority with his own musical ideas; and the band leader, Cutler, who
is timidly skeptical of her decision to have her stuttering nephew record
the verbal introduction to one of their songs. In wrangling with white

men, she constantly reasserts her right, as sanctioned by the folk, to function as an expert on black cultural production, and she dramatizes black people's relationship to American capitalism. Ma bitterly says, of her white manager and record producer,

> They don't care nothing about me. All they want is my voice. As soon as they get my voice down on them recording machines, then it's just like if I'd be some whore and they roll over and put their pants on. Ain't got no use for me then.[48]

And, "If you colored and can make them some money, then you all right with them. Otherwise, you just a dog in the alley."[49] In interacting with her band members, she must remind them that as their employer she has the right to determine their repertoire.

What one sees in action are aspects of the tremendous drive that presumably enabled women like Ma Rainey, Bessie and Mamie Smith, Victoria Spivey, and other blues queens to succeed. Yet, what one does not get from Wilson's written script is a sense of the cost at which this success is purchased. Recall that Wilson has written at the outset that the blues are a consuming passion that allows one "to reassemble and gird up for the next battle." The men's stories, told downstairs in the rehearsal room, out of the earshot of the white producer and manager, are extended allegories that function like—if I may switch musical idioms—riffs or individual solos on the theme of justice for African Americans. Laced with irony, they constitute a variety of (spoken) blues performances on how to negotiate life.[50] Thus, there is, for example, a lesson about grace under pressure exemplified in the story of Slow Drag's acquisition of a nickname; a discussion of African Americans' relationship to Africa and to white America, lodged in a tale about reefer and peanuts in a stew that has become "left over" from history; and the penultimate meditation on the existence of God, delivered in two parts as Levee recounts his mother's rape by a group of white men jealous of his father's agricultural self-sufficiency.

But if one judges from the written script, Ma Rainey has no comparable narrative. There is never an instance of doubt or exhaustion when she must re-arm herself for battle; there is never a memory retold

and celebrated so as to teach the listener or remind the teller of an appropriate blues stance. But an actress and director must ask what, other than thematic demands, has prompted the observation that occurs when the focus again shifts away from the band to Ma, Cutler, and Toledo sitting upstairs in the studio. While in her previous scene she had complained about disrespect from her producers, here she says,

> It sure done got quiet in here. I never could stand no silence. I always got to have some music going on in my head somewhere. It keeps things balanced. Music will do that. It fills things up. The more music you got in the world, the fuller it is.

And continuing in this meditative mood, she asserts,

> White folks don't understand about the blues. They hear it come out, but they don't know how it got there. They don't understand that's life's way of talking. You don't sing to feel better. You sing 'cause that's a way of understanding life.[51]

Why doesn't Ma sing, since music is a means of confronting loneliness? Why doesn't *she* tell a story?

One explanation may be, particularly if one looks at Wilson's other representations of women, that the playwright has little idea of what kind of story this woman might relate.[52] Interestingly, Wilson is quoted as having explained to *New York Times* reporter Samuel Freedman,

> The whole time I was writing, I was listening to records in my room. I was listening to the male blues singers—Charlie Patton, Son House—because I was writing the men in the band. And I was trying to write honestly, . . . to aquire [sic] the force of the blues.[53]

Seemingly, the text appropriates the cachet surrounding the historical Ma Rainey in order to advance male narratives, replicating in a certain sense the kind of exploitation African-American musicians have experienced *vis à vis* Euro-Americans. But where does such indifference leave an actress, particularly if she has been trained in Method Acting, and thus is anxious about her motivation at this point in a text whose realistic genre posits a cause-and-effect relationship for behavior? Where

does it leave a director who does not wish to participate in such an appropriation? Where does it leave audience members who may stand to benefit from seeing African-American women function in roles other than nurturer or Sapphire?

I would suggest that this moment where "[I]t sure done got quiet . . ." is an instance of an absence that in performance can be charged with potential. Having just finished jockeying for respect with her white producers, and left in the company of her two most trusted band members, Ma might indulge the luxury of laying aside her aggressive defensiveness, she might begin to sing, thereby displaying some of the vulnerability and self-reflexivity that fuel the blues singer's stance. Dependent upon the carriage of the body, the quality of the actress's unadorned voice, and spectators' own sense of the terrors life poses, a moment of transcendence might occur when those assembled experience why "[T]his be an empty world without the blues."[54] In this moment, absent from the printed page but wonderfully charged in performance, Ma's particular blues performance can be constructed.

Now, I suppose that someone like Bigsby would argue that my directorial choice violates the text by filling in a moment that is not "there" on the page. Some feminists might wonder why I would choose to cover up or fix the chauvinist appropriation that Wilson has written. My response to both is to refer once again to an African-American folk aesthetic that understands as a generating motive, and values as an ideal in performance, the potency and heightened emotion arising from a dense interlock of competing energies. Thus, the unwritten, or an absence from the script, is a potential presence implicit in performance. The visible, written "A" brings in its wake its unseen double, the "not-A," that, when embodied, can result in a third entity whose identity is individually determined by those in its presence. Maya Deren says that in the mathematics of Vodoun, $1 + 1 = 3$;[55] VèVè Clark cites the *marasa trois*:

Marasa consciousness invites us to imagine beyond the binary. . . . On the surface, marasa seems to be binary. My research of Haitian peasant lore and ritual observance has revealed that the tension between oppositions leads to another norm of creativity—to interaction or deconstruction as it were.[56]

Ma Rainey, the Sapphire meeting all aggressive moves with her own calculated countermeasures, Ma Rainey, the mother instilling confidence and decorum in a stuttering country bumpkin, can under the right conditions metamorphose into Ma Rainey, the. . . .

You fill in the blanks. My job as a critic working in the theater is to locate and structure the moment for your final decoding. My job as a critic writing for a reading public is to note the absence and, given the multiple discourses in which the text, I, and a readership are embedded, to speculate on the ways that absence may become present in performance.

NOTES

1. Houston A. Baker, Jr. and Patricia Redmond, "Introduction," *Afro-American Literary Study in the 1990's* (Chicago, 1989), p. 13.

2. Cheryl Wall, *Changing Our Own Words: Essays on Criticism, Theory and Writing By Black Women* (New Brunswick, 1989).

3. Henry Louis Gates, Jr., ed., *Reading Black, Reading Feminist: A Critical Anthology* (New York, 1990).

4. See Jonas Barish, *The Antitheatrical Prejudice* (Berkeley, 1981), and Susan Harris Smith, "Generic Hegemony: American Drama and the Canon," *American Quarterly* 41:1 (March 1989), pp. 112–122. This issue also includes responses by Joyce Flynn, C. W. E. Bigsby, and Michael Cadden. I am grateful to William Worthen for calling this exchange to my attention.

5. Smith, p. 114.

6. C. W. E. Bigsby, "A View from East Anglia," *American Quarterly* 41:1 (March 1989), p. 132.

7. Bigsby, p. 132.

8. Houston Baker, Jr., *Blues, Ideology, and Afro-American Literature: A Vernacular Theory* (Chicago, 1984), chap. 1.

9. Sandra L. Richards, "African American Women Playwrights and Shifting Canons," accepted for publication in Susan Bennett, Tracy Davis, and Kathleen Forman, ed., *Feminist Theatres for Social Change*.

10. Margaret B. Wilkerson, ed., *Nine Plays* (New York, 1986); Kathy Perkins, ed., *Black Female Playwrights: An Anthology of Plays Before 1950* (Bloomington, 1989); Elizabeth Brown Guillory, ed., *Wines in the Wilderness: Plays by African American Women from*

20. Henry Louis Gates, Jr., "Criticism in the Jungle," in Gates, ed., *Black Literature and Literary Theory* (New York, 1984), p. 9.

21. See, for example, Philip Auslander, *Presence and Resistance: Postmodernism and Cultural Politics in Contemporary American Performance* (Ann Arbor, 1992).

22. Nellie McKay, "Black Theater and Drama in the 1920's: Years of Growing Pains," *Massachusetts Review* 28:4 (Winter 1987), pp. 615–626.

23. This comment is noteworthy, too, because it seems to suggest a deficit if Aristotelian standards are used to judge dramatic structure. But if a folk aesthetic is deployed, then this organizational method is traditional, for as Eleanor Traylor has noted, slave performance styles—which became distorted and codified as minstrelsy—were episodic. Certainly, this elastic structure is also found in certain European popular performance modes, such as *commedia del arte*. See Eleanor Traylor, "Two Afro-American Contributions to Dramatic Form," in Errol Hill, ed., *The Theater of Black Americans* (Englewood Cliffs, 1980; rpt., New York, 1987), pp. 45–60.

24. Theophilus Lewis, "Theater," *The Messenger* 5:9 (September, 1923), p. 818.

25. Theophilus Lewis, "Theater," *The Messenger* 6:8 (August, 1924), p. 230.

26. Daphne Duval Harrison, *Black Pearls: Blues Queens of the 1920s* (New Brunswick, 1990), p. 39.

27. Albert Murray, *The Omni-Americans: Black Experience and American Culture* (New York, 1970), p. 58.

28. John Gennari, "Jazz Criticism: Its Development and Ideologies," *Black American Literature Forum* 25:3 (Fall 1991), p. 450, italics mine.

29. Henry Louis Gates, Jr., *The Signifying Monkey* (New York, 1988), pp. 66 ff.

30. Gennari, p. 459.

31. Gerald L. Davis, *I Got the Word in Me and I Can Sing It, You Know: A Study of the Performed African-American Sermon* (Philadelphia, 1985), p. 11. Note that Davis acknowledges the influence of Paul Carter Harrison's evaluation of the black church in such essays as "Introduction: Black Theater in Search of a Source," in Harrison, ed., *Kuntu Drama: Plays of the African Continuum* (New York, 1974), pp. 3–29.

32. Davis, p. 32.

33. Davis, p. 33.

34. Though I am not addressing African theater in this essay, I think it is important to note, nonetheless, that this principle recalls what Robert Farris Thompson has described in West African performance as "an aesthetic of the cool." See his essay by that title in Hill, ed., *The Theater of Black Americans*, pp. 99–111.

35. Alice Rayner, "The Audience: Subjectivity, Community and the Ethics of Listening," *Journal of Dramatic Theory and Criticism* 8:2 (Spring 1993), pp. 3–24.

36. Perkins, p. 77.

the Harlem Renaissance to the Present (New York, 1990); Sydné Mahone, ed., *Moon Marked and Touched by Sun: Plays by African-American Women* (New York, 1994); Eileen Ostrow, ed., *Center Stage: An Anthology of Twenty-One Contemporary Black American Plays* (Oakland, 1981); James V. Hatch, ed., *The Roots of African American Drama* (Detroit, 1991); and William Branch, ed., *Black Thunder* (New York, 1992). Were we to broaden the discussion to include the African diaspora, we could include Paul Carter Harrison's *Totem Voices: Plays from the Black World Repertory* (New York, 1989), and William B. Branch's *Crosswinds: An Anthology of Black Dramatists in the Diaspora* (Bloomington, 1993) in this listing; similarly, Femi Euba's critical study, *Archetypes, Imprecators, and Victims of Fate: Origins and Development of Satire in Black Drama* (New York, 1989).

11. Elizabeth Brown Guillory, *Their Place on the Stage: Black Women Playwrights in America* (New York, 1988); Leslie Catherine Sanders, *The Development of Black Theater in America: From Shadows to Selves* (Baton Rouge, 1988); Allen Woll, *Black Musical Theatre: From Coontown to Dreamgirls* (Baton Rouge, 1989); Carlton Mollette and Barbara Mollette, *Black Theatre: Premise and Presentation* (Bristol, 1986; rpt. 1992); and Steven R. Carter, *Hansberry's Drama* (Urbana, 1991). Note Geneviève Fabre, *Drumbeats, Masks and Metaphor*, trans. by Melvin Dixon (Cambridge) was not published in English until 1983, and Mance Williams, *Black Theatre in the 1960s and 70s* (Westport) was published in 1985.

12. See, too, *Callaloo* 8:1 (Winter, 1985), devoted to Larry Neal; and David Lionel Smith, "The Black Arts Movement and Its Critics," *American Literary History* 3:1 (Spring, 1991), pp. 93–110.

13. Paul K. Bryant-Jackson and Lois M. Overbeck, ed., *Intersecting Boundaries: The Theatre of Adrienne Kennedy* (Minneapolis, 1992); Alan Nadel, ed., *May All Your Fences Have Gates* (Iowa City, 1994).

14. *Black American Literature Forum* 25:1 (Spring 1991).

15. Joyce Flynn, in particular, addresses this issue in her "A Complex Causality of Neglect," *American Quarterly* 41:1 (March 1989), pp. 123–127.

16. The term is Michael Cadden's; though more gender-neutral, it is consistent with Bigsby's evaluation. See Cadden, "Rewriting Literary History," *American Quarterly* 41:1 (March 1989), pp. 133–137.

17. Kimberly Benston, "Performing Blackness: Re/Placing Afro-American Poetry," *Afro-American Literary Study in the 1990's*, p. 183.

18. The first quotes are from Alain Locke's essay, "Negro Youth Speaks," while the latter, about spirituals, is taken from his "Negro Spirituals" in *The New Negro* (New York, 1925; rpt. Macmillan, 1968), pp. 51 and 200 respectively.

19. See, for example, LeRoi Jones, "The Revolutionary Theatre" in *Home: Social Essays* (New York, 1966).

37. Bernard L. Peterson, Jr., *Early Black American Playwrights and Dramatic Writers: A Biographical Directory and Catalog of Plays, Films, and Broadcasting Scripts* (Greenwood, 1990), p. 115.

38. In fact, according to Peterson, Hurston wrote two versions of this play; the first is republished in Perkins's anthology and furnishes the basis for my analysis. In recounting the plot of the second version, which won honorable mention in the *Opportunity* contest of 1926, Peterson makes no mention of the musical elements; silences regarding the paternity of the protagonist's child are explained in the second version, leading Peterson, so I suspect, to categorize the play as a melodrama.

39. Zora Neale Hurston, *Color Struck* in Perkins, pp. 92 and 95.

40. Marshall and Jean Stearns, *Jazz Dance: The Story of American Vernacular Dance* (New York, 1968); Lynne Fauley Emery, *Black Dance, From 1619 to Today*, 2nd rev. ed. (Salem, 1988); Katrina Hazzard-Gordon, *Jookin': The Rise of Social Dance Formations in African-American Culture* (Philadelphia, 1990).

41. Emery, p. 208.

42. A pioneer of the folk play movement, Koch explained his impulses in starting the Carolina Playmakers in terms such as the following, "simple plays, sometimes crude, but always near to the good, strong, wind-swept soil. They are plays of the travail and the achievement of a pioneer people" (Walter Spearman, *The Carolina Playmakers: The First Fifty Years* [Chapel Hill, 1970], p. 8). Tristram Coffin and Hennig Cohen, in *Folklore in America* (Garden City, 1966), p. xix, argue that, in the context of America's successful participation in World War I, interest in a folk heritage was part of a nationalist project of reaffirming for the American populace the validity of its roots while beginning to superimpose its political and cultural values on other areas of the world.

43. John Brown Childs, "Afro-American Intellectuals and the People's Culture," *Theory and Society* 13 (1984), pp. 69–89.

44. Hurston, p. 97.

45. Sandra L. Richards, "Under the 'Trickster's' Sign: Towards a Reading of Ntozake Shange and Femi Osofisan," in Janelle Reinelt and Joseph Roach, ed., *Critical Theory and Performance* (Ann Arbor, 1992), pp. 65–78. My work builds on some of the insights of Diedre La Pin, "Story, Medium and Masque: The Idea and Art of Yoruba Storytelling," Ph.D. diss., University of Wisconsin, Madison, 1977.

46. August Wilson, *Ma Rainey's Black Bottom* (New York, 1985), p. xvi.

47. Sandra G. Shannon, "The Long Wait: August Wilson's *Ma Rainey's Black Bottom*," *Black American Literature Forum* 25:1 (Spring 1991), pp. 135–146.

48. Wilson, p. 79.

49. Wilson, p. 79.

50. Philip E. Smith II, "*Ma Rainey's Black Bottom*: Playing the Blues as Equipment for Living," in Karelisa V. Hartigan, ed., *Within the Dramatic Spectrum* (Lanham, MD, 1986), pp. 177–186.

51. Both quotations appear in Wilson, p. 82.

52. Note that the most recently produced Wilson play, *Two Trains Running*, contains only one female character, Risa, who has mutilated her legs in order to discourage romantic liaisons (sexual advances?) from men. In a Goodman Theatre newsletter, *Onstage* 7:2 (1992/1993), p. 3, director Lloyd Richards is quoted as saying that he and Wilson discussed whether Risa should say anything about this act. They concluded that the men's explanations of her behavior were sufficient!

53. Samuel G. Freedman, "What Black Writers Owe to Music," quoted in Smith, p. 179.

54. Wilson, p. 83.

55. Maya Deren, *Divine Horsemen: The Living Gods of Haiti* (New Paltz, NY, 1983 rpt; 1953), pp. 40–41.

56. VèVè Clark, "Developing Diaspora Literacy and *Marasa* Consciousness," in Hortense J. Spillers, ed., *Comparative American Identities: Race, Sex, and Nationality in the Modern Text* (New York, 1991), pp. 43–44.

CATHY CARUTH

TRAUMATIC AWAKENINGS

Les désirs entretiennent les rêves. Mais la mort, elle, est du coté du réveil.

—Jacques Lacan[1]

Ever since its emergence at the turn of the century in the work of Freud and Pierre Janet, the notion of trauma has confronted us not only with a simple pathology, but with a fundamental enigma concerning the psyche's relation to reality. In its general definition, trauma is described as the response to an unexpected or overwhelming violent event or events that are not fully grasped as they occur, but return later in repeated flashbacks, nightmares, and other repetitive phenomena. Traumatic experience, beyond the psychological dimension of suffering, suggests a certain paradox: that the most direct seeing of a violent event may occur as an absolute inability to know it, that immediacy, paradoxically, may take the form of belatedness. The repetitions of the traumatic event—unavailable to consciousness, but intruding repeatedly on sight—thus suggest a larger relation to the event that extends beyond what can simply be seen or what can be known, and that is inextricably tied up with the belatedness and incomprehensibility that remain at the heart of this repetitive seeing.

I am going to look in what follows at the problem of seeing and knowing as it appears in a dream told by Freud—the dream of a father who has lost his child—and in the reinterpretation of this dream by Jacques Lacan in his seminar "Tuché and Automaton." While Freud

introduces the dream in *The Interpretation of Dreams* as an exemplary (if enigmatic) explanation of why we sleep—how we do not adequately face the death outside of us—Lacan suggests that already at the heart of this example is the core of what would later become, in *Beyond the Pleasure Principle,* Freud's notion of traumatic repetition, and especially the traumatic nightmares that, as Freud says, "wake the dreamer up in another fright." In Lacan's analysis, Freud's dream is no longer about a father sleeping in the face of an external death, but about the way in which, in his traumatic awakening, the very identity of the father, as subject, is bound up with, or founded in, the death that he survives. What the father cannot grasp in the death of his child, that is, becomes the foundation of his very identity as father. In thus relating trauma to the identity of the self and to one's relation to another, Lacan's reading shows us, I will suggest, that the shock of traumatic sight reveals at the heart of human subjectivity not so much an epistemological but, rather, what can be defined as an *ethical* relation to the real.

THE STORY OF A DREAM

At the beginning of the seventh chapter of *The Interpretation of Dreams,* Freud introduces a surprising dream that links his theory of the dream to the question of external reality, and specifically to a reality of violence and loss. Freud narrates the dream as follows:

> A father had been watching beside his child's sick-bed for days and nights on end. After the child had died, he went into the next room to lie down, but left the door open so that he could see from his bedroom into the room in which his child's body was laid out, with tall candles standing round it. An old man had been engaged to keep watch over it, and sat beside the body murmuring prayers. After a few hours' sleep, the father had a dream *that his child was standing beside his bed, caught him by the arm and whispered to him reproachfully: "Father, don't you see I'm burning?"* He woke up, noticed a bright glare of light from the next room, hurried into it and found that the old watchman had dropped off to sleep and that the wrappings and one of the arms of his beloved child's dead body had been burned by a lighted candle that had fallen on them.

The explanation of this moving dream is simple enough. . . . The glare of light shone through the open door into the sleeping man's eyes and led him to the conclusion which he would have arrived at if he had been awake, namely that a candle had fallen over and set something alight in the neighbourhood of the body. It is even possible that he had felt some concern when he went to sleep as to whether the old man might not be incompetent to carry out his task. . . .

[T]he words spoken by the child must have been made up of words which he had actually spoken in his lifetime . . . For instance, *"I'm burning"* may have been spoken during the fever of the child's last illness, and *"Father, don't you see?"* may have been derived from some other highly emotional situation . . .

But, having recognized that the dream was a process with a meaning, and that it can be inserted into the chain of the dreamer's psychical experiences, we may still wonder why it was that a dream occurred at all in such circumstances, when the most rapid possible awakening was called for. [1]

Unlike other dreams, Freud remarks, what is striking in this dream is not its relation to inner wishes, but its direct relation to a catastrophic reality outside: the dream takes its "moving" power, it would seem, from the very simplicity and directness of its reference—the burning of his child's body that the father sees through his sleep. Seeing the light through his closed eyes, the father comes to the conclusion that he would have come to if he were awake: that the candle has fallen on the body of his child. Yet the very directness of this dream, Freud remarks, does not, surprisingly, wake the father and permit him to rush to save the burning corpse, but precisely *delays* his response to the waking reality. If the meaning and reference of the dream are indeed clear, Freud suggests, then it is not apparent why they should appear at all *in* a dream, that is, in a form that delays the father's response—a response that is urgently called for—to the reality to which it points. Precisely because the dream is so direct—and because the reality it refers to is so urgent in its demand for attention—this dream poses the question: in the context of a violent reality, *why dream rather than wake up?*

Freud first attempts to answer this question by referring the dream to the theory of wish fulfillment, in spite of its direct representation of the child's unwished-for death. For while the dream points to the

horrible reality of the child's burning, it does so, Freud points out, precisely by transforming the dead child into a living one. The dream fulfills, therefore, the father's wish that the child be still alive:

> Here we shall observe that this dream, too, contained the fulfillment of a wish. The dead child behaved in the dream like a living one; he himself warned his father, came to his bed, and caught him by the arm, just as he had probably done on the occasion from the memory of which the first part of the child's words in the dream were derived. For the sake of the fulfillment of this wish the father prolonged his sleep by one moment. The dream was preferred to a waking reflection because it was able to show the child as once more alive. If the father had woken up first and then made the inference that led him to go into the next room, he would, as it were, have shortened his child's life by that moment of time.

While the dream seems to show the reality of the burning outside, it in fact hides, Freud suggests, the reality of the child's death. The dream thus transforms death into life and does this, paradoxically, with the very words that refer to the reality of the burning. It is in order to fulfill the father's wish to see the child alive, in other words, that the knowledge of the child's burning is turned into a dream. If the father dreams rather than wakes up, it is because he cannot face the knowledge of the child's death while he is awake. It is thus not so much that the father simply does not see the burning corpse ("father, don't you see")—he does see it—but rather that he cannot see it and be awake at the same time. For the father, Freud seems to imply, the knowledge of the death of his child can perhaps only appear in the form of a fiction or a dream.[2] The dream thus tells the story of a father's grief as the very relation of the psyche to reality: the dream, as a delay, reveals the ineradicable gap between the reality of a death and the desire that cannot overcome it except in the fiction of a dream.

After completing his original analysis, however, Freud remains unsatisfied with the explanation and returns to the dream again at a later point in the chapter, where the problem of the dream's delay of awakening comes back to take on new meaning. For the interpretation of the dream as the fulfillment of the father's wish leads to a deeper question that con-

cerns not only this singular instance of dreaming, but the way in which the father may represent the very nature of consciousness itself:

> Let me recall the dream dreamt by the man who was led to infer from the glare of light coming out of the next room that his child's body might be on fire. The father drew this inference in a dream instead of allowing himself to be woken up by the glare; and we have suggested that one of the psychical forces responsible for this result was a wish which prolonged by that one moment the life of the child whom he pictured in the dream. . . . We may assume that a further motive force in the production of the dream was the father's sleep; his sleep, like the child's life, was prolonged by one moment by the dream. "Let the dream go on"— such was his motive—"or I shall have to wake up." In every other dream, just as in this one, the wish to sleep lends its support to the unconscious wish. (610)

The wish in the father's dream to keep the child alive—the first reason Freud gives for the father's dream—is inextricably bound up, it turns out, with a more profound and enigmatic wish, the father's wish to sleep. This wish is enigmatic because, as Freud suggests, it does not come only from the body but from consciousness itself, which desires, somehow, its own suspension. And this wish, moreover, is not limited to this single father, exhausted by his task of watching over the child, but indeed refers to a desire common to all sleepers. The dream of the burning child does not simply represent, therefore, the wish fulfillment of a single father, tired and wishing to see his child alive once again, but more profoundly and more enigmatically, the wish fulfillment of consciousness itself:

> All dreams . . . serve the purpose of prolonging sleep instead of waking up. The dream is the GUARDIAN of sleep and not its disturber. . . . Thus the wish to sleep (which the conscious ego is concentrated upon . . .) must in every case be reckoned as one of the motivations for the formation of dreams, and every successful dream is a fulfillment of that wish. (267–268, translation modified)

The specific wish behind the dream of the burning child, Freud suggests, as the wish behind any dream, is tied to a more basic desire, the desire of consciousness as such *not to wake up.* It is not the father alone

who dreams to avoid his child's death, but *consciousness itself* that, in its sleep, is tied to a death from which it turns away. The dream is thus no longer simply linked to a wish within the unconscious fantasy world of the psyche; it is rather *something in reality itself,* Freud seems to suggest, *that makes us sleep.* The question concerning the father, *why dream rather than wake up?* thus ultimately becomes, in Freud, a more profound and mysterious question concerning consciousness itself: *What does it mean to sleep? And what does it mean to wish to sleep?*

THE STORY OF AN AWAKENING

Freud's analysis of the dream, and its implicit question in *The Interpretation of Dreams,* seems to leave us with the sense of a consciousness both tied up with, but also blinded to, a violent reality outside. But when Lacan turns to the dream in his seminar, he suggests that the question of sleep and Freud's analysis of it contain within them, implicitly, another question, a question discovered not through the story of the father's sleep, but rather through the story of how he wakes up:

> You will remember the unfortunate father who went to rest in the room next to the one in which his dead child lay—leaving the child in the care, we are told, of another old man—and who is awoken by something. By what? It is not only the reality, the shock, the knocking, a noise made to recall him to the real, but this expresses, in his dream, the quasi-identity of what is happening, the very reality of an overturned candle setting light to the bed in which his child lies.
>
> Such an example hardly seems to confirm Freud's thesis in the *Traumdeutung*—that the dream is the realization of a desire.
>
> What we see emerging here, almost for the first time, in the *Traumdeutung,* is a function of the dream of an apparently secondary kind—in this case, the dream satisfies only the need to prolong sleep. What, then, does Freud mean by placing, at this point, this particular dream, stressing that it is in itself full confirmation of his thesis regarding dreams?
>
> If the function of the dream is to prolong sleep, if the dream, after all, may come so near to the reality that causes it, can we not say that it might correspond to this reality without emerging from sleep? After all, there is such a thing as

somnambulistic activity. The question that arises, and which indeed all Freud's previous indications allow us here to produce is—*What is it that wakes the sleeper?* Is it not, *in* the dream, another reality?—the reality that Freud describes thus—*Dass das Kind an seinem Bette steht,* that the child is near his bed, *ihn am Arme fasst,* takes him by the arm and whispers to him reproachfully, *und ihm vorwurfsvoll zuraunt: Vater, siehst du denn nicht,* Father don't you see, *dass ich verbrenne,* that I am burning?

Is there not more reality in this message than in the noise by which the father also identifies the strange reality of what is happening in the room next door? (57–58)[3]

In explaining the dream as fulfilling the wish to sleep, Lacan suggests, Freud implicitly points towards the fact that this wish is enigmatically defied in waking up; for if consciousness is what desires as such not to wake up, the waking is in conflict with the conscious wish. But what is particularly striking for Lacan is that this contradiction of the wish to sleep does not simply come from the outside, from the noise or light of the falling candle, but from the way in which the words of the child bear precisely upon sleeping and waking: they do not indeed simply represent the burning without, but rather *address* the father from within, and appeal to him as a complaint about the very fact of his own sleep. It is *the dream itself,* that is, *that wakes the sleeper,* and it is in this paradoxical awakening—an awakening not to, but against the very wishes of consciousness—that the dreamer confronts the reality of a death from which he cannot turn away. If Freud suggests that the dream keeps the father asleep, that is, Lacan suggests that it is because the father dreams, paradoxically enough, that he precisely wakes up. The focus of the dream thus becomes, in Lacan's analysis, no longer a function of sleep, but rather a function of awakening. If Freud asks, *what does it mean to sleep?* Lacan discovers at the heart of this question another one, perhaps even more urgent: *what does it mean to awaken?*

It might seem, in his focus on awakening, that Lacan moves from the fictional dream world of Freud—the fictional world of the child once again alive—to the simple reality of the external world, the accident of the candle falling on the body, which is also the reality of the child's death. But what can it mean that the father is not awoken simply by the sound of the candle's fall, but rather by the words of the

child *within* the dream, the dream that should have been, in its fulfill-
ment of the wish to sleep, also the resuscitation of the child? Indeed, to
the extent that the father is awakened by the dream itself, his awaken-
ing to death is not a simple movement of knowledge or perception, but
rather, Lacan suggests, a paradoxical attempt *to respond, in awakening, to a
call that can only be heard within sleep.* I would propose that it is in this para-
doxical awakening by the dream itself that Lacan discovers and extends
the specific meaning of the confrontation with death that is contained
within Freud's notion of trauma, which, in Freud's texts, is described as
the response to a sudden or unexpected threat of death that happens
too soon to be fully known, and is then endlessly repeated in reenact-
ments and nightmares that attempt to relive, but in fact only miss again,
the original event. For if the dreamer's awakening can be seen as a
response to the words, to the address of the child within the dream, then
the awakening represents a paradox about the necessity and impossibil-
ity of confronting death. As a response to the request, the plea, by the
child to be seen, the father's awakening represents not only a respond-
ing, that is, but a missing, a bond with the child that is built upon the
impossibility of a proper response. Waking up in order to see, the father
discovers that he has once again *seen too late* to prevent the burning. The
relation between the burning within and the burning without is thus
neither a fiction (as in Freud's interpretation), nor a direct representa-
tion, but a *repetition* that, in its temporal contradiction, shows how the
very bond of the father with the child—his responsiveness to the child's
words—is linked to the missing of the child's death. To awaken is thus
precisely to awaken only to one's repetition of a previous failure to see
in time. The force of the trauma is not the death alone, that is, but the
fact that, in his very attachment to the child, the father was unable to
witness the child's dying as it occurred. *Awakening,* in Lacan's reading of
the dream, *is itself the site of a trauma,* the trauma of the necessity and
impossibility of responding to another's death.[4]

From this perspective, the trauma that the dream (as an awakening)
reenacts is not only the missed encounter with the child's death, but the
way in which that missing also constitutes the very survival of the father,
a survival that can no longer be understood merely as an accidental liv-

ing beyond the child, but rather as a mode of existence determined by the impossible structure of the response. By shifting the cause of the awakening from the accident of the candle falling outside the dream to the words of the child inside the dream, that is, Lacan suggests that the awakening itself is not a simple accident, but engages a larger question of responsibility. In rethinking the meaning of the accident and linking it to this question about the nature of survival, Lacan is drawing here, I would propose, on Freud's central emphasis in his later work on trauma, on the example of the train accident, which is meant to show how the traumatic confrontation with death is sudden and unexpected, too soon to be grasped fully by consciousness.[5] In Lacan's text, this peculiar accidentality at the heart of trauma in Freud is linked to the larger philosophical significance of traumatic repetition:

> Is it not remarkable that, at the origin of the analytic experience, the real should have presented itself in the form of that which is unassimilable in it—in the form of the trauma, determining all that follows, and imposing on it an apparently accidental origin? (55)

Likewise, in the awakening of the father from the dream, the gap between the accident of the burning outside and the words of the child in the dream produces a significance greater than any chance awakening out of sleep, a significance that must be read in the relation between the chance event and the words it calls up:

> Between what occurs as if by chance, when everybody is asleep—the candle that overturns and the sheets that catch fire, the meaningless event, the accident, the piece of bad luck—and the poignancy, however veiled, in the words, *Father, don't you see I'm burning*—there is the same relation to what we were dealing with in repetition. It is what, for us, is represented in the term neurosis of destiny or neurosis of failure. (69)

If the awakening reenacts the father's survival of his son's death, then it is no longer simply the effect of an accident, but carries within it, and is defined by, its response to the words of the dead child that lie at its root.

It is this determining link between the child's death and the father's survival, I would propose, that is Lacan's true discovery in the dream and in its analysis by Freud: if Freud reads in the dream of the burning child the story of a sleeping consciousness figured by a father unable to face the accidental death of his child, Lacan reads, in the awakening, the story of the way father *and* child are inextricably bound together through the story of a trauma.[6] Lacan, in other words, reads the story of the father as a survival inherently and constitutively bound up with the address of a dead child. The father's story of survival, in other words, is no longer simply his own, but tells, as a mode of response, the story of the dead child. This story itself has a double dimension. Depending on whether the child's words are read as referring to the burning within or to the burning without, the father's survival can be understood, as we shall see, in terms of two inextricably bound, though incompatible, responses to the child's address. In thus implicitly exploring consciousness as figured by the survivor whose life is inextricably linked to the death he witnesses, Lacan resituates the psyche's relation to the real not as a simple matter of seeing or of knowing the nature of empirical events, not as what can be known or what cannot be known about reality, but as the story of an urgent responsibility, or what Lacan defines, in this conjunction, as an *ethical* relation to the real.[7]

A FAILED ADDRESS

If the words of the child ("Father, don't you see I'm burning?") can be read, in this light, as a plea by the child to see the burning *within* the dream, then the response of the father in this awakening dramatizes the story of a repeated *failure* to respond adequately, a failure to see the child in its death. From this perspective the dream would appear to reveal a reality beyond the accident of a single empirical event, the chance death of a child by fever. For showing, in its repetition, the failure of the father to see even when he tries to see, the dream reveals how the very consciousness of the father as father—as the one who wishes to see his child alive again so much that he sleeps in spite of the burning corpse—

is linked inextricably to the impossibility of responding adequately to the plea of the child in its death. The bond to the child, the sense of responsibility, is tied to the impossibility of recognizing the child in its potential death. And it is this bond that is revealed, exemplarily, as the real by the dream, as an encounter with a real established around an inherent impossibility:

> What encounter can there be henceforth with that forever inert being—even now being devoured by the flames—if not the encounter that occurs precisely at the moment when, by accident, as if by chance, the flames come to meet him? Where is the reality in this accident, if not that it repeats something actually more fatal by means of reality, a reality in which the person who was supposed to be watching over the body still remains asleep, even when the father reemerges after having woken up? (58–59)

In awakening, the father's response repeats in one act a double failure of seeing—a failure to see adequately inside, and a failure to see adequately outside.

Indeed, Lacan's interpretive movement, from the accident of the candle falling, to the dream as what repeats something "more fatal" by means of reality, could be said to represent a parable implied by the movement from Chapter Four to Chapter Five of *Beyond the Pleasure Principle:* from the speculation on consciousness that explains trauma as an interruption of consciousness by something—such as an accident—that comes too soon to be expected, to Freud's explanation of the origins of life itself as an "awakening" out of death that establishes the foundation of the drive and of consciousness.[8] Freud's peculiar movement—from trauma as an exception, an accident that takes consciousness by surprise and thus disrupts it, to trauma as the very origin of consciousness and all of life itself—is, Lacan suggests, a way of showing how the accidental in trauma is also a revelation of a basic, ethical dilemma at the heart of consciousness itself, insofar as it is essentially related to death, and particularly, to the death of others.[9] Ultimately, then, the story of father and child, for Lacan, is the story of an

impossible responsibility of consciousness in its own originating rela-
tion to others, and specifically the deaths of others. As an awakening,
the ethical relation to the real is the revelation of this impossible demand
at the heart of human consciousness.[10]

AN UNAVOIDABLE IMPERATIVE

But the words of the child, "Father, don't you see I'm burning?" can
be read another way, as well: not only as the plea to see the child burn-
ing in the dream, but as the command to see the child burning without,
as the imperative, that is, to awaken. While Lacan does not explicitly
articulate this reading, he does suggest that the missing of the trauma
is also an encounter:

> For what we have in the discovery of psychoanalysis is an encounter, an essential
> encounter—an appointment to which we are always called with a real that eludes
> us. (53)

From this perspective, the awakening embodies an appointment with
the real. The awakening, in other words, occurs not merely as a failure
to respond, but as an enactment of the inevitability of responding—of
awakening to the survival of the child that is now only a corpse. The
pathos and significance of this awakening derive not simply from the
repeated loss of the child, in the father's attempt to see, but rather from
the fact that it is precisely the child, the child whom the father has not
seen in time, the child he has let die unwitnessed, the child whom the
dream (in the father's desperation to make the child live again) shows as
once again alive—it is this very child who, from within the failure of
the father's seeing, commands the father to awaken and to live, and to
live precisely as the seeing of another, a different burning. The father,
who would have stayed inside the dream to see his child alive once more,
is commanded, by this child, to see not from the inside—the inside of
the dream, and the inside of the death, which is the only place the child
could now be truly seen—but to see from the outside, to leave the child
in the dream so as to awaken elsewhere. It is precisely the dead child,

the child in its irreducible inaccessibility and otherness, who says to the father: *wake up, leave me, survive, survive to tell the story of my burning.*

To awaken is thus to bear the imperative to survive: to survive no longer simply as the father of a child, but as the one who must tell *what it means not to see,* which is also what it means to hear the unthinkable words of the dying child:

> Is not the dream essentially, one might say, an act of homage to the missed reality—the reality that can no longer produce itself except by repeating itself endlessly in some never attained awakening? (58)
>
> Only a rite, an endlessly repeated act, can commemorate this not very memorable encounter—for no one can say what the death of a child is, except the father qua father, that is to say, no conscious being. (59)

The father must receive the dead child's words. But the only way truly to hear is now precisely not by seeing and listening as a living father listens to a living child, but as the one who receives the very gap between the other's death and his own life, the one who, in awakening, does not see but enacts the impact of the very difference between death and life. The awakening, in its very inability to see, is thus the true *reception of an address* that, precisely in its crossing from the burning within to the burning without, changes and reforms the nature of the addressee around the blindness of the imperative itself. For in awakening, in responding to the address of the dead child, "Father, don't you see I'm burning?" the father is no longer the father of a living child but precisely now *the one who can say* what the death of a child is. The response is not a knowing, that is, but the performance of a speaking, and as such, in the very seeming passivity and lack of agency and mastery in the repetition of the response, precisely carries with it and transmits the child's otherness, the father's encounter with the otherness of the dead child.

Such an awakening, if it is in some sense still a repetition of the trauma (a redramatization of the child's dying), is however not a simple repetition of the *same* failure and loss—of the story of the father alone—but a new act that repeats precisely a departure and a difference: the

departure of the father at the command of his burning child, and the difference, the intolerable difference, between the burning within and the burning without.

As an act, the awakening is thus not an understanding but a transmission, the performance of an act of awakening that contains within it its own difference—"Repetition," Lacan says in the third part of the seminar, "demands the new." This newness is enacted in the fact, precisely, that the words are no longer mastered or possessed by the one who says them—by the child who has died and for whom it is eternally too late to speak, or by the father who receives the words as coming from the place of the child, the self that was asleep. Neither the possession of the father nor the possession of the child, the words are passed on as an act that does not precisely awaken the self but *passes the awakening on to others.*

The accident is thus not a reality that can simply be known but an encounter that must take place each time anew in the accident of where the words happen to fall:

> But what, then, was this accident? When everybody is asleep, including the person who wished to take a little rest, the person who was unable to maintain his vigil and the person of whom some well intentioned individual, standing at his bedside, must have said, He looks just as if he is asleep, when we know only one thing about him, and that is that, in this entirely sleeping world, only the voice is heard, *Father, don't you see I'm burning?* This sentence is itself a firebrand—of itself it brings fire where it falls—and one cannot see what is burning, for the flames blind us to the fact that the fire bears on the *Unterlegt,* on the *Untertragen,* on the real. (59)

The accident, the force of the falling of the candle, is no longer confinable simply to a real that consists in the empirical fact of burning, or the fever, the accident by which the child caught fever or by which the candle fell while the father slept. The force of the fall is precisely the accident of the way in which the child's words transmit a burning that turns between the death of the child and the imperative of the father's survival, a burning that, precisely, like the candle, falls to awaken, anew, those who hear the words.

The full implications of such a transmission will only be fully grasped, I think, when we come to understand how, through the act of survival, the repeated failure to have seen in time—in itself a pure repetition compulsion, a repeated nightmare—can be transformed by, and transmuted into, the imperative of a speaking that awakens others. For now, however, I will simply point to the imperative of awakening that underlies Lacan's own text, the theoretical text of psychoanalysis. For it is in the language of theory itself, Lacan suggests, that psycho-analysis transmits, as he puts it, the "fever" of Freud, the burning of Freud's driving question, "What is the first encounter, the real, that lies behind the fantasy?" (54). And it is to this burning question, and to this fever he senses in Freud's text, that Lacan's own text precisely responds:

> The function of . . . the real as encounter—the encounter insofar as it may be missed, insofar as it is essentially the missed encounter—first presented itself in the history of psychoanalysis in a form that was in itself already enough to *awaken* our attention, that of the trauma. (55, emphasis added)

Lacan suggests that the inspiration of his own text is awakened by the theory of trauma at the center of Freud's text, and that the Freudian theory of trauma speaks already (in this story of the burning dream and of the burning child) from within the very theory of wish fulfillment. The passing on of psychoanalytic theory, Lacan suggests, is an impera-tive to awaken that turns between a traumatic repetition and the ethical burden of a survival.[11] It is indeed not simply Freud's perception and analysis of a reality outside or inside (a reality of empirical events or of internal "fantasies") that Lacan transmits, but rather, most importantly, what Lacan refers to as the "ethical witness" of Freud.[12] The transmis-sion of the psychoanalytic theory of trauma, the story of dreams and of dying children, cannot be reduced, that is, to a simple mastery of facts, and cannot be located in a simple knowledge or cognition.

Indeed, the event of the trauma of the dream and the story of the child's death in the texts of Freud and of Lacan resonate uncannily

with the unexpected stories of their own losses: Freud's text is inadvertently shadowed by the death of Freud's own daughter Sophie from a fever, and Lacan's text gains prophetic resonance from the death of his own daughter, Caroline, in a car accident, a few years after the delivery of the seminar on the dream of the burning child.[13]

In Lacan's text, as in Freud's, it is rather the words of the child that are ultimately passed on, passed on not in the meaning of the words alone, but in their repeated utterance, in their performance: a performance that, in Lacan's text, takes place in the movement of the repetition and the gap between the German from which these words address the future, and the French in which they are heard and received, and in which they are endlessly echoed:

> Qu'est-ce qui réveille? N'est-ce pas, dans le rêve, une autre réalité?—cette réalité que Freud nous décrit ainsi—Dass das Kind an seinem Bette steht, que l'enfant est près de son lit, ihn am Arme fasst, le prend par le bras, et lui murmure sur un ton de reproche, und ihm vorwurfsvoll zuraunt: Vater, siehst du denn nicht, Père, ne voit-tu pas, dass ich verbrenne? que je brûle? (57)

The passing on of the child's words does not simply refer to a reality that can be grasped in these words' representation, but transmits the ethical imperative of an awakening that has yet to occur.

NOTES

1. Quotations from Freud are taken from *The Standard Edition of The Complete Psychological Works of Sigmund Freud*, trans. and ed. James Strachey, Vol. V (London, 1953).

2. On the relation between the dream of the burning child and Freud's dream of his own father, see Jane Gallop, *Reading Lacan* (New York, 1985).

3. Quotations from the English texts are taken from Jacques Lacan, "Tuché and Automaton," in *The Four Fundamental Concepts of Psychoanalysis*, ed. Jacques-Alain Miller, trans. Alan Sheridan (New York, 1973). Quotations from the French text are taken from Jacques Lacan, "Tuché et automaton," in *Le séminaire, livre XI: Les quatre concepts fondamentaux de la psychanalyse* (Paris, 1973).

4. Leonard Shengold provides a reading of the burning as highly symbolic and linked to desire in *"Father, Don't You See I'm Burning?" Reflections on Sex, Narcissism, Symbolism, and Murder: From Everything to Nothing* (New Haven, 1991). Lacan's text resists an

oversymbolic reading, I believe, but he does link the burning to desire in Chapter Four of the seminar, and in his final comments in the fifth chapter. It would be necessary to rethink the drive through the curious resistance to symbolism of trauma, rather than reading the traumatic nightmare through the established repression and Oedipal theories of received psychoanalysis. One notion that such a rethinking would have to engage would be that of ambivalence, and specifically the possibility of the father's ambivalence toward the child that Freud allows when he suggests in his interpretation that the father may feel some guilt at having left a man to watch over the child who was not up to his task (see the complete Freud passage). Rather than addressing this ambivalence in terms of the individual father in a father-son antagonism, Freud seems to incorporate it into a larger problem of consciousness as such when he says that it is consciousness itself that does not wish to wake up: for in this case the wish to keep the child alive that Freud originally says motivates the dream indeed becomes secondary to the wish of consciousness to sleep, and may only serve the wish of consciousness, even in the face of the death of a child, to protect its own sleep.

5. The passages I refer to are the examples of the accident nightmare in *Beyond the Pleasure Principle*, and the comparison of the trauma of the Jews with a train accident survivor in *Moses and Monotheism*, which I have discussed at length in "Unclaimed Experience: Trauma and the Possibility of History," *Yale French Studies* 79 (1991), pp. 181–192.

6. Shoshana Felman evocatively reads the Lacan essay in terms of the "encounter between sleep and waking" in *La folie et la chose litteraire* (Paris, 1978). It should be noted that the relation between sleeping and waking, analyzed in my essay in terms of father and child, involves another character, the *Wächter*, who has fallen asleep next to the child and remains asleep even when the father awakens. Lacan describes the moment between sleeping and waking also in terms of this split between father and *Wächter*, and picks up on this notion of splitting in the third part of the seminar. He thus touches on another dimension of trauma that, in the history of psychiatry and psychoanalysis, goes alongside the temporal understanding of trauma as experiencing too late: the notion of dissociation of the psyche around the event—the splitting off of a "traumatic memory" from the rest of consciousness (and unconsciousness, for that matter). This notion had been developed at length by Pierre Janet, and in contemporary trauma theory there is a certain division around the Freudian understanding of trauma as repetition and reenactment (which, whether acknowledged or not, has a constitutively temporal basis,) and dissociation theories that are often identified with Janet (although Freud also wrote on splitting). (On Janet and Freud, see Bessel A. van der Kolk and Onno van der Hart, "The Intrusive Past: The Flexibility of Trauma and the Engraving of Memory," in *Trauma: Explorations in Memory*, ed. Cathy Caruth [Baltimore, 1995]). It is interesting to note (and may be behind Lacan's own reading) that the *Wächter* in the dream of the burning child

resonates with Freud's own general definition of the dream, in *The Interpretation of Dreams*, as the guardian of sleep, "der Wächter des Schlafens."

7. My reading of this seminar (Chapter Five in *The Four Fundamental Concepts of Psychoanalysis*) can be, in part, understood as a reading of Lacan's comments in Chapter Three:

> The status of the unconscious, which, as I have shown, is so fragile on the ontic plane, is ethical. In his thirst for truth, Freud says: "Whatever it is, I must go there, because, somewhere, this unconscious reveals itself." . . . Freud said: "There is the country where I shall take my people." . . . I am not being impressionistic when I say that Freud's approach here is ethical. . . . Freud shows that he is very well aware how fragile are the veils of the unconscious where this register is concerned, when he opens the last chapter of *The Interpretation of Dreams* with the dream which, of all those that are analyzed in the book, is in a category of its own—a dream suspended around the most anguishing mystery, that which links a father to the corpse of his son close by, of his dead son. . . . (pp. 32–33)

Slavoj Žižek suggests that the awakening in Lacan's reading of the dream is a precise reversal of the usual understanding of dream as fiction and awakening as reality: he argues that the awakening of the father, in Lacan's reading, is an "escape" from the real into ideology. Aside from the difficulty of accepting that awakening to a child's dead corpse could ever be understood as an escape, the force of Lacan's reading is clearly, I think, to suggest that the encounter with the real cannot be located simply inside or outside the dream but in the moment of the movement from one to the other, what he calls "the gap that constitutes awakening." See Slavoj Žižek, *The Sublime Object of Ideology* (London, 1989).

8. One might also be able to understand Freud's description of the death drive in this context in terms of the very specific death in the burning child dream, the death that is of a child. For the death drive, the originating and repeated attempt by the organism to return to the inanimate, the awakening into life that immediately entails an attempt to return to death, could be seen generally as a sense that one has died too late. And what could it mean to die *too late*, except to die *after one's child*?

It is important to note here the shift that is not articulated in Freud but implied by Lacan's reading, from the notion of trauma as a relation to one's own death to the relation to another's death; Freud's own shift from *Beyond the Pleasure Principle* to *Moses and Monotheism* may suggest that the death of the other was always inseparable from his notion of one's "own" death. The peculiar temporality of trauma, and the sense that the past it foists upon one is not one's own, may perhaps, from this perspective, be understood in terms of a temporality of the other (or the other's potential death). (In emphasizing the potentiality in this temporality, I am taking issue with Ellie Ragland's interpretation of the burning child dream, in which she implies that the death drive means we have all been traumatized, as opposed to our

all being potentially traumatized, which I believe is closer to the paradoxical temporality of the death drive. See Ragland, "Lacan, the Death Drive and the Burning Child Dream," in Sarah Webster Goodwin and Elisabeth Bronfen, ed., *Death and Representation* [Baltimore, 1993]).

9. The description of the foundational moment of consciousness as a responsibility towards others in their deaths (or potential deaths), as indeed the response to a call from those (potential) deaths, resonates with the ethical thinking of Emmanuel Levinas. He has indeed written of the "éveil a partir de l'autre," which is linked to a foundational moment also associated with trauma in "La philosophie et l'éveil." The ethical resonances of the problematics of trauma were first brought to my attention by Jill Robbins, whose brilliant work on Levinas (especially "Visage, Figure: Speech and Murder in Levinas' *Totality and Infinity*," in Cathy Caruth and Deborah Esch, ed., *Critical Encounters: Reference and Responsibility in Deconstructive Writing* [New Brunswick, 1994], and her forthcoming book, *Ethics and the Literary Instance: Reading Levinas*), whose discussions with me about the intersection between the two fields, and whose reading and suggestions concerning various chapters in this book have been invaluable. (On the specific appearance of the notion of trauma in Levinas, see Elisabeth Weber, *Verfolgung und Trauma: Zu Emmanuel Levinas' autrement qu'être ou au-delà de l'essence* [Vienna, 1990].)

10. This insight would indeed resurface in the history of trauma research, in the ongoing dilemma of "survivor guilt," most notably remarked by Robert Jay Lifton as a paradoxical guilt frequently attending survivor experience:

> In all this, self-condemnation strikes us as quite unfair. . . . This guilt seems to subsume the individual victim-survivor rather harshly to the evolutionary function of guilt in rendering us accountable for our relationship to others' physical and psychological existence. This experience of guilt around one's own trauma suggests the moral dimension inherent in all conflict and suffering.

See Robert Jay Lifton, *The Broken Connection* (New York, 1979), p. 172.

11. Jacques Derrida suggests, in a reading of *Beyond the Pleasure Principle*, that the passing on of psychoanalysis must be understood through the survival of the father beyond his children. See Jacques Derrida, *La carte Postale: de Socrate à Freud et au-delà* (Paris, 1980). Derrida moves between the notion of trauma and the notion of responsibility in "Passages—du traumatisme à la promesse," in his interview with Elisabeth Weber in *Points de suspension: Entretiens* (Paris, 1992).

To take up the matter of survival in the seminar fully, one would want to include also a reading of the "knocking dream" with which Lacan introduces his discussion of the dream of the burning child. In a prospectus for a dissertation at Yale University, Department of Comparative Literature, entitled "Waking Dreams," which includes a proposed chapter on the dream of the burning child, Mary Quaintance discusses the allusion to *Macbeth* in the knocking dream, and points to

the text by de Quincey on this play. I was interested to find that de Quincey suggests that what the knocking signifies is not, as one might expect, death, but rather the return to life. The crisis, that is, is the survival. This makes a striking indirect introduction to the problem of survival and the death drive in the dream of the burning child. (See Thomas de Quincey, "On the Knocking at the Gate in *Macbeth*," in *Miscellaneous Essays* [Boston, 1857].) As Marjorie Garber has pointed out to me, the *Macbeth* resonances in the knocking dream might be read also in the dream of the burning child through the emphasis on the burning candle.

(An exploration of the the literary allusion in the Lacan text might open onto other questions concerning the literary dimension of the passages in both writers, and might consider the possible resonance in Freud's description of the child's words in the dream with the words of the child in Goethe's "Erlkönig."

12. On the possibilities opened by the death drive, as dislocating an inside–outside opposition, for change (in a feminist context), see Jacqueline Rose, "Where Does the Misery Come From? Psychoanalysis, Feminism and the Event," in Richard Feldstein and Judith Roof, ed., *Feminism and Psychoanalysis* (Ithaca, 1989), reprinted in Jacqueline Rose, *Why War?—Psychoanalysis, Politics, and the Return to Melanie Klein* (Oxford, 1993).

13. There is some evidence in the third part of the seminar that Lacan unwittingly inscribes the death of Sophie into his text (and thus also unwittingly anticipates Caroline's). In this part of the seminar he turns to a discussion of the fort-da game of the child that Freud describes in *Beyond the Pleasure Principle*, the game of his grandson that he interprets as a traumatic repetition of the temporary departures of his mother. As Jacques Derrida has pointed out (in *La carte postale*), this analysis reflects in an odd way what would soon be Freud's own permanent loss of this same woman, his daughter Sophie, who died towards the end of the writing of *Beyond the Pleasure Principle*, a death at which Freud was not able to be present. As Lacan describes the fort-da game, moreover, he shifts suddenly into an autobiographical voice that echoes with the language of seeing throughout his seminar: "I, too, have seen, seen with my own eyes, opened by maternal divination, the child, traumatized by the fact that I was going away despite the appeal, precociously adumbrated in its voice. . . ." (p. 63, translation modified). Lacan's "I, too, have seen" perhaps marks the transmission of Freud's own unwitting anticipatory writing of his daughter's death into the psychoanalytic text of Lacan, which also, in its way, anticipates the death of his own child. (On the relation between the perspective of the traumatized child, analyzed in the fort-da game, and the dream of the burning child, which appears to relate the perspective of the adult, see also pp. 34–35 of *The Four Fundamental Concepts of Psychoanalysis*). Elisabeth Roudinesco tells of the death of Lacan's daughter Caroline in *Jacques Lacan: Esquisse d'une vie, histoire d'un systeme de pensée* (Paris, 1993). I discuss this part of the seminar in an extended version of this essay; see my *Unclaimed Experience: Trauma, Narrative, and History*.

ANDREW FORD

5

KATHARSIS

THE

ANCIENT

PROBLEM

Wнетнеr ONE regards the scholarship on *katharsis* as "a grotesque monument of sterility" or as "the Mt Everest . . . that looms on all literary horizons,"[1] there can be little doubt that it has cast a nearly impenetrable shadow over a word that is, after all, barely mentioned in one of Aristotle's briefer and more peripheral treatises. But this academic overkill at least makes clear that, at this stage of the game, it would be naïve to hope to settle the meaning of *katharsis* once and for all.[2] Accordingly, although I strongly prefer a particular minority interpretation, I do not expect to end the long-standing debate. Instead, I hope only to complicate the modern search for a solution by turning to a broader question, which I call the ancient problem. By this I mean Aristotle's problem: What needs in his poetic theory required that he insert this word into his definition of tragedy and then more or less drop it? What larger requirements of his systematic philosophy made him posit *katharsis* as the answer to what questions? The ancient problem with *katharsis*, as I define it, is thus not simply its meaning in the *Poetics*—which Aristotle must have thought transparent. Nor is it precisely the problem that is named by *katharsis*—the special appeal of music and tragedy it ambiguously signifies. The ancient problem, the problem for Aristotle, if unrealized

by him, was the one solved by saying *katharsis*, by bringing this near-
ly opaque word into his writings on art.

I propose, then, to give only a sketch of the modern controversy
in order to highlight what I think are the main issues in dispute. I will
then to turn to a passage on *katharsis* in the *Politics,* which remains,
though this fact is often enough obscured, our fullest extant discus-
sion of *katharsis* from Aristotle's pen.[3] Although this text has long been
consulted without decisive results for the interpretation of *katharsis*, it
nevertheless allows us to give a more inclusive account of what was
at stake in the enigmatic naming of the *Poetics*.[4]

THE MODERN PROBLEM

The Modern Problem has been to decide the meaning of *katharsis* in
Aristotle's definition of tragedy:

> Let tragedy therefore be defined as the imitation of an action that is serious, com-
> plete and possesses magnitude, with embellished language used variously in its
> different parts, presented through acting and not through narration, accomplishing
> through pity and fear the *katharsis* of such emotions.[5]

The last difficult clause is added to supply the final cause of tragedy,
its purpose, and so *katharsis* would seem to refer to what Aristotle else-
where calls "the special pleasure" of tragedy, the "pleasure arising from
pity and fear through imitation that the tragic poet is obliged to pro-
duce."[6] Defining the special pleasure that is *katharsis* has been so
controversial in subsequent Western literary theory because it raises
fundamental issues in the psychology and social use of art.[7]

But this is the only time in the *Poetics* that Aristotle uses *kathar-
sis* in reference to the goal of tragedy,[8] and the word is sufficiently
ambiguous to sponsor very different views of the function and uses
of art. Lexical studies distinguish four main meanings of *katharsis* at
the time Aristotle wrote.[9] Its root sense was essentially "cleaning," but
it was early used in religious vocabularies for ritual "cleansing" of
physical objects, and for the "purification" of souls through music and

incantations.[10] The Hippocratics also gave *katharsis* a special sense as a technical term for the expulsion of noxious bodily elements through "purging." Finally, Plato seems to have extended the word to intellectual "clarification" in a few passages, though he did not use it in connection with poetry or music.[11]

This broad range of usage allows for what we may call "lower" or "higher" interpretations of the *katharsis* produced by tragedy, depending on whether it is conceived as a more bodily or spiritual experience. Giving *katharsis* a medical sense in the *Poetics* suggests a rather low-level pleasure: watching a tragedy would be like taking a dose of hellebore—the painful story is bitter going down, but somehow restorative to the system. (Incidentally, the medical meaning of *katharsis* is the most common in Aristotle, especially frequent, in his biological works, for discharges like menstruation and urination.) As a religious term, *katharsis* may be either high or low: conceived as the offscouring of physical dirt, the cleaning may be the simple removal of defilement; but conceived along the lines of the sacred songs that healed the insane, *katharsis* may suggest a moral refinement of the spectator's soul. Even higher and more Platonic is *katharsis* interpreted as a psychological clearing up, perhaps even a clarification of moral ideas through woeful stories dramatically structured.

The search for higher functions in *katharsis* has been going on since the Renaissance, when the rediscovered *Poetics* was quickly aligned with the Horatian ideal of poetry that blends pleasure and instruction.[12] In various ways, *katharsis* was associated with moral improvement through the eighteenth century,[13] until the contrary view was influentially argued by Jakob Bernays.[14] Ridiculing the idea of tragedy as a "moral house of correction," Bernays adduced the *Politics* in support of his view of *katharsis* as a purely physiological phenomenon, an expulsion of painful emotions through painful emotions, as in homeopathic medicine. This text, to be considered in detail shortly, is the more suggestive because the *Poetics* often speaks of the "pleasure" of tragedy, but never mentions learning from it. It is true that, in Chapter Four, imitations are said to appeal to an innate pleasure all human beings take in learning, but Aristotle illustrates this learning

at a rather low level: we look at a picture of Socrates and take plea-
sure in divining that "it's Socrates."[15] It is also true that, in Chapter
Nine, poetry is pronounced a more philosophic thing than history,
because it deals in the kinds of things that might happen, rather than
chronicling the things that have happened in given cases. But this uni-
versalizing character attributed to poetry is, after all, only relative to
history, and it is not such a strong tendency as to exclude impossible
plots, provided they are persuasive.[16]

But a view like that of Bernays leads to unwelcome consequences:
the sublime art form of Athenian tragedy would seem to be reduced
to an emotional orgy, a workout of the passions for no other benefit
than the pleasure of their exercise. This hardly seems to square with
the high opinion of tragedy that Aristotle exhibits throughout the
Poetics, nor does it help us see why he should have expended so much
of his time in establishing the principles of unity and intelligibility for
an art form alleged to be fundamentally emotional in its appeal.
Moreover, a *katharsis* that does not involve learning seems a poor
response to Plato's charge in the *Republic* that tragedy waters the pas-
sions and weakens the reason.

Accordingly, after a century of dominance, Bernays has recently
fallen to a new consensus among exegetes of the *Poetics*.[17] Charging
that his theory is reductive and problematic in its details, they argue
in various ways that tragedy does indeed improve us and teach us, by
leading us to feel the right emotions toward the right objects. The
new consensus avoids simply returning to old didactic models by
insisting that a strict opposition between thought and feeling is too
simplistic for Aristotle. *The Nicomachean Ethics* and *Rhetoric* show that
for Aristotle emotions were inextricably tied to certain beliefs about
the world. To feel pity, for example, we must first judge that the suf-
fering is undeserved; to feel fear, we must calculate that a given disaster
is such as might happen to us. Such complexes of thought and feel-
ing have no need to be "purged," it is argued, and one can go further
to maintain that attending tragic plays habituates us to feel the right
emotions toward the right objects, which is a major condition for
Aristotelian "virtue" or human excellence.[18] In this view, tragic

katharsis becomes a complex engagement of our feelings and judgments together, not a gross orgy of weeping, but a structured evocation of emotions that shapes them so they may better conform to proper judgments in real life. Most would add that there is likely to be an epic and comic *katharsis* as well, so that all literature has a role in the education of the senses.

The new consensus restores a noble mission to art; yet I join the suspicion of certain readers that this view, though coherent and even nicely Aristotelian, is simply not Aristotle's.[19] For the bone in the throat of all theories of *katharsis* as learning or moral improvement generally is the passage from the *Politics* which clearly distinguishes the use of music for *katharsis* from its possible uses in learning or ethical training. In interpreting *Poetics* 6, I see no reason to resist the implication of the *Politics* that *katharsis* is a kind of pleasing and relaxing emotional experience which supervenes on certain stimuli; tragic *katharsis* would be the specific form of this response that attends the arousal of our emotions of pity and fear in an environment made safe by the fact that the tragic spectacle is only an imitation of suffering.[20]

This is not to say that our minds are numb at a tragic performance. We must use them to follow the plot, and the basic surprises of tragedy are not available to us unless we have formed certain reasoned evaluations and expectations. But the function of this well-crafted plot is never said to be to guide us in drawing moral conclusions; Aristotle offers no Platonic demand that tragic stories be true or morally improving.[21] The role of structure is simply to drive us more surely into involvement with the experience: a plot is probable or necessary so that we will not distance ourselves with incredulity; a plot is unified so that all the components of a tragedy may be focused on its single proper end—the "*katharsis* of pity and fear arising through imitation."[22] When Aristotle ranks tragic plots in Chapter Thirteen, he prefers stories of reasonably good men falling through some *hamartia,* because such plots elicit most specifically the requisite emotions of pity and fear. Playing on what people commonly believe to be fearful and pitiable may do little to expand their moral and intellectual horizons, but it does involve them.

Aristotle's response to Plato, then, would be that the pleasure afforded by tragedy is harmless, not that it incorporates a moral lesson or promotes moral habits. To those who would charge him with a Philistine insensitivity to the high value of art, Aristotle might reply that they are extravagant in their expectations of an art form developed in and for a democracy. And he could add that there is a certain inhumanity or at least inexperience in making all civic activities serve learning.

MUSIC IN THE CITY

Even if one resists a direct extrapolation from the *Politics* to the *Poetics,* there is much to be learned about the nature and role of *katharsis* by considering its context in the former work. The passage in question occurs within a larger discussion of the ideal state which fills books Seven and Eight. Book Eight is devoted chiefly to the education of citizens, and *katharsis* comes into the discussion (along with glancing mention of another imitative art—painting) apropos of music and its possible uses in civic education.[23]

It is not necessary to rehearse the entire plan here, but a few preliminary details may highlight the important point that Aristotle's idea of education aims at shaping the citizen's body and character as much as and even before developing the intellect.[24] Accordingly, the production of the best citizens begins with a scheme of eugenics and then proceeds to a number of restrictions designed to render children "immune"—the medical metaphor is Aristotle's—to unwholesome influences (7.15.9 1336b 23). Even before they are old enough for formal learning, children are to be kept away from slaves as much as possible; public profanity is to be outlawed, and someone is to keep an eye on the bedtime stories mothers and nurses tell. The indecent (*askhêmon*) paintings and statues featured in certain cults are to be confined, like their rites, within the temple precincts; children should not be allowed to go to comedies or other satiric festivities until they are old enough to drink and dine with adults.

This kind of habituation by no means ceases when formal instruction begins, but things become more complicated since there is little

agreement about what the contents of this schooling should be, or
even about its precise purpose. Aristotle takes a comprehensive view
of the debate, and accepts the competing claims that education should
be practically useful, morally improving, and directed at more recher-
ché knowledge (8.1.4 1337a 40–43). He reasons that schooling ought
to impart what is necessary, should improve one's character if possi-
ble, and may appropriately include higher studies with little immediate
use. To show the worthiness of more refined study, Aristotle consid-
ers closely the case of music, which raises perplexing questions: although
included in aristocratic education since time immemorial, music is not
useful in the way that reading and writing are; nor does it promote
health and strength, as gymnastics does. Why then should one study
it? Aristotle observes that most people partake of music for its plea-
sure, but he deduces that it was originally included in education as a
way for free men to occupy their leisure in a noble way, as one can see
from the banquet scenes in Homer at which a bard performs.

The peculiar case of music thus illustrates that there is such a thing
as liberal education, the pursuit of certain arts for their own sake by
those free enough to disregard their possible utility. I shall return to
the economic structure of liberal education, but here we should fol-
low Aristotle's argument about what to teach, and why. Now, the
teaching of music in order to provide enhancement to leisure in later
life, while traditional and undeniably appropriate, may still be a mat-
ter of historical accident, and we cannot be sure that the original reason
for its study is the truly right reason. To determine the real purpose
of including music in education, Aristotle is led to consider the nature
of music itself and what its powers are (8.5.1 1339b 13–14).

In defining the powers of music Aristotle again enters contem-
porary debates, and notes that some hold that music serves for
amusement and relaxation, like sleeping or taking a drink; others hold
that it is for ethical training, as gymnastics develops the body; final-
ly, it is said to contribute to intellectual development in cultivated
leisure (*phronesis* and *diagôgê*) (8.4.3 1339a 25–26). Again, he will wel-
come all three theses: music is universally agreed to be a pleasure,
and arguably belongs in younger people's education because it is a

harmless pleasure that is suitable for that context (8.5.2 1339b 26). For the same reason, music is also appropriately included in civilized leisure, because leisure should be pleasant as well as noble. But in this capacious mood, Aristotle will also argue that there is a yet "nobler" function for music in education, a use that improves the character of the soul. Aristotle is very clear that this is a special and higher use of music, one that is above the "natural" pleasure that it affords to "people of all ages and types" (8.5.4 1340a 3–5). This noble use of music for improving the character has been seized on as a prototype of tragic learning by those who wish to see an intellectual (*phronesis*) or improving (*diagôgê*)[25] power in tragedy. But if we are attentive to the mechanics of ethical training through music, we can see that the intellect is little involved.

The potential of music to influence character depends on a peculiarly Greek idea of its effect on the soul. It was widely assumed by the Greeks that certain kinds of melodies and rhythms actually "changed" the soul, and by their sheer physical nature directly put it in various emotional states (8.5.6 1340a 22). Aristotle agrees and instances the "songs of Olympus"—a piercing but apparently fascinating set of Eastern tunes for the pipes that put their hearers in a state of frenzied religious excitement called "enthusiasm." In a similar way, other rhythms and melodies were held to be naturally "imitative" of other moral states, in the sense that listening to them was very like undergoing actual emotional experiences, such as anger or gentleness, bravery or timidity, moderation or excess.[26] Given this strong effect on the psyche and its ability to produce ethical states in the auditor, the pleasure afforded by music has a potential for ethical training: "since music happens to be something pleasant, and virtue has to do with feeling delight in the right way and in loving and hating the right things, obviously nothing is more important than that children should learn and become habituated to judge correctly and to delight in virtuous characters and noble actions" (8.5.5 1340a 14–18). At school, the repetition of music imitating noble character will habituate students to feeling that way; and its attendant pleasure will encourage them to carry over those same states of mind into real life, in response to actual situations. For if we

are trained to respond in a certain way to an imitation, we are likely to feel the same way toward the original.

Thus the potential contribution of music to ethical habituation is the most "honorable" benefit it brings to education, but music does not, strictly speaking, teach us anything: it impresses itself strongly on the audience, and for this reason must be used selectively. It is only this selective use that makes music improving rather than vulgarizing, for some music has that power too. It is much the same with the visual arts: not only are obscene paintings and statues to be hidden from public view, but children are to be encouraged to look at the idealized paintings of a Polygnotus, who painted people better than they were, rather than the satirical representations of Pauson, who rendered them worse.[27]

Still, if this ethical habituation through music develops only rudimentary intellectual skills, it is very significant that a properly policed instruction in music gives citizens an ability to respond to it on a level above its common charms: sheltered from all evil influences—from lewd paintings and low comedy, drinking parties and riotous music—they will go beyond delighting in music to "delighting in it correctly"; in short, they will become "judges" or critics (*kritai*) of music (8.6 1340b 25).

Once Aristotle makes it clear that the ultimate result of musical education is to produce citizen-critics, he is able to settle a nagging question he had raised and dropped earlier, of whether the young should learn music by actually singing and playing instruments themselves, or just by listening.[28] This may seem a trivial issue, but it makes a great deal of difference to Aristotle whether one performs music oneself or merely listens to others perform. Some even held that actually practicing music would vulgarize future citizens, for most public music in Athens was supplied by professionals, and these were usually foreigners or slaves. Aristotle does believe that professionalism in music, as in any activity, degrades its practitioners in body and soul, and should be left to noncitizens. Yet he decides that the children should learn to play at least a little bit, on the grounds that, to be a good "judge" of anything, one needs to have engaged in that activity (8.6.1). Later, they are free to drop playing altogether if they wish, but they will have

learned "to delight in fine melodies and rhythms" and not the common pleasures of music, which are available "even to some animals, to say nothing of slaves and children" (8.6.4 1341a 15–17).

In acquiring this more refined experience of music, the gentleman critic will have to descend to actually playing a little, but any threat of vulgarization can be neutralized: one must omit exercises that call for extreme technical proficiency; one should drop those instruments that are only suitable for professional performance; and one should be careful in selecting which rhythms and melodies to employ in education. It is in discussing which kinds of music belong in the classroom that the *katharsis* passage occurs:

> Since we accept the division of melodies proposed by certain philosophers into (1) ethical, (2) practical, and (3) enthusiastic, with distinct modes corresponding to each, and [since] we maintain that music should be used not for the sake of one benefit only but for several (for it should be used for education and for *katharsis* as well— what I mean by *katharsis* I will indicate generally now but more clearly in the work on poetics—and thirdly for employment in cultivated leisure [*diagôgê*] both for amusement and for relaxation from toiling), it is clear that one must make use of all the musical modes, but not use them all in the same way: for education, the most ethical modes are to be employed; but for listening to others perform we must also use the practical and the enthusiastic. For any affection that occurs strongly in some souls occurs to a lesser or greater degree in all, such as pity, fear, or again religious ecstasy [*enthusiasmos*]. There are some people who are particularly susceptible to this latter form of excitement and we see them, once they have availed themselves of melodies that thoroughly excite the soul, put back on their feet again as a result of the sacred melodies just as if they had obtained medical treatment and *katharsis*. People prone to pity or fear or those who are generally emotional necessarily undergo the same experience, as do others to the extent that they share in each of these emotions, and for all there arises a certain *katharsis* and relief accompanied by pleasure. In a similar way [to the sacred melodies], the kathartic melodies offer a harmless pleasure for all.[29] Hence the use of such modes and melodies must be permitted for those whose business is providing music for the theater; the audience after all is double, partly free and educated but partly vulgar too, composed of laborers and farmers and other such, and these people too must be granted their spectacles as a relaxation. . . . It is appropriate thus to

permit those who perform publicly to make use of this sort of music; but for educa-
tion, as has been said, one must employ ethical melodies and modes.[30]

Basing his discussion on expert opinion (and incidentally sniping at
the likes of Plato, who philosophized extensively about music with-
out any experience in elementary education),[31] Aristotle accepts a
tripartite division of melodies and modes into (1) ethical music, which
"imitates" moral states such as courage or anger in the way described
above; (2) "practical" or "action" music, which rouses its hearers to
activity (one might think of a Sousa march); and (3) enthusiastic music,
which, like the songs of Olympus, creates a state of emotional exci-
tation in the hearer (8.7.4). The relevant questions are whether all the
modes and rhythms are useful or not, and which ones are useful for
formal education (8.7.2).[32] Unlike Plato, Aristotle is willing to allow
that music is to be used for more than one benefit; it is useful not only
for education (*paideia,* the sole and lifelong purpose granted it by Plato)
but also for *katharsis,* and thirdly, for cultivated leisure (*diagôgê*). The
trick is to use different kinds of music for these distinct purposes: we
should use the ethical modes for education, and the practical and enthu-
siastic for listening to when others perform (8.7.4–5). Rather than
abandoning orgiastic music, Aristotle simply puts it in its own place:
professional entertainers can use noneducative music in the theater,
for we have to give the uneducated, the vulgar, and the corrupt spec-
tacles for relaxation.

From this it should be clear that, however the experience called
katharsis works, it does not instruct us; its use is for other occasions that
offer other benefits. This clear distinction between *katharsis* and learn-
ing (*mathêsis,* 1341b 32) would seem to exclude any Aristotelian theory
of learning from art, beyond the very basic sense in which we are
impressed by the character of what we hear and see. Of this kind of
music Aristotle would agree with Artaud, one of the strongest twen-
tieth-century anti-*Poeticists:* "If music affects snakes, it is not on account
of the spiritual notions it offers them. . . ."[33]

This rather low view of *katharsis* is confirmed in a slightly earlier
passage where, as a precaution against professionalization and its

attendant vulgarization, Aristotle stipulates which instruments are to be excluded from school use:

> It is also clear from these considerations [namely, that children are to learn by playing instruments themselves only so as to be able later to judge performances rightly] what kinds of instruments must be employed. For we should not admit into the classroom either the pipes [*aulos*] or any instrument that requires profession-al skill, for example the concert lyre [*kithara*] and anything of that sort, but only such instruments as make children good listeners at their musical and other lessons. Moreover, the concert lyre is exciting rather than expressive of character, so that use of it must be reserved for those occasions in which the performance aims at *katharsis* rather than learning.[34]

We drop any instruments that require a professional degree of skill (since *kithara* is the word from which comes "guitar," we might trans-late this injunction as: learn a few nice songs on the guitar, but not the electric guitar); we also drop from education instruments that are inher-ently exciting (*orgiasikon*—arousing the kind of frenzy associated with ecstatic, especially Dionysiac, rites): they not only lack an ennobling character but can actually interfere with learning. Once again, the excit-ing instruments are not driven out of the polis altogether, but are assigned to those occasions in which the spectators experience *kathar-sis* rather than learning (*mathêsis*, 1341a 23); and such occasions include no doubt the public entertainments such as tragedies (1341b 10).

Soon after this discussion, Book Eight breaks off, apparently incom-plete. It thus leaves room for champions of different forms of *katharsis* to imagine mitigating or confirmatory arguments; but we have already seen enough to realize that *katharsis* belongs to a complex organiza-tion of musical and artistic activities in the state. Summarizing this discussion allows us to place *katharsis* among a number of distinctions that are far more significant than learning and not-learning.

THE THIRD USE OF POETRY

The political theorist approaches music as a natural phenomenon that appeals to all kinds of people and even some animals. The political

problem is to order its undeniable charms so that they may benefit the state, if possible, but certainly so that they do not harm it. Among the pleasures of music is *katharsis*, which some tunes and rhythms broadcast to the meanest tanner and the noblest philosopher in the theater. A common pleasure cannot be a very high pleasure, and *katharsis* is a strongly emotional rather than intellectual response. Yet it is not one to be dismissed. Aristotle's ideal state is formed on analogy with the structure of the soul, with the lower, less rational elements bound to serve the higher; but the lower elements are not to be neglected, even if they cannot be refined above their nature (7.13). Musical *katharsis*, base as it may be, is useful when relegated to public performances where there is no need to teach anything. In the theater, for example, everyone may take the pleasure of it to the extent that each has a little enthusiasm in the soul. If Aristotle's view of public art frees it from a need to be dogmatic, it does not make art revolutionary. The free and educated will be pleased at the city's spectacles, but will be immune to any vulgarizing effect; the lower orders will perhaps be even more pleased by a form of music that matches their natures, but they will also be refreshed, and so enabled to go back to work.

The regulations proposed for *katharsis* and for music generally not only harness its powers, but use them to underwrite important social distinctions. An obvious but significant distinction is that segregating professional musicians from amateurs. The public performer is granted wide scope in employing his arts, and the elite suffer a sort of restriction in only availing themselves of the pleasures of *katharsis* when it is supplied by menials. But of course this disenfranchisement results in freeing for other activities—such as voting—those hands which can barely strum a lyre. Music enters Aristotle's state only with a division of labor.

The most important, if less visible, distinction in the uses of music is the one that separates the free and educated from the rest of the population, the women, slaves, laborers, and foreigners whose birth has not rendered them fit for formation. The educated will respond to music's lower promptings, but they will also be able to do something more: they will judge the performance. To be sure, this is not aesthetic or literary

criticism—art was never separate from politics for the Greeks; the citizen-critics will judge only whether the character of the representation is noble or not.[35] Yet it is still a separate and higher response to music, bespeaking a separate and higher status.

There is something paradoxical in this divisive use of music, since its broad appeal would seem to make it rather democratic. Of course, it is precisely by such divisions of humans from animals, and then from each other, that civilizations are constructed. In the *Politics,* the dividing process begins when the pursuit of music is refined into its study as a liberal art. Something that is a source of joy to slaves and of income to laborers must be found to have a higher use, so that the free may continue to enjoy it without losing their distinction. Hence, if a phenomenon like *katharsis* shows that, on one level, the entire city may respond to a musical performance in the same way, its regulation enables Aristotle to sustain a nest of political distinctions within a single audience, between professional and amateur, free and unfree, noble and common. Now, the Athenian theater had already inscribed significant social distinctions in its very seating of the audience: at the great Dionysia, to which the entire city came, separate blocks of seats kept foreigners apart from citizens, and the citizens themselves segregated by sex and status.[36] Aristotle's educated "critic" adds a new division to the audience, a division based on knowledge. If Plato appropriated public art for political good in the obvious way of expelling most of it and censoring what was left behind, Aristotle is more subtle in removing only the most lascivious art from public view and leaving the rest as it is. For at the same time, he appropriates a special knowledge of it, the ability to judge it, and bestows this on his elite.[37] *Katharsis* thus stands, in the *Politics,* as an example of an intense but widely available response to music that must be overcome; it names a low power that paves the way for "criticism" and even makes it necessary.

If we wish to ask what kind of power comes with this knowledge, we should ask where the musically educated will deploy their skill. In an ideal state, such knowledge could perhaps be turned into laws ensuring that the right music is employed on the right occasions. But Aristotle's politics of music are far more realistic than Plato's in

the *Republic* or *Laws*. I doubt Aristotle would have expected musical education to have much practical effect in an actual Athens. It would hardly be likely to change the way dramatic prizes were awarded, since, as a safeguard against corruption, the judging of festival competitions was made deliberately random through an elaborate series of lotteries. No one could hope to elevate public taste by educating all potential judges in music, and anyway, the festivals are for the entire populace, not only for the wise.[38] Just because citizens are able to judge public art does not mean that public art must form ideal citizens.

It may be imagined that, in the actual theater, musical education would have served as a badge of status as reflected in the citizens' comportment: if the virtuous have learned to feel emotions appropriately, they may have refrained from the wailing and weeping at plays that so disgusted Plato. But I suspect that the most significant arena for the deployment of judging in the real world would have been those occasions of "cultivated leisure" (*diagôgê*) of which Aristotle speaks so highly. Specifically, Aristotle's allusion to Homeric banqueting scenes suggests that we should think of those closed aristocratic gatherings where invited guests might produce a song or two if they liked and pass comment on the music of others.[39] After all, gentlemen and ladies had sung and talked of poetry at symposia since the archaic age, and had not failed to mark sympotic conduct as an index of breeding and political loyalty. But styles of dining, like styles of criticism, change along with styles of politics, and one of the results of sophistic education in the democratizing fifth century had been to make cultivated table talk more widely practiced and less tied to in-group politics. In certain circles, after-dinner conversation was aestheticized to the extent that Sophocles could banter with a schoolteacher over drinks about whether it was permissible to call a blushing boy's cheeks "purple."[40] Plato (and probably Socrates before him) had found such pastimes unworthy of gentlemen, and gave us an image of truly refined leisure in his *Symposium,* one that dispensed with the flute girl and found its entertainment in philosophical conversation. Still, he seemed to realize that music could no more be banished from such conviviality than Alcibiades and his revelers could be kept from barging in on the party, and Aristotle

is at least as wise. He has enough respect for such communal meals that he provides for them specifically from the public revenues of his ideal state (7.11.1 1331a 25), and a little hymn he composed to virtue that survives would have made a nice presentation on such occasions.[41] It would be interesting to know what was discussed at the common meals Aristotle instituted in his Lyceum, and in the monthly symposia presided over by the master himself. To judge from the *Poetics,* one would hazard that, at a Platonic dinner party, one would talk about whether poetry was good; at an Aristotelian party, one talked about whether it was well done. In any case, the most significant use of musical education was as a way for aristocrats at leisure to display models of conduct to each other, all the while showing to the city at large a truly refined way of passing time. As Aristotle says: "it were disgraceful if, having secured peace and prosperity, we were no better than slaves in our leisure" (7.13.19 1334a 38–40).

Such I conceive to be Aristotle's provisions for music in the *Politics.* He maintains popular arts, with their popular satisfactions, but at the same time creates an intellectual and social space for elite art. As the solution to a political problem, *katharsis* presides not at the birth of tragedy out of the spirit of music, but at the birth of literary criticism out of the needs of cultivated leisure.

What, then, does this tell us about how to read the *Poetics?* On the modern question of the nature of *katharsis,* it would seem to suggest that the *katharsis* of pity and fear is a complex but finally irrational pleasure of the quintessentially democratic art form. It is in a sense dismissive: public theaters seem to be good for a city in a way more like a system of sewers than like museums. Be this as it may, the analysis pursued here suggests that we may also consider the *Poetics* as yet one further refinement in the appropriation of public art, as indicating one other place where special knowledge of poetry might be deployed. This is the lecture hall, where poetry may become, as far as possible, the object of scientific knowledge. Now, the citizen-critic need not be a philosopher, since he may not understand the causes of his judgments (which for Aristotle defines true scientific knowledge). For the *Politics,* it suffices if his character and opinions accord with the

philosopher's. But for those few who can exercise the highest part of the soul, pure theoretical reasoning (7.12.7 1333a 27–31), there is a knowledge of poetry even above judging it, and that is knowing the causes of the judgments.

This, of course, is the task of the *Poetics,* or Aristotle's "theory of literature," which is after all the equivalent of *peri tês poiêtikês* in our time. Despite its scattered pieces of advice to playwrights, the *Poetics* is not a handbook, since Aristotle is indifferent to whether poets succeed by art or by knack.[42] It is rather, as it announces itself in its opening, a description of the nature of poetry in itself, its particular forms and their particular powers, and what is the best way to make poems so that they do what they are supposed to (1.1447a 7–10). The philosopher's technical knowledge of poetry is a knowledge of its species and of the means of producing the effects proper to each. In the case of tragedy, this most scientific knowledge will be of how to arouse pity and fear to the degree that they lead to a *katharsis* of such emotions. For the *Poetics,* as for the *Politics, katharsis* is a phenomenon that is taken for granted. In a sense, it is relatively insignificant for the *Poetics,* since explaining the nature of *katharsis* is not its task. This were better left to psychology, just as the uses of *katharsis* are a matter for political inquiry. To become, as it appears to be, the very first art of poetry in the West, the *Poetics* must confine itself rigorously to explaining the means of achieving *katharsis* and the other emotions proper to literature.

The brief mention of *katharsis* thus acknowledges and confines to the margins of inquiry the traditional belief in poetry's irrational power and appeal. The god-sent "enchantment" of poetry had been widely proclaimed since Homer, and had been influentially analyzed by the great sophist Gorgias, when he spoke of the "marvellous" power of poetry to waken pity and fear and compared the power of language over the soul with the irresistible influence of drugs on the body's humors.[43] Aristotle's view of tragedy does not neglect its power to "move the soul," *psychagôgein,* as it was called,[44] but he severely limits his study to a very few psychagogic effects. For example, he dismisses discussion of set design from his treatise, allowing that it "is certainly psychagog-ic, but better left to the art of the scene painters" (6.1450b 16–20).

In a similar way, we should understand the neglect of music in the
Poetics, despite the recognition that music makes the pleasures of tragedy
"most intense" (26.1462a 15–17; cf. 1450b 16). The extent of this
restrictiveness can be indicated by Aristotle's remarkable comment that
tragedy should produce the same effect when one reads or hears the
story as it does when seen, and he takes notice of acting only to deplore
it as a vulgar and inessential adjunct to the tragic art.[45] In the end,
Aristotle reduces the tragic poet to a maker of plots, and the only means
of "moving the soul" he explores in the *Poetics* are the reversals and
recognitions that can be powerfully woven into a plot.

All these dismissals make the project of writing a *Poetics* a rather
abstract affair, and once we have bracketed discussion of the nature and
value of *katharsis*, it seems inevitable that the most elite knowledge
about poetry will be functionalist and formal. Aristotle's concerns are
sufficiently circumscribed to allow him to rule that "correctness in poet-
ry is not the same as correctness in politics or in any other art" (25.1460b
13–15). Far from being obliged to intimate political or moral order, the
poet, "just like a painter or any other maker of images," is free to rep-
resent things as they actually are, as they appear to be, as they used to
be, as reputed to be, or ought to be (25.1460b 8–11); the ultimate con-
sideration is only that he provoke the pleasure proper to the chosen
form. This may seem to make poetry an autonomous art, and Aristotle
has certainly sponsored reductive aestheticizing readings of literature.[46]
But it is not fair to the *Poetics* to make it a manifesto of formalism.
Aristotle is keenly sensitive to history, and speaks about the historical
forces that shaped the individual genres. He narrows his gaze in the
Poetics not because he believes poetry has no influence in the state, but
because the particular knowledge he seeks requires an object less hybrid
than drama. Unlike Plato in his *Republic* and *Laws,* and unlike his own
Politics, the *Poetics* aims to consider drama as a species of poetry, exam-
ined "in itself" as well as in respect to its effects on the audience. Within
this context, *katharsis* is allowed to be a real and powerful psychologi-
cal effect of tragedy, and its pursuit should direct all the choices of the
playwright; but for the theorist of literature, it belongs with those ele-
ments of drama that are too complicated to be looked at. Such a change

in the object of study is momentous, for to make theater an object of knowledge means reducing it to a form we call literature, a bare text whose inner dynamics seem to work its strange and unique effects. This severe but enabling reduction of the drama is analogous in its import to the later shift in the notion of literature itself, from a term for anything written, to a special kind of writing with its special ends.[47]

Hence, by giving *katharsis* a place in his treatise—and a very high place as the end of tragedy—Aristotle is able to put the magical, religious, superstitious, and irrational aspects of poetry outside the scope of his art. In the *Poetics*, the ancient problem solved by *katharsis* was to delimit the field of the literary theorist. All the while acknowledging poetry's irrational appeal, Aristotle yet marginalizes it to his own project, which is to describe the best ways to produce this effect. He needs the term to name the evident if paradoxical pleasure we take in pitiable and fearful representations, and the end is essential in defining anything. Yet he also needs it to remain largely outside the pale of the *Poetics,* if poetics is to have a definable subject. By naming this briskly and moving on to account for its production, Aristotle is able to give, as far as possible, a scientific account of poetry.

The *Poetics* thus purges *katharsis* from its account of drama as a way to make tragedy intelligible. But it is also fair to say that *katharsis* purges poetics in general, since its exclusion makes a higher than common account of poetry possible. Removing *katharsis* performs a lustration on a field of inquiry, and makes possible a new literary genre, the theory of literature.[48] Of course, much of the play has been lost by this exclusion—its scenes, costumes, music, gestures—everything, in short, but the script. But some notable things have been gained: in the course of this resistance to poetry's grasp on us, so as better to get a grasp on poetry, the theory of literature becomes possible, and drama enters the field of literature.

I would like to thank Peter Stallybrass for very helpfully discussing an early version of this paper with me, and Douglas Patey for casting a fine eye over the final version.

NOTES

1. The respective verdicts of J. Morley, as quoted in Stephen Halliwell, *Aristotle's Poetics* (Chapel Hill, 1986), p. 35, and G. F. Else, *Aristotle's "Poetics": The Argument* (Cambridge, MA, 1967), p. 443.

2. See, for example, Martha Nussbaum, "Aristotle," in *Ancient Writers,* ed. T. J. Luce (New York, 1982), p. 405: "This famous definition [of tragedy] . . . has probably generated more commentary than any other sentence in Aristotle's work."

3. At *Politics* 1341b 39–40, Aristotle refers to "the work on poetry" for a "fuller and clearer" discussion of *katharsis.* As it seems this can hardly refer to the single enigmatic use of the word in *Poetics* 6, most scholars suppose that the fuller discussion was contained in some work on poetry now lost, perhaps a "second book" of the *Poetics,* on which see, most recently, Richard Janko, *Aristotle on Comedy: Towards a Reconstruction of Poetics II* (Berkeley and Los Angeles, 1984). I have thought it convenient for this discussion to cite the *Politics* according to Schneider's chapter, section, and sentence numbers, which are printed in the Loeb Classical Library translation by H. Rackham, *Aristotle: Politics* (Cambridge, MA, 1977). I have added Bekker numbers (e.g., 1336b 23) as a guide to other editions. My few divergences from the text of D. Ross, *Aristotelis Politica* (Oxford, 1957) are remarked in the notes.

4. *Politics* 8. 1341b 33–1342a 29. As can be seen from I. Bywater, "Milton and the Aristotelian Definition of Tragedy," *Journal of Philology* 27 (1901), pp. 267–275, the passage was often cited in the Renaissance, though in support of widely varying versions of *katharsis.*

5. *Poetics* 6.1449b 24–28. References to the *Poetics* are by chapter and marginal Bekker numbers of the edition by Rudolf Kassel, *Aristotelis De Arte Poetica,* rpt. with corrections (Oxford, 1966). Translations are my own, though I have consulted the superb version of James Hutton, *Aristotle's Poetics Translated with an Introduction and Notes* (New York, 1982).

6. *Poetics* 14.1453b 11–14; cf. 13.1453a 36, 1452b 32–33. Naturally, this equation has been called into question, as in Else's view that *katharsis* is an operation on the *plot,* not on the audience. For his own later qualifications, see G. F. Else, *Plato and Aristotle on Poetry* (Chapel Hill, 1986), pp. 160–162.

7. For an interesting, but not wholly reliable, collection of views, especially from twentieth-century critics, see A.K. Abdulla, *Catharsis in Literature* (Bloomington, 1985).

8. Its only other occurrence in the *Poetics* is at 1455b 15 to describe a scene in

Euripides's *Iphigeneia among the Taurians,* in which Orestes is "saved through [a ceremony of religious] purification."

9. A basic history is to be found in F. Susemihl and R. D. Hicks, *Aristotle's Politics* (London and New York, 1884), 3:641–656; see also the discussions and references in Halliwell, *Aristotle's Poetics,* pp. 185–188, and Elizabeth Belfiore, *Tragic Pleasures: Aristotle on Plot and Emotion* (Princeton, NJ, 1992).

10. Discussed in E. R. Dodds, *The Greeks and the Irrational* (Berkeley and Los Angeles, 1957), pp. 77ff., 154, and n. 119.

11. So the *Sophist* itself indicates at 226d: "everyone uses the term" for separating better from worse, as in winnowing or straining. Thus Leon Golden, in *Aristotle on Tragic and Comic Mimesis* (Atlanta, 1992), p. 24, goes too far in saying "*katharsis* is just as much part of an intellectual tradition in which it signifies learning and clarification as it is part of a medical tradition in which it represents purgation."

12. For an excellent outline of the *Nachleben* of the *Poetics,* see Halliwell, *Aristotle's Poetics,* chap. 10. The Renaissance material is massively assembled in B. Weinberg, *A History of Literary Criticism in the Italian Renaissance,* 2 vols. (Chicago, 1961), and selected in Baxter Hathaway, *Age of Criticism* (Ithaca, 1962), pp. 205–300.

13. See B. Hathaway, "John Dryden and the Function of Tragedy," *PMLA* 57 (1943), pp. 665–673; E. Wasserman, "The Pleasures of Tragedy," *ELH* 14 (1947), pp. 283–307; A. O. Aldridge, "The Pleasures of Pity," *ELH* 16 (1949), pp. 76–87.

14. Jakob Bernays, *Grundzüge der verlorenen Abhandlung des Aristoteles über die Wirkung der Tragödie* (Breslau, 1857), the relevant chapter of which has been translated by Johnathan and Jennifer Barnes as "Aristotle on the Effects of Tragedy," in *Articles on Aristotle,* vol. 4, ed. J. Barnes, M. Schofield, and R. Sorabji (London, 1979), pp. 154–165. Influential developments of Bernays's views are in Ingram Bywater, *Aristotle on the Art of Poetry* (Oxford, 1909), pp. 17, 152–161 and D. W. Lucas, *Aristotle: "Poetics"* (Oxford, 1968), pp. 273–290.

15. For attempts to read a philosophical kind of learning into this passage, see G. M. Sifakis, "Learning from Art and Pleasure in Learning: An Interpretation of Aristotle *Poetics* 4 1448b 8–19," in J. H. Betts, J. T. Hooker, and J. R. Green, ed., *Studies in Honor of T. B. L. Webster I* (Bristol, 1986), pp. 211–222; Else, *Aristotle's Poetics,* p. 132; R. Dupont-Roc and J. Lallot, *Aristotle: La Poétique* (Paris, 1980), p. 165.

16. *Poetics* 24.1460a 26–7.

17. An influential early version was Humphrey House, *Aristotle's Poetics* (London, 1956), pp. 100–111. There is general agreement that tragedy leaves us improved among R. Janko, *Aristotle on Comedy,* pp. 139–142; Janko, *Aristotle: Poetics I* (Indianapolis, 1987), pp. xvi–xx; S. Halliwell, *Aristotle's Poetics,* pp. 168–201 (who is more tentative about connecting the word *katharsis* with the improving function of tragedy); M. Nussbaum, *The Fragility of Goodness: Luck and Ethics in Greek Tragedy and Philosophy*

(Cambridge, 1986), pp. 378–394; L. Golden, *Aristotle on Tragic and Comic Mimesis,* pp. 5–29 (a strongly intellectualist view). The latter four have contributed new articles to *Essays on Aristotle's Poetics,* ed. A. O. Rorty (Princeton, NJ, 1992), in which see also A. Nehemas, "Pity and Fear in the *Rhetoric* and the *Poetics,*" pp. 291–314. I hope to give these complex arguments the scrutiny they deserve on another occasion.

18. *Politics* 8.5.5 1340a 14–16.

19. See especially F. Sparshott, "The Riddle of *Katharsis,*" in *Centre and Labyrinth: Essays in Honor of Northrop Frye,* ed. E. Cook (Toronto, 1983), pp. 14–37 and J. Lear, "Katharsis," *Phronesis* 33 (1988), pp. 327–344 (reprinted in Rorty, ed., *Essays on Aristotle's Poetics,* pp. 315–340).

20. For the role of imitation in this process, see esp. *Poetics* 1453b12. *Katharsis* is not exactly a therapy, as Bernays suggested, since it applies to all in the audience.

21. The kind of plot Plato demanded, in which the good end happily and the wicked suffer, is declared "untragic" by Aristotle, the result of playwrights' catering to audience "weakness" and abandoning the painful but proper pleasure of tragedy for one closer to comedy: *Poetics* 13.1453a 13–14, 30–39.

22. Because Brecht realized this, he attacked classicizing notions of Unity along with other forms of coherence to avoid *katharsis,* which he considered an abuse of the spectators' emotions; see, e.g., *Brecht on Theater,* trans. John Willett (New York, 1978), p. 78.

23. My analysis of this complex and slightly meandering argument is close to that of W. D. Anderson, *Ethos and Education in Greek Music* (Cambridge, MA, 1966), pp. 121–141. While I am in sympathy with the view of Carnes Lord, in *Education and Culture in the Political Thought of Aristotle* (Ithaca, 1982), that Plato and Aristotle share a "healthy regard for the political importance of culture" (p. 20), I find his general reading of *Politics* 8, to which many now refer, a contorted attempt to discover in Aristotle a view of poetry as a form of education for adults. Lear, "Katharsis," has further arguments against taking Aristotelian *katharsis* as education.

24. "If in their tender years we make depravity and malignity foreign to them, their education will make them immune to the harmful effects of such things" (7.15.9).

25. For *diagôgê* as "intellectual culture," see Susemihl and Hicks, *Aristotle's Politics,* p. 585, and W. L. Newman, *The Politics of Aristotle,* 4 vols. (Oxford, 1902), 3:529.

26. He also mentions the ability of imitations to communicate feelings; we "suffer along" (*sumpathês*) with them. On the text here, see Anderson, *Ethos and Education,* pp. 186–188.

27. *Politics* 8.5.8; cf. Poetics 1448a 5.

28. First raised and dropped at 8.4.3-7 1339a 11–1339b 10.

29. Retaining the mss. *kathartika* at 1342a 15 (not Saupe's *praktika*). Discussed in Lord, *Education and Culture,* p. 132, n. 49.

30. *Politics* 8.7.4–6 1341b 32–1342a 29.

31. So Susemihl and Hicks, *Aristotle's Politics,* p. 606.

32. I follow Bonitz and others who omit *pros paideian* in 1341b 20. For discussion, see Lord, *Education and Culture,* p. 107.

33. A. Artaud, *The Theater and its Double,* trans. Mary C. Richards (New York, 1958), p. 81.

34. *Politics* 8.6 1341a 17–24.

35. See Lord, *Education and Culture,* p. 75.

36. On the audience, see A. Pickard-Cambridge, *The Dramatic Festivals of Athens,* second edition revised by J. Gould and D.M. Lewis (Oxford, 1988), pp. 263–278 and, somewhat speculatively, John J. Winkler, "The Ephebes' Song: *Tragóedia* and *Polis*," *Representations* 11 (1985), pp. 26–62, esp. 30–32.

37. On educational systems as institutions promoting inequality, see Pierre Bourdieu and J.-C. Passeron, *Reproduction: In Education, Society and Culture,* trans. R. Nice (London and Beverly Hills, 1977), and P. Bourdieu, *Distinction: A Social Critique of the Judgement of Taste,* trans. R. Nice (Cambridge, MA, 1984).

38. Hence Aristotle is able to say that, taken as a whole, the multitude judges musical and poetic performances better than a critic who may only know one part (*Politics* 3.6.1281b 7ff).

39. See the rich study of Ernst Koller, "Musse und musische Paideia: über die Musikaporetik in der aristotelischen *Politik*," *Museum Helveticum* 13 (1956), pp. 1–37, 94–124, esp. p. 36.

40. So the host of that dinner party, Ion of Chios, reports. See D. A. Russell and M. Winterbottom, *Ancient Literary Criticism: The Principal Texts in New Translations* (Oxford, 1972), pp. 4–5.

41. Athenaeus, *Deipnosophists* 696a–697b.

42. E.g. *Poetics* 1.1447a 19–20; 8.1451a 24. See the dismissal in *Politics* 1341b 8 of technical education in music, that is, education aimed at succeeding in the public competitions, as degrading.

43. Gorgias, *Helen* §§8–9, 14.

44. On "psychagogy" as a term in fifth- and fourth-century criticism, see Halliwell, *Aristotle's Poetics,* pp. 188–189.

45. *Poetics* 1453b 1–7; cf. 1450b 18–20; 26.1462a 2–12.

46. E.g., the Neo-Aristotelians and their fixation on form above all else. On which, see Kenneth Burke, "The Problem of the Intrinsic," in *Aristotle's "Poetics" and English Literature,* ed. E. Olsen (Chicago and London, 1965), pp. 122–141.

47. On the shift in the use of "literature," see Raymond Williams, *Keywords: A Vocabulary*

of Culture and Society (Oxford, 1983), s.v., and E. D. Hirsch "What isn't Literature?," in *What is Literature?* ed. P. Hernadi (Bloomington, 1978), pp. 24–34.

48. Tensions between tragedy and theories of tragedy from Aristotle through Hegel are the subject of M. Gellrich, *Tragedy and Theory: The Problem of Conflict Since Aristotle* (Princeton, 1988).

STEPHEN ORGEL **6**

THE OPENING is irresistible:

> I have heard
> That guilty creatures sitting at a play
> Have by the very cunning of the scene
> Been struck so to the soul that presently
> They have proclaimed their malefactions ...
> I'll have these players
> Play something like the murder of my father
> Before mine uncle....
> If he but blench,
> I know my course....
> The play's the thing
> Wherein I'll catch the conscience of the king.

THE

PLAY

OF

CONSCIENCE

To talk about the fortunes of catharsis in the Renaissance is to deconstruct this passage.

I

I am concerned here with Renaissance readings of the catharsis clause, but I have also necessarily to deal with the prior assumption, quite common in the modern critical literature, that we now understand what Aristotle meant when he wrote that "drama effects through pity and fear the purgation of such emotions," and that we can therefore see how far the Renaissance was, unlike us, adapting the Aristotelian dictum to its own purposes. The two major commentators on the fortunes of the *Poetics* in sixteenth-century Italy, R. S. Crane and Bernard Weinberg,

observe repeatedly—and undoubtedly correctly—that Renaissance critics tend to view Aristotle through Horatian glasses. This not only affects the obvious assumptions about the dramatic unities, but more subtly, determines the nature of claims about the social and political function of drama, its public status as rhetoric and oratory, and thereby its utility within the Renaissance state. Weinberg's and Crane's own assumptions, both about drama and about Aristotle, form no part of the discussion, but they are where I want to begin: both critics, like most commentators on Aristotle throughout the history of criticism, assume that, by the term "catharsis," Aristotle is describing the effect of the drama on the audience, and that it is therefore the spectators who are purged through pity and fear. There has been no such general agreement about what the spectators are purged of.

How exactly the purgation works has been a matter for endless debate; what has had little resistance is the notion that Aristotle is in fact talking about the audience here. That, therefore, is the part I wish to press on first: this has seemed to be the one thing we have thought we could be sure of about Aristotle's intentions. For modern scholarship, the chief opponent of this view has been Gerald Else, who argues that what is being described makes more sense if we understand it as something that takes place entirely within the drama itself, an element of dramatic structure, rather than of dramatic effect. Thus the pitiable and terrible events that precipitate the tragedy—Oedipus's murder of his father, Orestes's of his mother—are purged by the pitiable and terrible sufferings of the hero. The catharsis takes place within the structure of the drama: it is Thebes or Athens, the world of the play, that is purged, not the audience. Such a reading makes good sense within the logic of the *Poetics* because, as Else points out, the context in which the catharsis clause appears is not concerned with the audience: it says that tragedy is an imitation of a serious action, that it uses heightened language, operates through performance rather than narration, and that it ends by bringing about, through pity and fear, the purgation of such emotions. Aristotle then goes on to discuss the characters, and to deduce the six parts of drama. Read in this way, catharsis provides a symmetrical movement for the dramat-

ic action. An elliptical and parenthetical shift to the psychology of audiences at this point would need some explanation.[1]

Few critics have been persuaded by this argument, though to my knowledge there has been no real refutation of it, just a general insistence that it is implausible.[2] This is doubtless true, but will hardly settle the matter: plausibility is the least transhistorical of critical categories, the most particularly time-bound. The principal objection that has been raised to Else's view is that it leaves out of account a passage in the *Politics* about the cathartic effect of music, which is certainly concerned with audiences, and refers the reader for an explanation of catharsis specifically to Aristotle's works on poetry. But this is less than conclusive, because the catharsis clause in the *Poetics* can hardly be the explanation intended (it does not explain anything), and it is impossible to know how broadly or narrowly defined the presumably lost account of the term would have been. After all, if we are inventing definitions of catharsis that Aristotle might have written in some work that has not survived, we can certainly imagine one that explains the operation of elements of the tragic plot on the characters in terms of the operation of music on its listeners—for example, that the process of revelation and purgation endured by Oedipus is like the curative operation of ritual music on the pathological listener.[3] Needless to say, I am not claiming that this is what Aristotle wrote, but only that a formalistic argument that takes the laconic reference in the *Politics* into account is perfectly plausible. It is clear, however, why no refutation of Else has been found necessary: for all its clarity and elegant simplicity, Else's Aristotle does not say what we want Aristotle to say. The great disadvantage of Else's reading for the critic who wants what critics have wanted from Aristotle since the *Poetics* was first rediscovered at the end of the fifteenth century, a compendious guide to dramatic praxis, is precisely that it makes catharsis a purely formal element, and thus leaves the *Poetics* saying nothing whatever about dramatic effect: if Aristotle is anywhere concerned with audiences, this has got to be the place.[4]

As a metaphor for the operation of drama on the audience, however, the notion of purgation has always been found problematic, not

least in Aristotle's apparent assumption that ridding ourselves of pity and fear is something desirable. A few critics, starting in the Renaissance, have undertaken to deal with this difficulty by arguing that it is not we who are purged, but the emotions—that is, we end up with our emotions in a purified form—but this raises as many problems as it solves: what is impure about pity and fear? Moreover, most critics have been at least uncomfortable with the medical metaphor itself, observing that its operation is at best obscure. How does the evocation of pity and fear purge these emotions? Students of classical science point out that this is not even an accurate version of Greek medicine, which worked on the whole allopathically, by opposites, not homeopathically, by similarities—that is, to purge melancholy, you made people happy, not sad. Therefore, if Aristotelian catharsis is really a medical metaphor, drama would purge pity and fear by evoking their opposites, whatever these might be. This has been more a problem for modern commentators than it was for Renaissance exegetes, since much of Renaissance medicine did work homeopathically, and therefore Aristotle, however ahistorically, seemed to be saying something true; but this fact did little to clarify the ambiguities of the passage. One recent critic, Elizabeth Belfiore, has undertaken to resolve the question by insisting on the literalness of the medical metaphor, arguing that if we conceive pity and fear as purging not more pity and fear, but their opposites (she is rather vague about what these might be), the process makes perfect sense.[5] She does not notice that this requires us to believe that when Aristotle says that drama effects through pity and fear the purgation of such emotions, what he must mean is that it effects the purgation of the opposite emotions. Unless "the same" in Greek can mean "the opposite," allopathy will not solve the problem.

Aristotle wrote a compressed, elliptical, and radically ambiguous passage about catharsis that has, historically, simply not been capable of any single firm elucidation and has defied any critical consensus. I take this as the single, basic, incontrovertible fact about the passage: like so many biblical and Shakespearean cruxes, its meaning has only developed over time, has changed with the generations, and inheres entirely

in the history of its elucidation. Indeed, it was the very indeterminacy of the dictum that made it so extraordinarily enabling a feature of the *Poetics* as a basis for both the theory and practice of Renaissance drama. Nevertheless, we should begin by noting the genuine insignificance of the passage within Aristotle's argument, in contrast with the tremendous emphasis that has been placed on it by the critical tradition generally. This is the only place in the essay where tragic catharsis is mentioned; the clause occupies a total of ten words, and the subject is then dropped. In the one other reference to catharsis in the *Poetics,* the term has nothing to do with dramatic theory, but refers to the ritual purification of Orestes when he is recognized by Electra in Sophocles' *Iphigenia in Tauris.*[6] The reference in *Politics* 8 is, as we have seen, equally unhelpful, merely referring the reader for a discussion of the operation of catharsis to Aristotle's work on poetry.[7] Other uses of the term in *The Generation of Animals* and *The History of Animals* seem even less relevant, referring to physiological processes like menstruation, urination, and the ejaculation of semen. To understand the nature of tragic catharsis, those ten words in the *Poetics* are all the help the surviving texts of Aristotle provide.

II

The textual history of the *Poetics* is a meagre one.[8] No manuscript of the work was known in Western Europe until the end of the fifteenth century; and it was first published not in Greek, but in a Latin translation by Giorgio Valla in 1498, ten years before the first publication of the Greek text, the Aldine edition of 1508. Before this time, the essay was known in Europe only in Latin versions of Averroës's incomplete and often confused Arabic text. I want to take a moment for a close look at the earliest translations of the catharsis clause.

Here, to begin with, is how Averroës renders the passage: tragedy "is an imitation which generates in the soul certain passions which incline people toward pity and fear and toward other similar passions, which it induces and promotes through what it makes the virtuous imagine about honorable behavior and morality."[9] Obviously a good

deal has been added to the clause to attempt to make sense of it, but one indubitably clear thing about it is that pity and fear are conceived to be good things, and far from being purged, are what we are expected to end up with. Now, of course it is necessary to remind ourselves that Averroës has none of the context essential for understanding the passage in any historically relevant way. He does not even know what drama is, and assumes that tragedy and comedy are simply poetic forms analogous to eulogy and satire. Nor does he understand that Aristotle's categories of character, plot, melody, and so on, are all elements of the same single poetic structure, but assumes them to be the names of other sorts of poetry. All these matters are, however, tangential to his real interest in the *Poetics,* which lies in its discussion of figurative language. He takes *mimesis* to mean simply the devising of tropes; he has no real concept of imitation, since he assumes that the function of poetry is merely to tell the truth and make it beautiful. Nevertheless, despite all the confusions and lacunae, Averroës's notion that the *Poetics* promulgates a view of drama as ethical rhetoric is one that persists long after the discovery and analysis of the Greek text. Averroës in many respects continued to be the basis of Renaissance views of the essay, enabling it from the outset to be easily harmonized with Horace's *Art of Poetry.*

I want now to consider the earliest Renaissance translations of the clause from the newly discovered Greek; but it is necessary first to pause over two key terms in the passage. First, the word *catharsis* itself is made to carry a good deal of philosophical and spiritual baggage when it is translated "purgation," as it generally is in English. But in Greek, the word's basic meaning is simply "cleaning" (one can speak of the *catharsis* of a house); it can imply any sort of purification, from the most elementary and practical to the most profound and complex, and the standard rendering involves an unacknowledged assumption about the context. The second term is Aristotle's *pathemata,* the word that refers back to pity and fear, usually rendered "emotions"—"tragedy effects through pity and fear the purgation of such emotions." *Pathemata,* too, is a term upon the interpretation of which a good deal depends. It means literally "sufferings"; its root, *pathé,* is translated by Liddell and

Scott as "anything that befalls one." (In contrast, when Plato talks about the emotions, he uses the much more abstract term *thumos,* which is also the word for the soul, or the much more specific word *orgé,* passion in the sense of violent emotion.) *Pathemata* thus include both actions and reactions, both what the hero undergoes and how he feels about it. The word implies, literally, passive action, what is implied etymologically in English by its cognates "passion" and "patience," which together comprise the passive of "action."

Now to our Renaissance translators. Giorgio Valla, in 1498, has tragedy "completing through pity and fear the purgation of such habits"[10]—"completing," *terminans,* is an etymologically precise translation of the word usually translated "effecting," Aristotle's term *perainousa,* literally "bringing to an end": both words have as their root the word for a boundary or limit. Valla's Latin, however, probably misconstrues the force of the Greek: *perainousa* can also mean simply "bringing about, accomplishing," which need not imply an action already in progress. Valla's word for Aristotle's *pathemata,* passions or emotions, is, oddly, *disciplinae,* what we have been trained to do (this is the word I have translated "habits"). A generation later, Alessandro Pazzi, who, in 1536, edited and published the Greek text with a Latin translation that became the standard one, has tragedy "through pity and fear purging passions of this kind":[11] the passions in this case are *perturbationes,* disorders or violent emotions, something more like the Greek *orgia,* and a more loaded term than *pathemata.* In both these cases, there is obviously some bafflement about what is being described and how it works; both attempt to make the process a more reasonable one, something we would want drama to do—rid us of (implicitly bad) habits, cure disorders. A more subtle problem that neither translator really knows how to address is what Aristotle means by "*such* emotions," *ton toiouton pathematon:* are they the same emotions, of pity and fear, that are being purged, or others like them, or perhaps the whole range of emotions to which pity and fear belong? Valla's version, "*talium disciplinarum,*" implies that the purged emotions are the same as the ones doing the purging, whereas Pazzi's "*perturbationes huiusmodi,*" emotions of this kind, leaves the question open.[12]

III

This, then, is what the Renaissance theorist of the effects of drama had to go on when he wished to invoke Aristotle on catharsis. The first commentary, that of Francesco Robortello, did not appear till 1548, but thereafter elucidation and debate were frequent and energetic—the matter was, indeed, increasingly important in the development of dramatic theory. Needless to say, there was no consensus, but most commentators offered some version of one of three standard views: that tragedy is only concerned with the two passions of pity and fear, and it is therefore only these that are purged (and the argument then centered on trying to explain why this was beneficial); or that, on the contrary, pity and fear are good things and it is the other, antisocial passions that tragedy purges—for instance, envy, anger, hatred, and so on; or (the position enunciated by Guarini in the course of defending his *Pastor Fido*) that tragedy purges us in a much more general way, by tempering all our passions through its vision of the pity and fear inherent in the uncertainties of great men's lives, thereby making our own ordinary unhappiness easier to endure. The last of these has obviously added a good deal to the ten words of Aristotle's clause, but it is also the one that makes Aristotle most easily applicable to the uses of the Renaissance playwright.

If all these interpretations seem uncomfortably restrictive, they nevertheless enabled Renaissance theorists to project a surprisingly broad critical and psychological perspective for drama, and one not at all irrelevant to modern views of the passage. For example, Lorenzo Giacomini, in 1586, produced a protopsychoanalytic argument (anticipating the more famous protopsychoanalytic argument of Freud's uncle, Jakob Bernays, in 1857),[13] explaining that we purge our passions by expressing them, and that tragedy permits the spirit to vent its emotions, and thereby releases us from them.[14] Giraldi Cintio, in 1558, preempted Gerald Else's new critical reading by suggesting that, through pity and terror, "the personages introduced in the tragedy are purged of those passions of which they were the victims"[15]—the catharsis, that is, takes place in the characters, not in the audience. And Giason Denores, in a strikingly historicized (not to say

New-Historicized) account, anticipating Jack Winkler by four centuries, explained Aristotle's focus on pity and fear by observing that Greek drama constituted a vital part of the citizen's training for warfare and the defense of the state, and hence ridding the prospective soldier of these potentially disabling emotions was of primary importance to the playwright.[16]

Of course, there are also commentators who reject all three positions, which sometimes involves rejecting Aristotle entirely—it is important to stress that, for all the age's notorious devotion to the authority of the Ancients, this was always an option. J. C. Scaliger, for example, denies that catharsis can be a defining feature of tragedy, observing succinctly that it simply does not describe the effects of many tragic plots.[17] Tasso similarly argues that catharsis will not account for the operation of many kinds of tragedy, citing as examples "those tragedies which contain the passage of good men from misery to happiness, which confirm the opinion that the people have about God's providence"[18]—catharsis is faulted, in short, for not being applicable to medieval tragedy, and more specifically, in this construction at least, for not being Christian. But the largest issue in the debates over the clause, and the source of the general unwillingness to treat it simply as an abstruse and marginal moment in Aristotle's argument, was its apparent assertion of some sort of real social utility for drama. It is, from late antiquity onward, generally accounted for as an answer to Plato's charge that poetry conduces to immorality, and the consequent exclusion of poets from his ideal republic. On the contrary, the catharsis passage seems to insist, poetry serves an essential function, something more vital than its mere persuasive force as ethical rhetoric, in maintaining the health of the state.

But even here, many commentators observe that such a reading puts Aristotle in the position of contradicting himself. Early in the essay he implies that the purpose of drama is to give pleasure;[19] how then can its function also be to purge us through pity and fear? There are some attempts to reconcile these two claims (for example, we feel better when we're purged), but the real problem is that, for most Renaissance theorists, the defining feature of drama has nothing to do with its medicinal character, but lies in its quality as spectacle, and its

consequent ability to evoke wonder—this is what makes it different from epic poetry, though critics are fairly equally divided about whether it is therefore better or worse. Woe and wonder constitute the essence of the tragedy Horatio proposes to produce out of the story of Hamlet, and Hamlet says it is "the very cunning of the scene" that strikes the spectator "to the soul." Poetry alone will not have this effect; theater—"the scene"—is of the essence.[20]

As I have indicated, this is not invariably a point in tragedy's favor. Castelvetro, for example, argues that plays are designed to appeal to the ignorant multitude, who are incapable of reading philosophy; drama's sole end, he concludes, is to satisfy the vulgar desire for pleasure.[21] And though this is an extreme position, it is nevertheless the case that the Renaissance is in general so deeply concerned with theater as a way of managing the emotions that the notion of drama as a mode of knowledge (as, for Aristotle, it is a form of logic) hardly plays a significant role in the poetics of the Renaissance stage. Renaissance theorists are interested in everything Aristotle marginalizes in his argument, all the emotive, performative, and spectacular elements of drama, and just for that reason catharsis, which has so momentary and casual a presence in Aristotle, becomes, for the Renaissance, of correspondingly vital importance.[22] Through the invocation of catharsis, most critics are able to present drama as a genre of considerable social utility. The Belgian scholar Nicaise Van Ellebode sums it up when he recommends the patronage of tragedy particularly to rulers, as a way of improving the citizenry, observing that the effect of virtue:

> is especially to hold in check the turbulent movements of the soul and to restrain them within the bounds of moderation, and since tragedy, more than that, curbs these emotions, it must surely be granted that tragedy's usefulness to the state is extraordinary. For it causes two troublesome passions, pity and fear—which draw the soul away from strength and turn it toward a womanish weakness—to be regulated and governed by the soul with precise moderation.[23]

It is only the catharsis clause that makes such a claim at all tenable.

IV

The broadly political implications of catharsis for the Renaissance assume that the audience of drama is composed of basically virtuous people, who attend the theater for virtuous reasons, to be perfected, refined, or made better citizens. Critics like Castelvetro who deny this, who assume that audiences attend theater primarily to be amused, and that the function of drama is to amuse them (though it may thereby succeed in inculcating in them some of that philosophy they are too ignorant and shallow to read), also necessarily deny that Aristotle is correct about catharsis. Catharsis tends to be the basis for any utilitarian claim that is made for theater in the Renaissance.

Except, that is, in England—England is in this, as in its theatrical practices generally, the great exception in the European Renaissance. To begin with, Aristotle does not figure especially significantly in English discussions of tragedy—it is to the point that the first English translation of the *Poetics* appears only in 1705, and was itself a translation of a French version. The major Elizabethan literary theorist, Sidney, is certainly aware of the classic essay, but he bases his claims for drama primarily on the mimetic and idealistic qualities of the art. The one gesture toward catharsis forms a marginal and curiously arbitrary part of the argument, but its claims are characteristically both hyperbolic and ambiguous: tragedy is praised because it "maketh kings fear to be tyrants, and tyrants manifest their tyrannical humors; that, with stirring the affects of admiration and commiseration, teacheth the uncertainty of this world."[24] The second "tyrants," those who "manifest their tyrannical humors"—or perhaps, on a second reading, those who *fear to* manifest their tyrannical humors—turn out on a *third* reading, after we get through the next clause, to be only stage tyrants; but syntactically they are identical to the kings, and that extended moment of syntactical ambiguity is surely to the point, a reflection of the profoundly ambiguous theatricality of the Renaissance monarchy. Tragedy is claimed here to guarantee that the only tyrants will be stage tyrants in a world where the audience is composed of kings, but it takes us three readings to assure ourselves that Sidney has moved from monarch to player, spectator to actor, and the distinction between real kings and

theatrical tyrants is perceptible only through repeated and very close reading. Is Sidney's use of the gendered "kings," in preference to "monarchs," or "rulers," or even "princes" (the term the queen used to refer to herself), a reflection of just how close to home such an observation might have hit in the England of Elizabeth?

George Puttenham's account of drama, in *The Arte of English Poesie,* does not mention catharsis at all, which, however, appears instead in its most literal medical sense to explain the operation of elegies or "poetical lamentations":

> Therefore of death and burials . . . are the only sorrows that the noble poets sought by their art to remove or appease, not with any medicament of a contrary temper, as the Galenists use to cure [i.e., not allopathically] but as the Paracelsians, who cure making one dolor to expell another [i.e., homeopathically], and in this case, one short sorrowing the remedy of a long and grievous sorrow.[25]

It was, ironically, the enemies of theater who found in the concept of catharsis a potent argument through its acknowledgment that drama's function is in fact to elicit the emotions—though in these accounts, instead of freeing us from passion, theater only enslaves us to it. Such arguments are, of course, intended as refutations of the claims to social utility made in Aristotle's name, but insofar as catharsis is interpreted throughout the Renaissance as a kind of physical mimesis, an extension of dramatic mimesis into the audience, the antitheatrical polemics, for all their obvious Platonic bias, might be said to be perfectly Aristotelian. Needless to say, however, the *Poetics* remains a tacit source, never directly cited in such arguments. Aristotle appears as an authority on drama instead, ubiquitously, in a passage from the *Politics* where he recommends against young men attending theater "till they be settled in mind and immoveable in affection." Where Italian theorists had used Aristotle to answer Plato, Gosson, Stubbes, and Prynne use Plato to refute Aristotle.[26]

One would expect Ben Jonson, the most thoroughgoing dramatic classicist in Renaissance England, and thoroughly familiar with both Aristotle and the Continental commentaries, at least to take some

notice of the catharsis clause. But the long account of the *Poetics* in his *Discoveries* is concerned only to harmonize Aristotle and Horace, and catharsis again is not mentioned. The theory here is the mirror of Jonson's dramatic practice, which was, in its primary emphasis on the unities, more Horatian than Aristotelian. Only Milton in England saw in classic catharsis a genuine theoretical basis for tragedy, once again through the mediation of homeopathic medicine:

> Tragedy . . . hath ever been held the gravest, moralest, and most profitable of all other poems: therefore said by Aristotle to be of power by raising pity and fear, or terror, to purge the mind of those and such-like passions, that is, to temper and reduce them to just measure with a kind of delight . . . for so in physic things of melancholic hue and quality are used against melancholy, sour against sour, salt to remove salt humours.[27]

So Samson, his followers, the audience, all conclude the drama of *Samson Agonistes* with what the Renaissance understood to be an impeccably Aristotelian purgation, with "calm of mind, all passion spent."[28] This is surely the purest example the English Renaissance affords of the explicit utility of catharsis to the practice of drama. We may perhaps wish to find some notion of the Aristotelian doctrine at work in plays like *King Lear, Macbeth,* and *Hamlet,* but if we think of their endings, it is clear that Shakespeare is far less convinced than Milton and the theorists that the experience of catharsis leaves us in any way reconciled, calm, or happy.

V

Let us now return to Hamlet on the therapeutic drama he plans to present before the king. The play within the play is itself part of a much larger purgative drama, as Hamlet's *pathemata* work to effect the catharsis of his father's spirit in Purgatory: in this sense, which is the sense described by Gerald Else, catharsis may be said to be the subject of the whole play. But Hamlet's more pragmatic notion, that tragic catharsis is designed not for the satisfactory resolution of the plot, nor

for the refining and purification of virtuous citizen-spectators, but for the exposure and punishment of criminals is, to say the least, a very special application of the Aristotelian doctrine, an *expansio ad absurdum* of the dramatic theory, so to speak. Behind Hamlet's *Mousetrap*, however, lies not only Aristotle's catharsis clause, but a moral *topos* that reappears in a number of forms throughout Shakespeare's age. Thomas Heywood recounts two versions of it in his *Apology for Actors*, one of the very few defences of the stage in Renaissance England; the *topos* is invoked as a telling argument in favor of theater. It concerns a woman who has murdered her husband and years later attends a play on the same theme, and when the murder is represented on the stage, suddenly cries out in a paroxysm of repentant guilt, confesses, and is duly punished.[29] This is, in its way, a genuine instance of the Renaissance notion of Aristotelian catharsis at work, the pity and terror of the action eliciting a particularly pointed reaction of pity and terror in the spectator. Such a story is an obvious model for the projected revelation of Claudius's crime.

But in Hamlet's play, does the catharsis really work? Claudius sits through the dumb show, a clear mirror of his villainy, apparently quite impassively—directors have a good deal of trouble with this, and often deal with it by cutting the dumb show entirely (radical surgery is the normal theatrical cure for the dangerously interesting moments in Shakespeare). Nor is Claudius alone in failing to rise to *The Mousetrap*'s bait: the Player Queen's implicit criticism of Gertrude's doubly culpable remarriage, "In second husband let me be accursed; None wed the second but who killed the first" (Act III, Scene ii), elicits no acknowledgment of an overhasty and incestuous union, but only a famously cool response: "The lady doth protest too much, methinks." The king, indeed, seems to feel that what is potentially offensive about the play has to do with its relevance to the queen, not to him. And the point at which he finally rises and flees is not when the murder is represented, but when Hamlet identifies the murderer, "one Lucianus, nephew to the king," and reveals his intention, to seize the throne—when it becomes clear that the players are presenting a play about the murder of a king not by his usurping brother but by his usurping

nephew. Claudius is driven from the theater by the revelation of Hamlet's threat to his throne and his life; and the crucial admission that has been elicited by the play concerns not Claudius's crime but Hamlet's intentions. Still, Hamlet is partly correct about the ultimate effects of tragic catharsis, which does elicit a confessional soliloquy from Claudius in the next scene, without, however, any corresponding gesture of repentance. In effect, Claudius refuses the catharsis.

A more striking instance of theatrical dubiety about the effects of catharsis is found in Massinger's play *The Roman Actor*. I assume this is unfamiliar, so I summarize the plot: Parthenius, the toadying factotum of the tyrant Domitian, has an avaricious father. Paris, the Roman actor of the title, proposes curing him through the operation of dramatic catharsis: he will present a play about a miser in which the father will recognize his own vice, and will reform. The effectiveness of the treatment is guaranteed by reference to the usual story about the murderer brought to confess by witnessing a play on the subject. Domitian approves of the project, and orders the father to attend on pain of death. The miser in Paris's play acknowledges the error of his ways and is duly cured of his avarice, but Parthenius's father in the audience is unimpressed, and declares him a fool. Domitian warns the father that he is in mortal peril if he fails to take the play's lesson to heart, but he remains adamant, and is led off to be hanged.

In a second performance, the empress Domitia, already dangerously infatuated with Paris, commands him to play a tragedy of unrequited love. This so moves her that, at the point when the rejected hero is about to kill himself, she cries out to stop him (like the famous spectator at the murder of Desdemona), and the emperor calls a halt to the play. The love scene has, in fact, evoked a violent passion in her, and she determines to have Paris as her lover. She sends the emperor away, summons the actor, and orders him to make love to her; the emperor is informed, watches her woo him, interrupts them, has her imprisoned, and devises a theatrical punishment for Paris. He commands the actor to perform a play about a master who, as a test of his wife's fidelity, pretends to go on a journey, leaving her in the care of a trusted servant. Paris is to play the servant; Domitian announces his

intention of playing the role of the husband himself. The play begins: the wife declares her passion for the servant. He initially refuses her, but finally yields when she threatens to claim to her husband that in his absence the servant had raped her. They embrace, Domitian enters as the husband, draws his sword, kills Paris in earnest, and pronounces a self-satisfied eulogy.

The final act abandons the metatheatrical for the dubiously moral: all the principal characters who remain alive, including the lustful empress and the toadying factotum, join together and assassinate Domitian. There is a certain Tom Thumbish quality to the dénouement, as the conspirators shout "This for my father's death"; "This for thy incest"; "This for thy abuse"; and the empress—whose seduction of Paris was, after all, directly responsible for his death—stabs her husband crying "This for my Paris!" But the play aborts any Bakhtinian tendency to an anarchically celebratory finale with the rather lame promise that the assassins will be duly punished by the tyrant's successor.

VI

If one wanted a text to demonstrate the genuine relevance of the wildest antitheatrical polemics to actual theatrical practice in Renaissance England, *The Roman Actor* would do nicely. It acts out the charge that mimesis can only be pernicious, since we inevitably imitate the bad and ignore the good; it shows drama confirming us in our passions, not purging them, and far from providing moral exempla, turning us into monsters of lust. Massinger represents theater just as Gosson, Stubbes, and Prynne do, as the appropriate art for a pagan tyrant.

This is no doubt an extreme example, but it is also a very English one. A much more positive version of the same sort of directly the-atrical catharsis is presented in Corneille's *L'Illusion Comique,* in which a disapproving father, confronted with a spectacle revealing the implications of his demands regarding his son's career, relents, and the two are reconciled: across the Channel, the didactic purgation of the play within the play works just as it is supposed to. One of the most strik-ing characteristics of the Elizabethan and Stuart stage is the degree to

which its playwrights seem to share, and even to make dramatic capital out of, the prejudicial assumptions of their most hostile critics. Marlowe's damnable Faustus is a theatrical illusionist, the dangerously, seductively theatrical Cleopatra herself condemns the quick comedians who stage her and the squeaking actor who boys her greatness, Jonsonian drama constitutes a positive anatomy of antitheatrical attitudes—think of *Epicoene,* with its transvestite con-artist heroine, and *The Alchemist* and *Volpone,* those handbooks of charlatanry, greed, whoredom. Hamlet himself, attending the play within the play, offers to lie in Ophelia's lap, and thereby confirms the essential interdependence of theater and lechery. But perhaps even these examples are cathartic, miming the moralists to disarm and expel them.

I am indebted to the late David Sachs, who first called my attention to Gerald Else's reading of the catharsis passage and persuaded me that it was worth taking seriously. For guidance through the classical minefields, I am grateful to Andrew Ford, Jay Reed, David Halperin, and especially to Francis Sparshott's excellent essay "The Riddle of Katharsis," in Eleanor Cook, *et al.,* ed., *Centre and Labyrinth* (Toronto, 1983), pp. 14–37. Thanks are due for suggestions and enlightenment on various points to Randall S. Nakayama, Bradley Rubidge, and Peter Stallybrass. Finally, a timely and thoughtful question from Jonathan Arac helped to clarify the argument.

NOTES

1. *Aristotle's Poetics: The Argument* (Cambridge, MA, 1963), pp. 225–232, 423–447.

2. A brief summary of the arguments against it is in Stephen Halliwell, *Aristotle's Poetics* (London, 1986), p. 355.

3. This is not, however, Else's argument. He suggests, on the contrary, that the passage from the *Politics* is not relevant at all, that it is something Aristotle believed when he wrote it, but changed his mind about when he came to write the *Poetics* (pp. 442–443). I find this as unpersuasive as everyone else has found it—critics do tend to put their worst feet forward in dealing with catharsis.

4. And indeed, Jonathan Lear rejects the reading precisely because it is formalistic, accusing it of deriving from "a misapplication of a principle from new criticism" ("Katharsis," in A. O. Rorty, ed., *Essays on Aristotle's Poetics* (Princeton, 1992), p. 336,

but this is not really correct: Else argues only that an internally consistent interpretation of catharsis in the *Poetics* cannot be refuted "*merely* by appealing to a reference in another work which seems to imply another concept, especially if that reference is obscure or controversial in itself" (p. 441). In fact, Else's own explanation of the difference between the uses of the term in the two works, far from being New-Critical, is based on quite romantic assumptions about Aristotle's intellectual biography (see above, n. 3). I describe Else's reading as "new critical" below simply because it undertakes to keep catharsis within the limits of the text. A more particular objection to the argument as a reading of the Greek, raised by both Stephen Halliwell (*Aristotle's Poetics,* p. 355) and Elizabeth Belfiore (*Tragic Pleasures* [Princeton, 1992], p. 264), is that it requires us to take pity and fear, *eleos kai phobos,* to mean not the emotions of pity and fear, but events producing these emotions, and Aristotle specifically refers to them as *pathemata,* emotions. Else anticipates this objection, and cites a parallel usage earlier in the essay which does support his reading (pp. 228–229, ignored by both critics); but even without this, the objection seems excessively narrow. As indicated below, *pathemata,* the word normally translated "emotions," means literally "sufferings"; it includes both what the hero undergoes and how he feels about it. Indeed, to use emotional terms in this way is so commonplace that it is the criticism that seems eccentric: when Horatio, at the end of *Hamlet,* promises to satisfy his hearers' appetite for "aught of woe or wonder," he is promising a narration about events that will evoke these emotions, not about the emotions themselves.

5. *Tragic Pleasures*, pp. 257–336.

6. 1455b 15.

7. 1341b 39–40.

8. The indispensible guide to the material is Bernard Weinberg, *History of Literary Criticism in the Italian Renaissance,* 2 vols. (Chicago, 1961), hereafter cited as Weinberg. In cases where passages I discuss are included in Weinberg's survey, I have for convenience given the citation to his text, though I have occasionally revised his translation in the interests of clarity. An excellent brief overview is given by Halliwell, *Aristotle's Poetics,* pp. 290–302.

9. Weinberg, 1:358.

10. The Latin is "*de miseratione & pauore terminans talium disciplinarum purgationem*" (Weinberg, 1:372).

11. "*per misericordium uerò atque terrorem perturbationes huiusmodi purgans*" (Weinberg 1:372).

12. Aristotle's *ton toiouton pathematon,* "such emotions," is similarly ambiguous, and many critics have taken it to be equivalent to *ton touton pathematon,* "these emotions," which would clearly limit the emotions to pity and fear.

13. *Grundzüge der verloren Abhandlung des Aristoteles über Wirkung der Tragödie* (Breslau, 1857), in many ways the originary modern treatment of the subject.

14. *Sopra la purgazione della tragedia* . . . (1586), discussed in Weinberg, 1:626–8; the passage cited is discussed on p. 627.

15. Weinberg, 2:927.

16. *Discorso intorno à que' principii, cause, et accrescimenti, che la comedia, la tragedia, et il poema heroico ricevono dall philosophia* . . . (1586); the argument is summarized by Weinberg, 1:621–6. The passage about military training is discussed on p. 625. Compare John J. Winkler, "The Ephebes' Song: *Tragôedia* and *Polis*," *Representations* 11 (Summer 1985), pp. 26–62.

17. *Poetices libri septem* (Lyons, 1581), p. 29.

18. Weinberg, 1:571.

19. 1448b 4–19.

20. For a detailed discussion of the argument, see my essay, "The Poetics of Spectacle," *New Literary History* 2:3 (Spring 1971), pp. 367–389.

21. *Poetica d'Aristotele vulgarizzata et sposta* (1570/76); Weinberg, 1:502ff; the passage cited is on p. 506.

22. For the marginalization of catharsis in Aristotle, see Andrew Ford's essay in this volume.

23. *In Aristotelis librum de Poetica paraphrasis* (1572); Weinberg, 1:519–23; the passage cited is on p. 521.

24. *An Apology for Poetry*, ed. Forrest G. Robinson (New York and London, 1970), p. 45.

25. Book 1, chapter 24 (ed. Edward Arber, London, 1869), p. 63.

26. Stephen Gosson, *Playes Confuted in Five Actions* (1582), sig. C7r–v; Phillip Stubbes, *The Anatomie of Abuses* (1583), sig. L7r; William Prynne, *Histrio-Mastix* (1633), pp. 448–449 and elsewhere.

27. Prefatory note to *Samson Agonistes*, lines 1ff.

28. *Samson Agonistes*, line 1758.

29. *An Apologie for Actors* (1612), sigs. G1v–G2v.

7

ELIN DIAMOND

THE SHUDDER OF CATHARSIS

IN

TWENTIETH-

CENTURY

PERFORMANCE

In the final analysis, aesthetic behavior might be defined as the ability to be horrified. . . . The subject is lifeless except when it is able to shudder in response to the total spell. And only the subject's shudder can transcend that spell.

—T.W. Adorno[1]

IS IT POSSIBLE, I wonder, to recover the shudder in catharsis?

In Jacques Lacan's essay, "Anamorphosis," I am struck by the juxtaposition of two statements about seeing and feeling. The statements are: "I see myself seeing myself" and "I warm myself by warming myself."[2] For Lacan, the first statement, "I see myself seeing myself," signals the deludedness of the Cartesian *cogito*; the subject who thinks that her talent for self-reflexiveness means that she masters the visual field. Such hubris conceals what Lacan calls the "primal separation" that founds subjectivity, and as a corrective he proposes the dialectic of the eye and the gaze; the subject's I/eye is always "caught, manipulated, captured" (92) in the field of vision that precedes her. The subject never really sees herself, then, except through the gaze of the other. Contrary to this dance of deception, the statement "I warm myself by warming myself" is winningly straightforward. "I feel that sensation of warmth," Lacan writes, "which from some point inside me, is diffused and locates me as a body." At the felt convergence of body and warmth, self-reflexiveness drops away. My body radiates heat. I feel it and am absorbed in it.

Lacan is, in part, worrying the connections between his psychoanalytic theorizing and Merleau-Ponty's phenomenology, but for me the

juxtaposition has this estranging effect: seeing and feeling seem to occupy completely different registers. The "I/eye" is bound up, dangerously, with the look of the Other, call it a bobbing sardine can, the field of discourse, or the Name of the Father, while bodily sensations, pleasurable or painful, mark, with an authenticity that goes unquestioned, the fact of being in the body. The radical disjunction between the eye and the gaze is replayed, in this paragraph, in the disjunction between seeing and feeling. As a feminist living in postmodern culture, in the age of AIDS, I find this notion both ludicrously Platonic and completely plausible. Why *should* feeling and seeing cohabit, much less harmonize? Because we are speaking today of a profoundly embedded concept that says that they must; that concept is catharsis.

Whatever else it might have meant to Aristotle, catharsis involves a disturbing oscillation between seeing and feeling. Using for the moment my old Bywater translation, let me offer a conventional reading of the catharsis clause in Section 6 of the *Poetics*: my perception of the objects in tragedy causes me to experience the unpleasant emotions of pity and terror, which are somehow expelled or quelled, purged or purified, in my recognition of the object's meaning and truth. In Chapter 14 of the *Poetics,* Aristotle, even in Else's translation, makes the shudder of emotion vital to tragedy's plot: "Anyone who hears the events as they unfold will shudder and be moved to pity. . . ."[3] For Julia Kristeva, Greek tragedy's rhythm and song both arouse and harmonize the impure desires of the "mind's other," the passionate, corporeal, sexual body.[4] According to Martha Nussbaum, appetites, feelings, emotions, sexuality, were for the ancient Greeks "powerful links to the world of risk and mutability," thus sources of disruption that disturbed the agent's "rational planning" and produced distortion of judgment.[5] Such disturbances were "weakening, threatening, degrading to individuals and society,"[6] which is why ridding oneself of the body's shudder is consonant with the effects of what Nussbaum calls the "*katharsis* . . . word-family";[7] by Aristotle's time, psychological, cognitive, and epistemological meanings mingled with the physical. Catharsis described the "'clearing up' or 'clarification' . . . the removal of some obstacle (dirt or blot, or

obscurity, or admixture)"—in sum, the "clearing up of the vision of the soul by the removal of [bodily] obstacles."[8]

Catharsis, it would seem, situates the subject at a dangerous border. We recall that the Lacanian subject, when seized by the look of the Other, suffers a disturbance in the totalizing vision that affirms consciousness and mastery. In catharsis, the subject is seized by her shuddering body, which mars her rational vision and produces an unhealthy division of self and social being—a division which only catharsis itself can heal and regulate. For Brecht and Artaud, self-conscious modernists both, it was easy enough to reject catharsis on the grounds of bourgeois regulation. But it was less easy to ignore its performative power, the fact that catharsis marks and remarks a sentient convergence of body and meaning, when the material body, in all its otherness, makes itself felt to consciousness even as it enters discursive categories that make it mean; when it becomes not the body but the visible form and social incarnation of the body: that is, an embodiment.

Since Foucault, statements about the body with the verbs "becomes" and "enters" seem nostalgically ontological, presuming a body not already penetrated and disciplined by discourse, by gender codes, by culture. There is (and I would agree) no body without embodiment. But this latter assertion is never a foregone conclusion in Western performance theory. For Plato, the embodiment of bodies for the purpose of mimesis was generative and volatile, an incitement to uncivil passions; for Aristotle, it was heuristic, ameliorative, universalizing. For some twentieth-century theater theorists and feminists it is, problematically, both. In quite different ways, Luce Irigaray and Adrienne Rich propose that materiality and discourse work in productive tension, allowing one to imagine a (located) body, at times excessive to discourse, that can act performatively, effect new coalitions and new intimacies, improvise new identity-fictions.[9]

To investigate catharsis in twentieth-century performance, I will stay with "embodiment," not discourse, because embodiment is haunted by what it has swallowed, the material "body," and because the orchestration of that haunting is, I would argue, a crucial datum of performance. In my *American Heritage* dictionary, embodiment enjoys

the same playful materiality/discourse oscillation as the word "performance": embodiment is both the "act of embodying," and the "condition of being embodied," just as performance is the immediate act of doing, and the thing done.

But something is wrong here: I seem to have made catharsis inseparable from twentieth-century performance. If the shuddering body, particularly the female body, poses a vital question in performance, catharsis itself has come down to us too thickly larded with bourgeois idealism and apolitical aestheticism for us to, as Brecht would say, refunction it. Or if we are to refunction it, we will need some conceptual disturbance. When Lacan sought to illustrate the dialectic of eye and gaze, he imported from optics "anamorphosis," the phenomenon of the distorted image that can be viewed without distortion only from a special angle or with a curved mirror or cylindrical lens, as in Holbein's famous painting of 1533, "The French Ambassadors." In this work, two well-fed, bourgeois gentlemen, surrounded by objects of wealth and worldliness, confidently solicit the viewer's gaze; for the viewer, though, the image is marred by a confusing blur which, only when seen from a sharp angle, clarifies itself as a skull. This blur is what Lacan calls the "*tache,*" or blot in the visual field, which seems to gaze at the subject from a point that totally escapes her view; in effect it stands for the Other, or the *petit objet a,* the Lacanian sign of primal separation—infant from breast, body from mirror image—ultimately the object and cause of desire.[10] Catharsis, we recall, means the clearing away of blots from the visual field, but anamorphic images cannot be cleared, and far from harmonizing seeing and feeling, anamorphosis is inseparable from anxiety—in Ned Lukacher's fine phrase, it gives us the sense of "feeling seeing, like feeling the gaze of the other without seeing the other's eyes."[11] Invented in early modernity, anamorphosis seems the perfect modernist trope, an unresolvable, oscillating object that deflects the subject's mastery, and yet, according to Lukacher, the anxiety of "feeling seeing" produces its own clarifying shudder. "The anamorphic image," he argues, "is a kind of catharsis insofar as it clarifies the disorder, the illness that inheres within intellectual inaccuracy . . . the untruth or perversity that is always constitutive of the truth."[12]

In modernist and postmodern performance, the precarious border between body and cultural embodiment has provoked acts of anamorphic catharsis addressed not only to spectators but to a culture deemed ill and oppressive. Despite the efforts of scholars to purify the term of its primitiveness, residues of ritual purification and medical purgation have returned to twentieth-century performance, dilating its connotations outside the precincts of the theater to areas of social behavior and health.[13] Similarly, to think about catharsis in art contexts, as I am about to do, is not to remove performance from questions of social agency. Twentieth-century performance theory deliberately sought a conceptual overlay between the space of theater and the spaces of social action; indeed, the theorizing about reception was based on the assumption that the actor's body, as much as and finally more than the text, was the crucible of discovery, and that production was less about product than cultural rehearsal, a means of discovering new, revolutionary embodiments.[14] This is why my discussion of catharsis moves back and forth from spectator to performer, the latter reflecting back to the former the oscillation of seeing and being seen, body and embodiment. Eleanora Duse, Helene Weigel, and Karen Finley, theorists in their own media of anamorphic catharsis, may or may not induce such effects, but they will certainly show us what they might be.

I offer, then, three glimpses of catharsis in twentieth-century performance under these rubrics: "Bourgeois Catharsis: Duse's Sublime"; "Social Catharsis: Weigel's Mouth"; "Permanent Catharsis: Finley's Twist and Shout." An epilogue follows.

BOURGEOIS CATHARSIS: DUSE'S SUBLIME

> When in the midst of reproaching her lover [Duse heard] the cries of Mme Raquin, she trembled, a shudder went through her whole being and one felt so moved that one was actually unable to applaud.[15]

At the end of the nineteenth century, catharsis was the legitimating imprimatur of the new modern drama and the new science of psychoanalysis. Freud and Breuer labeled their innovative treatment of

hysterics "the cathartic method," in which hysterical female patients, narrativizing the scenes of their originary traumas, were purged of debilitating symptoms. William Archer, Ibsen's major English translator, praised the "new drama" for "cast[ing] out the foreign elements of rhetoric and lyricism"—the overblown language of melodrama—in favor of "natural" dialogue, and the "purification or *katharsis*" of dramatic form.[16] In their search for truth, psychoanalysis and the new realism privileged what nineteenth-century uterine-theory physicians and melodramatists had ignored: the complex etiology of motivation—the inherited traits, social laws, and forgotten traumas that shaped human character. In the interior of Freud's consulting room and on the object-filled stages of the small subscription theaters that dared to present the new drama, that character was often the hysterical woman: the woman with a past became a theater of discovery.

It is important to remember that in the industrialized European cities of the late nineteenth century hysteria seemed ubiquitous. E.M. Stutfield sat through a matinee performance of Ibsen's *Little Eyolf* in 1897 and insisted there were as many hysterical women in the audience as on the stage.[17] And Janet Lyon has recently documented the common journalistic attribution of "hysteria" to avant-garde manifestoes, political posters, and to the wildly performative suffragettes who marched into Parliament, chained themselves to pillars, went on prison hunger strikes, and who, in the words of later civil rights marchers, put their bodies in the way of authority.[18] It is tempting to think that the terrific popularity of Jakob Bernays's treatise on hysteria (1857, 1878), which insisted on the purgation reading of catharsis, was both a recognition of the severely diseased state of modern society and a recipe for expunging its more noxious (read "female") elements.[19]

In emplotting hysteria, early realist theater was a potent source of complex cultural embodiments for bourgeois professionals and intellectuals, including Freud, who turned Ibsen's *Rosmersholm* into material for a case history. More to my purpose here, this theater created the desire for a different performing body. Melodrama had offered complete adequation between the symptomatology of hysteria—eye-rolling, choking, uncontrollable laughter—and the actor's verbal and physical

signs. The hermeneutic pleasure of the new realism lay in its diminished gestural range, the presentation of a corporeal text riddled by gaps, feints, evasions. Hysteria in effect created the performance text for dramatic modernism. Spectators were offered the physician/analyst's point of view, invited to scrutinize the performer's body for the signifiers of psychic trauma, and thus incited to write, often under great perturbation, their own explanatory narratives.

It was Eleanora Duse (1858–1924), the most celebrated European actress after Bernhardt, who was able to demonstrate the full range of cathartic action in this theater apparatus which, like the psychotherapist's office, was dedicated to discovering the truth. Able to blush at will, to make herself symptomatic, Duse gave rapt audiences the intense pleasure of watching a fictional embodiment disappear into a shuddering erotogenic body. Though she was raised in an itinerant theater family, among actors whose techniques were formed by acting manuals dating back to the seventeenth century, Duse invented a form of psychological realism that took her far beyond the style of Italian *verismo* of the 1870s and 1880s or French naturalism of the 1880s and 1890s. By the turn of the century she had created a hysteric's sensorium, replete with what one colleague called *la faccia convulsiva* (the distorted face), a rigidity of chest muscles and shoulders, and, above all, hands that seemed cut off from all volition, that wound handkerchiefs, played with rings, bunches of flowers, flew up, clutched, and flew again.[20] Considered by her friends to be *le type même* of the *fin de siècle* hysteric, Duse seemed able, in fact, to perform the radical anamorphosis implied in Freud's analysis of hysteria.

When he was convinced that hysterical paralysis had no organic basis, Freud explained his patients' symptoms by the term "hysterical conversion," a process which he could never fully describe, in which the affect attached to trauma is withheld from consciousness and diverted into bodily innervations. In hysteria, the physiological body is in effect supplanted by a distorting erotogenic body, and it is this body that Freud learns to listen to and to read.[21] Duse's characteristic gesture, wrote one observer in 1897, "has an automated quality, a certain stiff letting go of her arms down her sides [then] a certain way of raising her open hands with all five fingers pointing outward, that would be utterly baroque

were any other actress to try to imitate her."[22] The gesture *was* baroque, that is, nonreferential, hysteria's somatic pantomime—as well as perhaps Duse's means of deflecting the voyeurism of the realist theater apparatus. In 1923, at the age of sixty-five, Duse performed in Ibsen's *The Lady from the Sea* in London, and here's what James Agate wrote: "If there be in acting such a thing as pure passion divorced from the body yet expressed in terms of the body it is here. Now and again Duse would seem to pass beyond our ken and where she has been there is only fragrance and a sound in our ears like water flowing under the stars."[23]

From one sentence to the next, the erotogenic anamorphic shudder passes into the ethereal sublime. Sucked into what Adorno called the "total spell," Agate testifies to the experience of bourgeois catharsis—Duse's consumers were invited, in performance after performance, to fetishize her body's sublation. Wishing for most of her life to purify the language of the stage (she referred to the theater as a "charnel house"), Duse would have been pleased with Agate's description. By all accounts, in this performance and throughout her career, Duse offered her adoring audiences spirituality and relief—relief from the confusions of carnality, from the increasing standardization of what was called "modern life"; relief, too, perhaps, from the sight of hysterical suffragettes messing up the street.

One of Duse's favorite parts was Nora in Ibsen's *A Doll House*. When she danced the tarantella, it was noted, "she turned pale, cast down her chin, and her tormented eyes screamed out in silence."

I would like you to remember this image.

SOCIAL CATHARSIS? WEIGEL'S MOUTH

> . . . for a performance of Oedipus, one has for all practical purposes an auditorium of little Oedipuses.
>
> —Brecht[24]

Of all theater theorists in this century, Brecht leads the way in vilifying catharsis as the suppression of critical reason. In this, he and

Adorno were in rare agreement. Traditional theater, Brecht charged, because it encouraged emotional identifications with arresting actors in linear plots, reneged on its revolutionary potential to serve up the stories, A-effects, intellectual *Spass*—the nourishment a spectator in the "scientific age" needed to throw a wrench into capitalism, not to mention fascism. Catharsis-driven bourgeois theater, Brecht insisted, used emotional lures to avert our eyes and minds from the social dialectic informing every gesture, every word. Brecht's theater practice was, in effect, deliberately anamorphic. The idea of the *Verfremdungseffekt* was to drive a wedge not just between actor and character, but between the historical subject and the actor's function. While the critical actor is presumed to have superior knowledge in relation to the character, the subject herself remains as skeptical and uncertain as the audience to whom the play is addressed. She disappears neither into a representation of the character nor into a representation of the actor: each remains processual, contingent, incomplete. Thus even in the *Gestus* (a constructed moment, usually a gesture or a tableau, designed to compel recognition of the play's social attitudes) the actor remains insufficient and open: a social embodiment demonstrating at least two fictional embodiments.

Brecht would have been happy to refunction Lacan's gaze as the dialectical force field of history, in which the spectator's imaginary identifications—the plenitude of full seeing—are interrupted by the contradictory relations of the symbolic. What Brecht called the dialectical zigzag, that which threatened the seamless unity of the real, would become the unseeable blot, that which installs lack where there had been narcissistic identification. For Brecht, the Lacanian lover's plaint, "You never look at me from the place from which I see you" (Lacan, 103), would be welcome testimony to the way capitalism distorts social relations. It also glosses beautifully the Brechtian disjunction between subject, actor, spectator: this is how the alienated actor should feel seeing. Of course, such fantasy refunctioning makes hash of Lacan, and on Brecht's side, anamorphic anxiety pales before the "sensuous delight" in the "historical sense" that he hoped to inculcate.[25] And yet this very desire for a new alignment of seeing and feeling—sensuous pleasure

in historical cognition—caused his friend Walter Benjamin to attempt to refunction catharsis for Brecht.

In "What is Epic Theater?" Benjamin linked Brecht's "gestural" gestic moment to his own concept of "dialectics at a standstill." The "astonishment" it produces, should "be inserted into the Aristotelian formula . . . should be considered entirely as a capacity. It can be learned."[26] This reference to a capacity that can be learned points in at least two directions. On the one hand, to Brecht's *Lehrstüke* from the late 1920s, his plays designed for workers' assembly halls and for students in Marxist schools, not for formal production before spectators. In the learning plays, performers learn by doing, exchanging solo and choral roles—a praxis "grounded in a dialectic of lived theory and thought behavior."[27] On the other hand, a capacity that "can be learned" suggests that it was once known, like the capacity for mimesis—that which, according to Benjamin, we had as children, and that mystics and other so-called primitives retain: the capacity to experience sensuous similarities and correspondences despite our reification in an administered world.[28] For Benjamin, Brecht's "quotable gestures" interrupt the flow of performance, "damning the stream . . . [making] life spurt up high from the bed of time and, for an instant, hover iridescent in space.[29] Such moments show that epic theater is a theater of recognitions, "though the specific recognitions of actors and audience may well be different from one another."[30] This is of course a crucial point in Brechtian theory, where most of us have stopped. But what if we went on?

According to Benjamin, these moments of recognition and astonishment are not only intellectual but deeply sentient. Nor is this a private titillation, but a way of feeling the otherness of the other. Without sentient knowledge of this otherness, there can be no aesthetic consciousness, or even subjectivity. Let me complete the epigraph by Adorno with which I opened this paper:

> In the final analysis aesthetic behavior might be defined as the ability to be horrified . . . the subject is lifeless except when it is able to shudder in response to the total spell. And only the subject's shudder can transcend that spell. Without

> shudder, consciousness is trapped in reification. Shudder is a kind of premonition
> of subjectivity, a sense of being touched by the other.[31]

The much-vaunted spectator's detachment in Brecht does not con-
tradict this "sense of being touched by the other." In fact, as his later
writings indicate, Brecht saw the A-effect, the *Gestus,* and historiciza-
tion as enabling profoundly pleasurable encounters with alterity ("what
... of our delight [in differences], in distance, in dissimilarity—which
is at the same time a delight in what is close and proper to ourselves?").[32]
The shudder marks the body within its embodiments, estranged but
palpable—a sensorium of dialectical consciousness. If Brecht did not
know how to incorporate this notion into his acting theory, Helene
Weigel did.

There is a much-discussed scene from *Mother Courage,* when Helene
Weigel is forced to identify the corpse of her son, Swiss Cheese, his
death the result of a firing squad because she "bargained too long"
with his executioners. In Brecht's text, Mother Courage refuses, twice,
to identify the corpse. In performance, when the questioners left,
Helene Weigel completed the moment by turning her head with
mouth extended fully and mimed, silently, the cathartic scream her
character could not utter. George Steiner, who witnessed the "silent
scream" at the first Berliner Ensemble production in 1949, compared
it to the screaming horse in Picasso's *Guernica.* He writes:

> The sound that came out was raw and terrible beyond any description that I could
> give of it. But in fact there was no sound. Nothing. The sound was total silence. It
> was silence which screamed and screamed through the whole theatre so that the
> audience lowered its head as before a gust of wind.[33]

Like Agate, Steiner struggles to find metaphors for what was "beyond
... description."[34] In photos of this moment, Weigel's facial contor-
tions, the tension in her chest and back muscles, suggest another text,
Duse's "*faccia convulsiva,*" with its mesmerizing eyes that screamed out
in silence. It's a tempting comparison, but it opens the rather tedious
question of whether Weigel was caving into Dusean psychological

expressivity, and whether the audience's shudder—the involuntary lowering of their heads—was not acknowledgment of the very empathy Brecht tried to forestall.

It is more interesting, I think, to see that famous image not as the transcendence of thought, but as an anamorphic realization of "dialectics at a standstill," in which what cannot be thought—death—becomes the felt other.[35] As in the Holbein painting it is the gaze of the death's head that causes the spectators to, in Lacan's words, lay down their gaze.[36] What we see—the fully extended mouth as aporetic hole—stands for the terror of the unseen in the seen, both the blot in the visual field, and in this case, the Mother's lack—an intolerable sight. Language spreads itself over the indescribable hole—"[we] lowered [our heads] as before a gust of wind," Steiner writes. Weigel might have been pleased by the effect, but in her Brechtian practice she would have wished that wind to be historical, not the apocalyptic blast that blows Benjamin's wide-mouthed angel out of the continuum of history, but the wind and crosscurrents of revolutionary change. A theater historian writes that the idea for the scream came from a newspaper photo Weigel had seen of an Indian woman crying over the murder of her son.[37] Through her mimesis of the other's pain, Weigel blasts out of the Mother Courage context, and gives body to an embodiment of public pain.

PERMANENT CATHARSIS: FINLEY'S TWIST AND SHOUT

I like to do work that deals with hurt. . . .

—Karen Finley[38]

She stands sweating, sometimes weeping, at the end of the performance, arms outstretched like a diva, her near-naked body wrapped in a bedsheet. Her last monologue was explicitly about the willed embodiment of suffering ("I wish I could relieve you of your suffering. I wish I could relieve you of your pain . . . I wish I could relieve you of your death").[39] The audience applauds wildly, approving her

suffering, grateful for the end of her suffering. An Artaudian harpy, she has signaled through the flames at flat-out intensity for well over an hour. Now she is at peace. For the moment. Her arms cross over her breast. She lowers her head, then raises it. She might scream again. She is not ours.

Karen Finley's performances, born in the Reagan years, attempt to reinvent the possibility of catharsis in postmodern culture. Accustomed as we are to media saturation—the constant newspaper coverage of Bosnian women screaming over murdered children—to bodily display that works harder and harder to lure our fantasies, Finley marks and remarks the trauma of social being, of embodiment, by making us traverse her shuddering impure woman's body. In most performances she covers herself with symbolic defilement (chocolate pudding=excrement, alfalfa sprouts=sperm). Her mouth, unusually large, like Weigel's, is more than an organ of speech, it's an orifice that seems infinitely extendible, a necessary passage for the shouting, railing, and trancelike chanting of scenarios that are too shocking to remember fully until, at the end, she wraps her visibly tired body in a shroud and recites the Black Sheep monologue, closing with "silence at the end of the road."[40] Ironically, her performance texts of the late 1980s, which provoked Congressional censorship in 1990 and made her a coast-to-coast, real-life cultural pariah, were gathered under the explicitly cathartic title *We Keep Our Victims Ready.*

There is a context for Finley's work that I can limn only briefly here. When the history of postmodern performance in the United States is written, it should not be neglected that Gerald Else's translation of Aristotle's *Poetics* (1957) and Leon Golden's revisions (1962) removed catharsis from the bodies of spectators and actors to the formal workings of the tragic plot just when our government planned intervention in Vietnam, and when the Living Theater (founded 1951) and the Open Theater (1963) were displacing or eliminating the authority of the text to explore the radical textuality of the actor's body. Performance art of the 1960s, in opposition to conventional theater, sought to free what Herb Blau calls the "polymorphous thinking body" from the "canonical character."[41] Theoretical inspiration

for these early experiments was less Brecht than Artaud, in whose cruel theater "an immediate and physical language" (Artaud's words) would penetrate its spectators, "act . . . upon [them] like a spiritual therapeutics." Artaudian cruelty is a theater of "total spectacle" intended to destroy barriers between "analytic theater and plastic world, mind and body"—a theater composed of and addressed to the "entire organism."[42] For Artaud, the bubonic plagues of Europe provided the best metaphorics for physical, psychical, and cultural transgressions. He identified the body's blistering eruptions with the invasions of brain and lungs, mind and respiration, and these with the frenzy of violent, gratuitous acts—sodomy with corpses for example—of a panicked population. From such gratuitousness, Artaud says, from such acts without use or profit, from such total expenditure, a theater of cruelty is born.

If Finley's explicit protest against racism, sexism, and homophobia connect her to the feminist performance work of Robbie MacCauley, Split Britches, and Anna Deavere Smith,[43] her particular acts of total expenditure bring her close to Kristeva's concept of abjection and *le vréel*, the true-real.[44] The latter refers to the psychotic's foreclosure of the Law that Kristeva hears in the words of modernist poets like Artaud. To take the signifier for the real is to make the signifier the body; this means that there is no space for the signified, for representation. The true-real is the refusal of embodiment, of discourse, of separation. Lacking subjectivity, the "I" knows only the abject, that which "draws me toward the place where meaning collapses."[45] The body tries to discharge the abject, but "I experience a gagging sensation and, still farther down a gagging in the stomach; it's not good enough to expel food so I expel *myself*, I spit *myself* out. . . ."[46] Aggressively accepting the link in Western metaphysics between the female body and nature, matter, substance, Finley piles on defilement, deflecting voyeurism into disgust. There is no way out of the abject body except through death, and death, for Finley, is patriarchy's gift to women.

But of course: what Finley smears on herself is pudding, not shit. Because this is true performance, not true psychosis, there is still, as

Toril Moi puts it, some space for the signified, but as nearly as possible, as *mimetically* as possible, Finley seems to open herself to the torture of the true-real, the body riven by the signifier. "Such a practice," Kristeva says, "cannot be carried out with impunity."[47] "I want my body," screams Finley, "but it's never been mine," her head lowering in symbolic testimony to the suffering she performs.[48] This is a mimesis of anamorphosis at its most cruel: the subject seized in the spectacle of the world with no means of masking—of objectifying—its subjection. Both victim of and enraged witness to a variety of cultural oppressions, Finley works to immerse us in her immersion. Though at some point the performance will end, what is suggested is shuddering without end: permanent catharsis.[49]

Finley's gaping mouth is most evident when she screams the pronoun "I"—as in one of my favorite lines, "I was not intended to be talented."[50] Here the material enunciation of subjectivity is simultaneously affirmed and cancelled by the passive construction of the sentence. Body mobilized and annihilated by discourse. There is, however, a more disturbing, more revealing instance of her gaping mouth that is fixed permanently in my memory. In a small, hot theater on the Lower East Side, Finley was completing an exhausting performance. She walked over to the side of the stage near where I was sitting to begin the "Black Sheep Monologue," a mourning incantation about a friend she lost to AIDS. Suddenly someone at the back of the room opened the door and a wide shaft of light cut through the blackness. Finley's mouth opened in horror. She yelled, "Shut the door!"

EPILOGUE

I don't want an angry political funeral. I just want you to burn me in the street and eat my flesh.

—Jon M. Greenberg

Recently I went to a memorial event for a man who died of AIDS. This man had been a member of New York ACT UP (AIDS Coalition

to Unleash Power), a group that has over the years perfected a unique style of performative politics.[51] I knew him through his best friend, now a close friend of mine, whom I met when I regularly attended ACT UP meetings in 1990. We gathered in a dirt park at First and Houston. A beat-up van arrived with his coffin, and six male friends hoisted it out. Someone started beating a drum. We moved onto First Avenue, stopping late Friday afternoon traffic, then turned right on Seventh Street toward Tompkins Square Park, seventy or so people following and walking with the raised coffin. We passed a nice cafe on a gentrified corner of Seventh where some well-dressed foreigners, their coffee cups suspended in disbelief, watched as the coffin passed.

At the park, the man's friends opened the lid. He was Jon Greenberg. He had started TAP, Treatment Alternatives Program, and inspired many who were desperate about government apathy. His writings were distributed. He had had the idea that AIDS, the viral assault on the body's immune system, had to be refunctioned to mean "aggressive acceptance," a way of embracing the other and, in so doing, of taking responsibility for one's own physical and spiritual health. "The virus is breaking down my defenses," he wrote, "so I can learn how to live in harmony, in unity with the other."

One by one his friends spoke before the open coffin. They looked in, touched him, kissed him, spoke to him lovingly. From where I was sitting, I could see the shut eyes of his face as his friends loaned him, their memory of him, a kind of subjectivity.

A volleyball game started behind us. Then some young boys who'd been running through the park stopped on the periphery. I saw them inch closer to the edge of the coffin. They looked in. My friend who was standing vigil by the casket made an involuntary movement toward them. She wanted them to leave but was afraid to disturb the speakers. I understood why my friend wanted to turn aside their curious gaze, but for the first time that afternoon I felt something like relief.

NOTES

1. T.W. Adorno, *Aesthetic Theory,* trans. C. Lenhardt, ed. Gretal Adorno and Rolf Tiedemann (London and New York, 1984), p. 455.

2. Jacques Lacan, "Anamorphosis," in *The Four Fundamental Concepts of Psychoanalysis,* trans. Alan Sheridan, ed. Jacques-Alain Miller (New York, 1981), pp. 80ff. All references are to this edition, and will appear in parentheses in the text. (The French original reads: "*Je me vois me voir*" and "*Je me chauffe à me chauffer.*" "I warm myself *in* warming myself" might be a better translation of the latter, as it would eliminate the sense of sequential action implied in "I warm myself *by* warming myself"— the translator's choice.)

3. Gerald F. Else, *Aristotle's Poetics: The Argument* (Leiden, 1957), p. 407.

4. Julia Kristeva, *Powers of Horror: An Essay on Abjection,* trans. Leon S. Roudiez (New York, 1982), p. 28. Kristeva argues that Aristotelian catharsis works by his "contributing an *external* rule, a poetic one, which fills the gap, inherited from Plato, between body and soul"; moreover, rhythm and song are purifiers, in that they protect the subject from the abject "by dint of being immersed in it. The abject, mimed through sound and meaning, is *repeated* [since] [g]etting rid of it is out of the question." She comes to the stunning conclusion that "Aristotle seems to say that there is a discourse of sex and that it is not a discourse of knowledge—it is the only possible catharsis" (pp. 28–29).

5. Martha C. Nussbaum, *The Fragility of Goodness: Luck and Ethics in Greek Tragedy and Philosophy* (Cambridge, 1986), p. 7.

6. Francis Sparshott, "The Riddle of *Katharsis,*" in *Centre and Labyrinth: Essays in Honour of Northrop Frye,* ed. Eleanor Cook, Chaviva Hosek, Jay Macpherson, Patricia Parker, and Julian Patrick (Toronto, 1983), p. 25.

7. Nussbaum, p. 389.

8. Nussbaum, p. 390.

9. See especially Luce Irigaray's "Plato's Hystera" in which the mother's body is both ground and object of representation (*Speculum of the Other Woman,* trans. Gillian C. Gill [Ithaca, 1985], pp. 243–364) and Adrienne Rich, "Notes toward a Politics of Location," in *Blood, Bread, and Poetry: Selected Prose* (New York, 1986), pp. 210–231. See also Judith Butler's work on the performativity of gender, sexuality, and politics in *Gender Trouble: Feminism and the Subversion of Identity* (New York, 1990), and her worrying the knot of materiality and language in "The Lesbian Phallus and the Morphological Imaginary," *differences* 4:1 (Spring 1992), pp. 142ff.

10. See Constance Penley's elucidation of these Lacanian concepts in *The Future of an Illusion: Film, Feminism, and Psychoanalysis* (Minneapolis, 1989), pp. 3–28.

11. Ned Lukacher, "Anamorphic Stuff: Shakespeare, Catharsis, Lacan," *South Atlantic Quarterly* 88:4 (Fall 1989), p. 876.

12. Lukacher, pp. 869–870.

13. See especially Antonin Artaud, *The Theater and Its Double* (New York, 1958), Jerzy Grotowski, *Towards a Poor Theatre,* trans. T. K. Wiewiorowski (New York, 1969), Richard Schechner, *Essays on Performance Theory* (New York, 1977).

14. Twentieth-century practices based on the body as a source of knowledge would have to include Stanislavsky's "affective memory"; Meyerhold's "biomechanics"; Brecht's epic theater training; Artaud's "affective athleticism." In the 1960s and 1970s, groups like the Living Theater, the Open Theater, the Performance Group, the Omaha Magic Theater, and many others too numerous to mention developed their own version of "psychophysical" exercises designed to explore the creative potential of the performer's body. Theater work as political intervention owes much to Brecht and to Augusto Boal (*Theater of the Oppressed*), but long-established groups like the San Francisco Mime Troupe, Teatro Campesino, and El Teatro de La Esperanza (1970s–present), whose productions are developed from and for their local communities, have their own complex histories.

15. Luigi Rasi, on seeing Zola's *Thérèse Raquin* in 1879, cited in Susan Bassnett, "Eleanora Duse," in John Stokes, Michael Booth, and Susan Bassnett, *Bernhardt, Terry, Duse: The Actress in Her Time* (Cambridge, 1988), p. 135.

16. William Archer, *The Old Drama and the New* (Boston, 1923), p. 280.

17. See my "Realism and Hysteria: Toward a Feminist Mimesis," *Discourse* 13:1 (Fall–Winter 1990–1991), pp. 59ff.

18. Janet Lyon, "Militant Discourse, Strange Bedfellows: Suffragettes and Vorticists Before the War," *differences* 4:2 (Summer 1992), pp. 100–133.

19. Bernays wrote that, between the first edition of his work on catharsis (1857) and the second (1878), "no less than 70 works were published in Germany on the topic. After the second edition, 80 more works were published on the topic." Bernays, as quoted in Adnan K. Abdulla, *Catharsis in Literature* (Bloomington, 1985), p. 134 n2.

20. See Stokes, Booth, and Bassnett, pp. 141–142.

21. See Monique David-Menard, *Hysteria from Freud to Lacan,* trans. Catherine Porter (Ithaca, 1989), pp. 1–16.

22. Stokes, Booth, and Bassnett, p. 137.

23. Stokes, Booth, and Bassnett, p. 168.

24. Bertolt Brecht, *Brecht on Theatre,* trans. and ed. John Willett (New York, 1964), p. 87.

25. Brecht, p. 276.

26. Benjamin, quoting Brecht; see Walter Benjamin, *Understanding Brecht* (London, 1973), p. 13.

27. Andreas Huyssen's phrase in *After the Great Divide: Modernism, Mass Culture, Postmodernism* (Bloomington, 1986), p. 83.

28. See Benjamin's "On the Mimetic Faculty," in *Reflections: Essays, Aphorisms, Autobiographical Writings,* trans. Edmund Jephcott (New York, 1986).

29. Benjamin, *Understanding Brecht,* p. 13.

30. Benjamin, *Understanding Brecht,* p. 25.

31. Benjamin's use of mimesis had the sense of transformative translation, the subject bringing to life "the inner logic" of the mute object. For Adorno and Horkheimer, in *The Dialectic of Enlightenment,* mimesis is what is left after the suppression of primitive magic; in Susan Buck-Morss's words, what survives "as a principle of artistic representation." See Buck-Morss, *The Origin of Negative Dialectics* (New York, 1977), pp. 87–88. See also Michael Taussig's elaborations of Benjaminian mimesis in *Mimesis and Alterity* (New York, 1993), pp. 1–43ff.

32. Brecht, p. 276.

33. George Steiner, *The Death of Tragedy* (New York, 1963), p. 354.

34. Steiner, p. 354.

35. See Kimberly Benston's meditation on this image in "Being There: Performance as Mise-en-Scène, Abscene, Obscene and Other Scene," *PMLA* 107: 3 (May 1992), pp. 443–444.

36. According to Lacan, the viewer lays down her gaze because the painter (perhaps the actor—Lacan raises but avoids the theater analogy) has given her eye something to feed on. Here Weigel's anamorphic art effects the opposite: the eye/I is subsumed in the experience of "feeling seeing."

37. Cited in Eugenio Barba and Nicola Savarese, *A Dictionary of Theatre Anthropology* (London, 1991), pp. 234–235.

38. Cited in Andrea Juno & V. Vale, *Angry Women* (San Francisco, 1991), p. 44.

39. Karen Finley, *Shock Treatment* (San Francisco, 1990), p. 144.

40. Finley's trancelike affect during sections of the performance has been frequently noted; her face goes blank, her voice drops, becomes rhythmic, preacherly. Her response: "I do go into somewhat of a trance when I perform because I want it to be different than acting . . . I'm really interested in being a medium. . . . I put myself into a state, for some reason it's important, so that things come in and out of me, I'm almost like a vehicle." In "Karen Finley: A Constant State of Becoming: Interview by Richard Schechner," *The Drama Review* 2:1 (Spring 1988), p. 154.

41. Herbert Blau, *Blooded Thought: Occasions of Theater* (New York, 1982), p. 30. In the 1960s and 1970s, the performer's body worked to critique presence and decenter subjectivity. Consider Chris Burden's "body art" in the early 1970s, in which he directed a friend to shoot him in the arm with a .22-caliber rifle (*Shoot* 1971), and

crawled through glass (*Through the Night Softly* 1973). During these years he also had himself crucified on a Volkswagen, and announced a performance in which he said he would disappear, and after publicizing his intention, actually vanished. (See Henry M. Sayre, *The Object of Performance: The American Avant-Garde since 1970* [Chicago, 1989], pp. 101–102; and Blau, *Blooded Thought,* p. 69). In the 1970s, feminist performance art by Valie Export, Judy Chicago, Eleanor Antin, Linda Montano, Martha Rosler, and Carolee Schneeman, among others, produced various critiques of the aesthetic dematerialization of the woman's body in order to disturb the viewer's rationalizing, fetishizing gaze. As dangerous as Burden's body work and more political, Austrian Valie Export's performances of the 1970s used live batteries, dead birds, manacles, and video to explore "the sensations of the body when it loses its identity, when the ego gnaws its way through the scraps of skin, when steel casings straighten the joints . . ." (*Austria: Biennale di Venezia 1980: Valie Export* [Vienna, 1980], p. 13). The rigorous deconstructions of Export, Rosler, and Antin contrast sharply with the radical feminist idealism of Carolee Schneeman in her aptly named *Eye Body* (1963), which sought to convert nudity into "a primal, archaic force" (Sayre, p. 96). In her well-known *Interior Scroll* (1975), she undressed, painted her body in large strokes, unrolled a text from her vagina and read it. A decade later, Finley's work is no less body-centered, but Schneemann's exuberance has become Finley's abjection.

42. Artaud, pp. 85–100.

43. In the postmodern vein of the 1980s, these very different performers resignify the body within highly self-conscious discursive and performative frames—storytelling, parody, collage—as a means of exploring desire, sexual and racial identity, community, and political struggle. Finley is the only one of this group for whom the nude body has been, consistently, a central signifying element. For a discussion of Finley's body-abjection in cultural politics, see Lynda Hart, "Karen Finley's Dirty Work: Censorship, Homophobia, and the NEA," *Genders* 14 (Fall 1992), pp. 1–15.

44. See Julia Kristeva, "The True-Real," in *The Kristeva Reader,* ed. Toril Moi (New York, 1986), pp. 216–237.

45. Kristeva, *Powers of Horror,* p. 2.

46. Kristeva, *Powers of Horror,* p. 3.

47. Kristeva, "The True-Real," p. 236.

48. Karen Finley, *Shock Treatment,* p. 113.

49. Interestingly, the shudder of Finley's catharsis comes *after* performance: "After I perform I have to vomit, my whole body shakes, I have to be picked up and sat down. It takes me about an hour before I stop shaking" (Schechner, p. 154).

50. Schechner, p. 107.

51. For an important discussion of ACT UP–style activism in relation to the ceaseless condition of mourning in which the gay and lesbian community finds itself, see Douglas Crimp's "Mourning and Militancy," *October* 51 (Winter 1989), pp. 3–18. It is my hope that this section of the essay will be read as a footnote to the complex recognition Crimp urges at the close of his essay.

CINDY PATTON

<div style="text-align:right">8</div>

On SUNDAY, March 7, 1993, controversial AIDS-beat journalist Gina Kolata reported on the National Research Council's newly published report, "The Social Impact of AIDS." It appeared that the Reagan-Bush silence was over, and that the Clinton administration would wake up to the necessity of producing prevention material and programs, even if these might be offensive to those outside the communities in which they had been developed. But veteran AIDS activists, who had for a decade chafed under government unwillingness to support meaningful, normatively effective safe-sex organizing within communities, were skeptical: the "experts" apparent "discovery" of the value of "messages whose language and imagery were intended for specific neighborhoods" (26) was outrageously late.[2]

Underneath the tentative convergence of "community organizing" and

PERFORMATIVITY AND SPATIAL DISTINCTION

THE END OF

AIDS EPIDEMIOLOGY

With AIDS now entrenched in many American cities, some experts are reaching a startling and controversial conclusion. They say the epidemic in the United States can be all but stamped out, even without a vaccine or wonder drug, by prevention efforts that zero in on 25 or 30 hard-hit neighborhoods across the nation.[1]

"targeting" lies a massive discursive refiguration of the epidemic. But the shift Kolata describes, from "anyone can get AIDS" to a proposed ground-zero approach to prevention, substitutes for the inaction of vagueness an active campaign which would only ever arrive after seroprevalence rates were so high that prevention could only mean containment within spaces marked out for destruction. Kolata's opulent revisualization of HIV (and more subtly, of homosexuals and drug

users) from a macroscop*ing* blanket "spread throughout the nation" (1) (we are everywhere) to a microscop*ic* patchwork of hotspots, "clustered in two of nine [New York City] ZIP codes" (26) (they are there), obscures the larger dispute between scientific theories of the epidemic: epidemiology versus tropical medicine. The enabling moment of this account of a shift in perspective, a shift that is immediately linked to plans to "stamp AIDS out" (1), is Kolata's premise that the debate stems, not from long competing social scientific frameworks, but from a breakthrough—a new, more effective technique for producing HIV epidemiology: "The new view of the disease's pattern of spread emerged from a recent analysis by a committee of the National Research Council that suggests AIDS is devastating a handful of neighborhoods while leaving most of the nation relatively unscathed" (1). She acknowledges, however, that "others disagree" with this view:

> The AIDS epidemic "is very rapidly spreading throughout smaller and smaller communities each year," said Dr. June E. Osborn, chairwoman of the National Commission on AIDS. "AIDS sustains itself awfully well. As soon as the virus is present, as it now is everywhere, risk-taking behavior becomes significant." (26)

The critical shift Kolata enacts has everything to do with misunderstanding Osborn. In Osborn's account, risk is contingent on viral presence, a drifting territorialization of already existing behavior by an agent which now traces its course through dispersing spaces of "smaller and smaller communities." This is the epidemiologic mind at its clearest, marking spaces through describable trajectories of a disease phenomenon, performatively reinventing the meaning of quotidian acts by placing them in a model of transmissibility. The only lack of clarity is the linkage of space and time, which creates the paradox Osborn is describing, where once-innocent or completely unnoticed acts are redescribed as "risk-taking behavior" only because a transmissible agent may now take advantage of—inscribe the very trajectory of—an already existing, but not "significant" conduit. This description, which Kolata reduces to the losing side in a disagreement, highlights the performative aspect of epidemiology which the

heteronormative culture finds so troubling: situating risk as a form of transient presence in a chain of transmission breaks down the line between "homosexual" and "heterosexual behavior," destroying both the idea that homosexual behavior can be considered risky regardless of the presence of opportunistic microbes, and the presumption that heteronormative practices are by definition safe.[3]

Kolata's insertion of the epidemiologic perspective is designed principally to fulfill the obligations of journalistic objectivity; the bulk of her account sides with the "wide variety of experts from a variety of disciplines [who are] urging a tighter focus" (1). But the debate she is describing is less about the "pattern" of "spread" than it is about *which* policy framework should be privileged in explaining the proliferation of HIV during the Reagan-Bush decade of official nonresponse. The presentational surface of the "debate" as one among scientists elides the work of community activists who have toiled for a decade in the face of inaction, and transforms the resistant communities formed and protected by prevention organizing into the "targets" of a "new" government-sponsored, heat-seeking-missile-like, HIV prevention program. Critical to this shift is a refiguration of the relation between bodies and space, concepts that rely on more complex notions of space and movement already embedded within two principle policy discourses which underwrite very different ideas of the "solution" to disease.

THE SUBJECT OF THE OTHER

Making sense of this discursive shift and understanding its ramifications for activism requires reevaluating a theoretical move which has come to occupy a central place in work on AIDS discourse and practices. I want to augment important and excellent work on the relations of power and knowledge in the discourses and institutions administering the epidemic by reintroducing a notion of space linked to movement. In particular, I will suggest that detailed work on the modes of constituting the Other in AIDS discourses and policies has obscured or left untheorized concepts of movement and of spatial interrelation which are equally critical in AIDS discourse, not only at the global level, in terms of international

border restrictions and travel policy, but also at the most proximate level,
in terms of embodiment of transmission and its interruption. I propose
these revisions, not out of an idle interest in theory-tuning, but in an
effort to better understand how local organizing interventions collide
with or may be aided by larger institutional and discursive formations.
I will return eventually to Gina Kolata's account of the dispute sur-
rounding the National Research Council report of February 1993, but
first I will describe why I think the subject-centered account of Othering,
though important in signalling relations of power between central and
marginalized groups, misses a critical dimension of the systems which
underwrite medical policing.

KNOWING THE SELF: THE INSIDIOUS SUBJECT

One of the most cogent social science accounts of the construction
of the self-other dyad and its relation to historical and contempora-
neous containment strategies in the context of HIV education is Ronald
Frankenberg's article, "The Other Who is Also the Same: The
Relevance of Epidemics in Space and Time for Prevention of HIV
Infection."[4] While this work signals the temporal and spatial dimen-
sions of epidemics, it ultimately grounds these in concerns about
boundary maintenance by creating a distinction between what are
called "self" and "other." I want to argue that this move returns us to
a model of knowledge/power reliant—at a minimum, by analogy—
on a transcendent subject akin to the one poststructuralism has so
opulently critiqued, and at the cost of misrecognizing the role of "fig-
ural" and "literal" movement in the constitution of policing procedures
and bodies' evasion of them.[5]

While Frankenberg largely abandons structuralist and psychoan-
alytic accounts of "self," the "subject" which he obliquely retains
obscures the mobility of bodies and the mechanisms through which
discourse and policy about epidemics constitute the body through
its location, re-, dis-, trans-, and mis-location prior to the inscription
of coherent notions of self-other. In short, the insistence on the
primacy of Othering fails to recognize that the body is often already

"in place" before it becomes self or other, and that, in fact, these *plac-ings* are often constitutive of those bodies' first legibility. This is not an argument for a prediscursive body, but for a body *placed* extradis-cursively, prior to its inscriptions *through* or legibility *in* discourse. The constitution of self-other in interpreting evidence of epidemics may sometimes underwrite subsequent moves in biomedical and policy dis-courses. This performative gesture is not intrinsic to managing disease, although it may be characteristic of epidemiologic modes of consti-tuting the bodies of and within illness. I will show in a moment that tropical medicine is able to articulate bodies and illness in a mode that is not performative.

Frankenberg traces attempts to cordon off an "other who is also the same," and argues that, "The control of epidemics points up with special saliency those aspects of power in society and culture that are centered on the control of the other's space and time."[6] Rereading other influential accounts of epidemics, he lushly details the modes through which premodern and modern authorities use spatial desig-nations—quarantine, ghettoization—to control disease and the other at the same time. By eliding movement in the attempt to trace out regimes for separating self and other, the critic must performatively constitute the very objects which are in the next moment viewed as empirically discoverable—the critic constitutes a group of subjects who effect the othering. For example, Frankenberg argues that

> A ruling class or group seeks to control, and often succeeds in controlling, who is defined as other and who is recognized as same. It is, however, never a totally external other, which could have no social or cultural relevance. Nor has it usual-ly, if ever, been a new other but an old one put to new uses. The relevant boundary membranes in the body politic like those in the body personal are both internal and semipermeable.[7]

But the conclusion that the central same is ultimately incapable of con-stituting and externalizing its Other, because boundaries are "semipermeable," is more symptomatic of the failure of the self-other model than it is an account of the failed workings of a hegemony. By

hypostatizing subject-like positionalities, the important question is lost: how do bodies move through these fenestrations and to what effect? The "other" is apparently capable of transcending a "boundary" without crossing space, without passing outside (boundaries are always "internal"). While it may be descriptively powerful to invoke a membrane always apparently letting on to itself, this metaphor does not seem to yield useful suggestions for helping bodies-in-resistance to define a line of flight from the codifying power of the core against which they have been nominated "other."

While discursive regimes which rely on constitutions of self and other clearly underwrite a wide range of practices of epidemic management, as Frankenberg's rereading of McNeill, Ziegler, Brandt, and Cipolla clearly shows, the sudden reversion to a virtually transdiscursive category of other (the perpetual "old one put to new uses") just barely falls short of reintroducing the subject of humanistic Marxism as the agent ("ruling class") of same-other codification practices.[8] Frankenberg is anxious that the "other" of a particular regime may be constituted through discourses that the critic ought to be able to unravel in their intrinsic politicalness. But while he offers the caveat that "the emergence of a *single,* so to speak, focal, *other,* in association with each specific epidemic may be an artifact of historical documentation and/or the historians' craft,"[9] it seems equally problematic to claim that even a "focal" other operates singly.

I have made a different argument, but with a similar subject-reinstating effect, though it displaced power from a class and onto a codifying structure. In the "queer paradigm" which I have invoked in many essays since my first statement of this principle in 1985, I have suggested that AIDS discourse contains maneuvers to recuperate nonqueers into the central paradigm linking queerness and AIDS.[10] Instead of recognizing the fragmenting effects of the movement of already constituted subjects called by other names into the space marked "homosexual," and now effaced by conscription with race, nationality, and so on, I described a system of substitutions and disseminations as if the "queer paradigm" were only a palimpsest from which the traces of the original queer could always still be read.

I constructed a discursively ordered self-other model, Frankenberg read off coherent class interests; neither of us fully considered how displacements of bodies or categories affected the grip of the controlling forces, or resistance to them. Frankenberg argues, rightly, that the famous "four Hs" of early AIDS epidemiology are "others" in relation to a range of constitutive centers of claim to "self,"[11] and I have tried to distinguish the regimes of control centering on gender, race, and age which also frame the specific forces which impinge on the various nominal queers. Though Frankenberg and I employ importantly different critical perspectives, our respective attempts to acknowledge the similarity of oppressions faced by those subject to containment strategies, while at the same time arguing for the specificity of individual life cases, now seem to me to be inadequate: our common problem was that we failed to demonstrate how (or even whether) the several centers which constitute the various "Others" of AIDS discourse aggregate into something like a ruling class or a grounding discursive formation.

We have, I now believe, pressed too hard on the homophobic core, or at least understood the constitution of a "self" through reverse-discourse in too unified a manner, a manner that insists too strongly on the bipolar structure of subject-constitution that is required within the self-other model. Surely these figural "Others" must operate quite differently in different regimes, sometimes simply in relation to a unifiable "Self" (whether individual or writ larger as class or nation), but in other cases as the multiply other "Other" in relation to many competing or autonomous sites of knowledge claims. The "homosexual" of AIDS discourse, while palpably still the central figure, is a different "other" from "heterosexual," "hemophiliac," or "woman," not to mention from "doctor," "nation," or "African." If it is relatively easy, through concepts like stigma, to correlate a range of marginalized others in similarly antipodal positions to the idea of a codifying center ("self" writ large), this does not mean they are in the same *place*, subjected to the same discursive and institutional tyrannies. And it is extremely hazardous to assume that the range of "selfs" which multiple notions of "other" inflect are, in fact, constitutive of a single, dominating system. It becomes

difficult to see that space and time and the fate of those without the capacity to make specific, protective claims on their institutions are all linked through the idea of movement, if only because the body impinged upon may wish to save itself through flight.

While self-other nominating procedures are clearly deployed in health policy, they are specific to particular registers of discourse. The discursive maneuver captured under the critic's rubric of "Othering" is too frequently assumed to be similar to or even taken up by "individuals" as a characterization of their own position in discursive and institutional regimes. While something like "identification" may mimic a discursive practice of diacritical constitution, maintaining the homology between discursive and institutional procedures of codification and individual practices of placement, rather than describing the specificities of their coincidence, would seem to return us to the integrative accounts of individual psychology, a move which requires some justification in the wake of poststructural and postmodern critiques.

Accounts which ground institutional containment strategies in this discursive moment of self-other seem to presume an unproblematized individual practice of psychological differentiation. This homological argument begs the reverse account, in which the individual (or subject—they collapse again in this procedure) is presumed to take up her or his position in relation to these discourses of self-other, implicitly reinscribing poststructuralism's supposedly fragmented subject as, in fact, a reservoir for the discourse writ small. This argument makes sense only as long as everyone stays in "their place": when bodies move between or are relocated through discourse, or carry discourses with them into foreign terrains, the work of self-other codes is fractured, transformed, or completely disappears. Reintroducing movement means that neither the individual interpretant, nor the critic, policy-maker, or social scientist doing work in relation to her or him, may any longer require coherence in the place of that body. The move away from notions of individual psychology to subject positions was critical not only intellectually, but practically for those developing community organizing and transmission-halting strategies in the context of the HIV epidemic. But this work has to go further in allowing for, protecting, and speaking to

the tattered space of the body moving in, defining, and being defined through its inscription in and of space. Overemphasis on self-other in the absence of the critical reintroduction of ideas of movement keeps returning to the tyranny of the subject, what he or she may know and suffer. What is needed is a map or a trajectory for evading the effects of discourses which insist on the primacy of epistemological rather than, for example, proprioceptive, access to the body. Put rather crudely, we must escape the scene in which the doctor reviews the patient's T-cell count instead of asking her how her body feels. Put more polemically, we must unseat a system in which AZT is evaluated based on monthly differences in mortality rates, and instead consider the somatic experience of those subject to its toxic side effects. This requires a critique of the battles between warring medical discourses as well as their modes of constituting (and engendering the resistance of) bodies.

PERFORMATIVITY: ACTANTS AND THEIR "SOCIAL"

New work in queer and gender theories on performance and performativity emerged importantly in response to a critique of essentialized identity and debates about the end of identity politics.[12] Given this particular entrance of performance theory, but especially speech-act theory, into a highly political domain, there has been, I believe, an overemphasis on the actant-subject and a relative lack of consideration of the stage or context or field of the performance or performative act. There have been highly developed poststructural and postmodern accounts of these bodies-in-performance or their performative acts, but little in the way of poststructural and postmodern efforts to reintroduce concepts for what was once called the "social."[13]

This has resulted in two problems: first, the presumption that the "social," in which identities are made performatively visible, operates according to the description of modernist social science, or according to the modernist narratives of the movements themselves. For example, critics of identity seem to presume that those who assert identity believe in their identity in the ways that the critics disdain. So far, there is no evidence that claimants to identity actually believe those

identities to be "essential": at least in my own experience, claimants offer a variety of conflicting accounts for the events which critics pre-sume to be utterly transparent moments of misrecognized construction. If people do not believe in their identities in the ways we have sug-gested, then queer theorists (including myself) are merely critiquing our own attachments to identity, a therapeutic practice of importance and consequence, but not a radical intervention in political organizing.

But second, by looking primarily at the actant's performance, or its performative effect, such theory has dismissed or bracketed the role of institutions and discourses, not as the "cause" or "context" of per-formance, but as another actant in the performative scene. It may seem anthropomorphic when I describe epidemiology as performative, but I mean quite seriously that discourses are not necessarily distinct from or in any sense prior to other actants.

Clearly, the space of hypostatization of performances (the post-modern social?) needs to be more fully theorized. While it has become common to rely on speech-act theory and critical reception to it as the jumping off point for theorizing performativity, I want to start from a place more recognizably within social theory. I will say more later about ways to constitute space in nonidealist terms, but I want to say why it seems useful at this point to view performance and performativity as distinct, if sometimes indirectly related, forms of contestation entail-ing different relations of actants to space. One of these forms, which de Certeau calls tactics, but which may as easily be called performance, involves deployment of signs which have already attained meaning and/or standard usage within the legitimated discourse and crystallized practices of a "social," understood as a place of contestation.[14] They are not constitutive of the actants, although their irregular usage has the effect of defacing the "social," in which the signs appear in regular rela-tions, and may so deface them that they are decapitalized and lose their status as markers of power. This is performance; it is not a direct engage-ment of homologous actants, but rather the activity of freelancing agents (what are popularly called "fragmented subjects") who occasionally attain visibility as a trace or a defacement of the "social." They do not appear as actants as such, because they have no homologous actant to

engage in a mutually constitutive moment which makes an actant visible against the larger field of power. Performance operates through timing and repartee, and is not recognizable except as defacement within the space-oriented, capital-oriented domain of the proper: "What it wins it cannot keep."[15] The little victories of tacticians do not count as wins in the proper's game of accumulation.

I will characterize tropical medicine's discourse as a performance reliant upon stable signs (the marks of coloniality, with their geography of race[16] presupposed by the certainty about the centrality of Europe), which it reinscribes but does not own. This suggests that, compared to epidemiology, tropical medicine, as a performance on an already secure colonialist terrain, is less labile, less subject to intervention by resistant forces. By contrast, I will describe epidemiology as *performative,* as an actant within a place in which the constitution and reproduction of citational chains is constitutive of power. As problematic as our engagement with epidemiology has been, it has permitted us an entrance into the legitimated discourses, which has provided us a partial platform from which to launch a series of direct assaults. Clearly, distinguishing between performance and performativity, at least in the way I am attempting to here, now requires a theorization of the place and process of forming and disrupting power relations, an activity useful to the decisions of both ASOs (AIDS Service Organizations) and ACT UP (AIDS Coalition to Unleash Power). It is no longer sufficient to look at the performance itself, or the inscription of a group within the legitimate channels of public health administration: it is critical now to observe the role of and space created by actants on the order of epidemiology and tropical medicine.

TROPICAL MEDICINE AND EPIDEMIOLOGY:
COMPETING COLONIALISMS

Many of the concepts in what in the West are called tropical medicine and epidemiology developed as crucial parts of nineteenth- and early twentieth-century colonial expansion, and are both generated in and generative of ideas of movement and space. Tropical medicine,

obviously, from its very name, dealt with the problems Euro-Americans encountered in their local occupations, reflecting both the reality and the fantasy of the colony. As Bruno Latour has shown, the displacement of the scientific laboratory from the academy to the field was crucial to the "discovery" of etiologic agents, not only because it produced the isolationary research conditions for finally establishing germ theory and the technology of vaccination, but also because it provided the colonial imaginary with a series of metonymically linked spaces of colonization: the colony of scientists in the client-state colony studying the colony of germs on the surface of the agar plate.[17] These cemented a homological turn of mind which could justify colonial power as an extension of the emerging modern will-to-control through positive science.

Tropical medicine wedded imperial notions of health and geography to bourgeois notions of the domestic as a space within a space (the public). Donna Haraway has examined notions of immunity in epistemologic terms as a system of recognition of self and other.[18] I want to suggest that immunity is equally legible in spatial terms, as an issue of domestic *placement* and proximity. For tropical medicine, "natural immunity"—the capacity to live in proximity to germs, to be the domestic partner of germs—is the property of the colonized. Colonial inhabitation produced the fantasy of acquiring not only the land and its people, but immunity, and in advance: immunization provides the means of colonial occupation. Because disease is always inside the domestic space, that is, endemic to the colony, the fantasy of acquired immunity, a sort of miscegenation by medical means, sustains the hierarchical difference between the colonized, immune body and the paternal, colonizing body, which is, ironically, subject to disease: the colonized body can, thereby, live in close proximity with, in fact share in the immunity of, the body which is naturally close to disease. The notion of domesticity, combined with the idea of a natural but fixed space of disease, propelled tropical medicine toward an immunization model for coping with disease in the colonizer, and later, promoted border policing to insure that tropical disease did not enter Europe.

Movement is bidirectional along a single axis; incursion into the constructed domestic space of the colony is always accompanied by

nostalgia for "going home": the diasporal imaginary of displacement and return. Critically, both the sick European body and the body of the researcher/physician are subject to diasporal movement, but from opposite directions. The sick colonist might "go home" or the physician might go to the colony to study a disease or treat afflicted European bodies. They might sometimes Europeanize the natives by treating them "there" for "endemic" diseases to which the European was not subject (now often called the "disease[s] of poverty"), or for imported "civilized" diseases. The Euro-American generals might even enact their fantasies of genocide by unleashing germs which would decimate the natives. Later they might even claim a major victory for world health by eradicating from the Third World the very smallpox they had imported. Indeed, part of the plan to eradicate the disease they had imported was to require smallpox immunization stamps as a condition for obtaining entry visas into Euro-American countries, which reconstituted smallpox as endemic to the tropics, an import gone native. Smallpox vaccination now marked the civilized: the scar left behind had dual meaning, marking the body prepared to admit itself to the master culture, and the body protecting itself against the return of those who had survived the colonial occupation.

Tropical medicine was based in the idea that local diseases did not affect indigenous people in the same way that they affected the Euro-American occupier. A tropical disease is always proper to a place, to a *there,* but only operates *as disease* when it afflicts people from *here.* Pathogens in a locale achieve historicity only when consolidated as disease in the colonist's body. The colonist's ailing body is heroic, not the victim of his or her dislocation, but the most intimate site of domesticating the tropics. Tropical disease is contained by virtue of already being *there,* in the "tropics": even if he (*sic*) could not always get well, the colonist could always go home. Critically, the very idea of tropical medicine rests on the ability to reliably separate an indigenous population, perceived to be physically hearty but biologically inferior, from a colonizing population, believed to be biologically superior even while subject to the tropical illnesses. Tropical medicine thus grows out of and supports the idea that a First World body is the proper gauge of

health: the Third World is the location of disease, even while its occu-
pants are not properly the subjects of tropical medicine. But this
distinction is not one made through performatively reestablishing the
identity of bodies, but through a distinction already secured through
the placement of bodies, or rather, the hypostatic *situation* of the trop-
ical body and the diasporal placement of the colonists' body. Sustaining
this bimorphic, binomial space is accomplished by perpetually refilling
the category, "exotic ailment." Only Europeans are subjects, and not in
relation to disease, but in relation to a prior presumption about "being
from here." Tropical medicine, then, is ostensive, a *pointing* which pre-
supposes a map and a hierarchy of bodily placement.

Epidemiology, on the other hand, is performative: by separating
pathogens from the body, epidemiology enables itself to declare "dis-
ease" from some but not all conjunctures of body/pathogen.
Epidemiology operates from an apparently simple definition: an epi-
demic is more cases than expected. Declaring an epidemic depends on
an expectation: in its perpetual movement, pathology becomes visible
against a background state of health. These migratory sites of pathol-
ogy can at any time be linked. This framework requires a vectoral
imagination, since movement is always outward from the center. Each
new locale becomes a new center capable of projecting its vectoral
links to yet more periphery, which in turn become new centers. In
this sense, vectors are multidirectional: it makes no sense to speak of
return. Bodies are at once subject to and perpetrators of pathology,
both "sick" and reservoirs or carriers, linkages in and not distinct from
the larger network of disease. Epidemiology is thus less concerned
with detailing the diseases which may befall the European body in a
place, as it is with visualizing the place of the body in the temporal
sequence called "epidemic" and represented by a graph. It is no longer
the body fighting disease which is heroic, but epidemiology, the "dis-
ease detective," which alone has the power to visualize and disrupt the
"natural history" of germs' vectoral movement.

While in theory any body could be a vector, epidemiology "dis-
covered" that only some bodies actually connected the hot spots of
disease. If tropical medicine already and always knew where disease

was and who could fall sick, epidemiology had to describe both the space of disease (descriptive mode) and indicate the bodies most likely to carry (transport/harbor) disease (predictive mode). Bereft of a stable *place* of pathology, epidemiology must constantly construct and correlate populations and subpopulations in order to make epidemics visible, hence the interest in technologies of "surveillance" (descriptive) and of "sentinel studies" (predictive).

The background definition of health becomes the ideologic linchpin which makes possible the panopticon of epidemiology, a visualizing practice which invented not only the vectors and subjects of disease, but situated itself at the center of the optimal place from which to observe the disease phenomenon. Because the performatively constituted subjects and disease were always different (different risk groups for different diseases), the panoptic center perpetually shifted, destabilizing both the concept of disease and the security of guarding oneself against it. If the colonial homology could mask the medical crimes of transporting disease *to* the colony, epidemiology could hide the crimes of class-tiered health care delivery, not through the speech-act of naming disease, but in constituting the background definition of health in relation to the concerns of the middle class. Epidemics would be noticed only if and when they threatened the middle class, and later, as with polio in the 1950s, when they were proper to the middle class. Epidemiology reverses tropical medicine's concern with who may fall sick by removing disease from the natural environment and placing it in the body. Instead of viewing tropical inhabitants as more or less immune to the diseases which surround them, *indigene* are now themselves the location of disease, reservoirs, carriers; poverty is no longer "natural" but an assault on the middle classes.

Epidemiology defines the boundaries of a disease by constituting a category of subject ("risk group"), an imagined community produced through vectors which epidemiology simulates as though discovered. Disease may radiate out from a place—an epicenter—but is not proper to it. An epicenter is unstable and uncontained by definition: epidemic disease must be confined and policed. Thus, epidemiology seeks eradication of disease, either through proliferating cures or through

eliminating vectors, that is, through isolating the disease and vectoral bodies from healthy bodies. History means the possible destruction of natural history, the supplanting of the disease's history with a history of the healthy body. This entails a very different notion of the domestic: rather than being a space of delicate coexistence, the domestic is inarticulate space where disease has not penetrated, the space to be protected by doing work in the "public" space of disease. The first line of defense is to seal off the disease within the afflicted body, to cure it, or at least to prevent its migration outside that body (hence, epidemiology's tendency to understand curative drugs and condoms as a means of containment, of keeping HIV in the infected cell or infected body, rather than highlighting their "positive" capacity of keeping HIV out of the uninfected cell or body). Thus, the infected site—cell or body—is the object of scrutiny, the "public" space whose policing is presumed to keep disease from going elsewhere. Only in the absence of these possibilities is the second line of defense invoked, cordoning off the actual bodies affected. This is when epidemiology converges again with tropical medicine, where it risks collapsing the space of disease and the space of the body. But there is still a difference between the two: because epidemiology is concerned with containing vectoral movement, in order to prevent vectors from simply going ballistic, there is no "other place" where, in principle, the body can retreat to. Prevention—the hypostatization of space under the regime of epidemiology—is always a matter of blocking the vectors between the groups that were performatively created by epidemiology's reading of the trajectory of the germ.

THE WORK OF SPACE

If the spatial dynamics of formations are privileged, we can make sense of the debate in the media account with which I began. Instead of viewing the author and her audience as merely confused, we can see the kind of work going on in the article as an attempt to bring popular conceptions of the epidemic in line with an attempt to create colonies of disease populated by wholly distinct individuals. This is a shift from what I believe is a fundamentally epidemiologic understand-

ing of the HIV epidemic, which seeks to understand *who* a body is, to one which is fundamentally related to notions of place—to *where* a body is, a set of ideas closer to those of tropical medical discourse.

The article—and many similar mass media, policy, and medical accounts—operates within something like a hyperspace version of the child's board game, Chutes and Ladders. It is not that they do not rely on the tropes of self and other at all, as Frankenberg has described,[19] but that they attempt to recodify the *place* of affected bodies, less through constituting them as now or newly other, but through constituting their *location* as synonymous with disease, which is understood to be already contained.

Like Baudrillard's admonition to "forget Foucault" because he can only retrospectively describe what has already passed, the bodies-in-resistance might cry out to forget epidemiology, which will only produce its knowledge when it is too late. But it is critical to understand that the hypostatization of space which marks the outer edge of epidemiology's performative capacity, perhaps its failure, becomes something quite different when the tropical ostensive returns, not to produce its other, but to reiterate the spatial logic which was never fully replaced in the graphically spectacular vectoral display of epidemiology. This alternative, powerful, and fatal description obscures the pragmatics of transmission and its interruption, not by confusing practices and identities, but by asserting that both are already confined to a place. If epidemiology's risk groups produced flawed policy by making it possible for those evading prevention messages to say "I'm not one of *those,*" the tropical model allows for an equally disastrous disavowal with the idea that "I don't live/go there," which not only disrupts the address of prevention, but also once again domesticates and isolates those who are living with HIV, people who have fought for a decade for their own right to public voice. The tropical model removes epidemiology's ambivalence about quarantine: prevention becomes a matter of local containment, rather than a matter of dispersing knowledge about safe sex and safe needle use. It encourages a sense of safety through securing a fantasy of emplacement, rather than encouraging development of a personal philosophy of prevention.[20]

Kolata's article graphically registers this shift in perspective:

The council said the epidemic was "settling into spacially and socially isolated groups and possibly becoming endemic in them." As a result, the committee wrote, "many geographic areas and strata of the population are virtually untouched by the epidemic and probably never will be," while "certain confined areas and populations have been devastated." (I)

Undeniably, a weak notion of self-other is present here, but the juxtaposition of "the population" and "populations," open "geographic areas and strata" versus "confined areas" of "destruction," stakes its self-assurance in ostensive, spatial terms, not performatively self-producing ones. Transmission is differential in relation to a density of space:

"[I]f you are going to have sexual transmission outside of infected communities, you need a fairly high rate of contact." The disease can and does break out of the tight communities where it festers, but it cannot sustain itself there, [Dr. Albert Jonsen, an ethics professor at the University of Washington and the chairman of the National Research Council's committee] said. (26)

"Community" is transformed here from a positive term meant to cover an affiliative grouping seeking legibility in order to make claims for civil rights and their protection on the state and its medical apparatus; community becomes instead a colony. Gay men are not so much other in relation to a self which nominates them, as they are simply self-identical to a space which is already set apart. Unlike the codifying impulse of epidemiology, which names in order to break the chain of vectoral movement, infected gay men are already contained by virtue of being tied to a space, the very space of their domestic legibility under capitalism, their ZIP codes: "Within those neighborhoods, the researchers said, H.I.V. [sic] infections clustered in two of nine ZIP codes. Gay men who were not part of this community were not infected" (26). Similarly, though apparently situated in no *particular* place, drug users are rendered not other but already contained by virtue of their very hypoactivity; though not legible, they do not move out of their space:

> The second epidemic in New York involved drug users and their sex partners. There, too, the infections were spread within small local networks of people. Dr. Lindenbaum [CUNY anthropologist on the committee] and Dr. Gagnon [SUNY-Stonybrook sociologist on the committee] wrote that intravenous drug users and their sex partners appeared "to be a relatively immobile population." (26)

Rather than recognizing the "community," which has not only reconstituted itself through prevention organizing, but has been the very site of the epidemic's greatest publicity, another medical expert is recruited to Kolata's scheme to reduce resistant queer culture to a colony, a space to which the scientists and policy-makers ("we") may go, and from which they may return triumphant, but unaffected: "'If we want to really deal with the epidemic, we have to go where the epidemic is,' said Dr. Brandt, a member of the National Research Council's committee" (26).

But what will they do when they get there? That depends on how well activists are able to recognize and resist or capitalize on the securing of space by the emerging tropical discourse. It is urgent to rethink the terrain on which activism occurs, determining whether and how micropractices of resistance can operate in a new land where space, instead of medical discourse, secures identities.

De Certeau provides an opening when he rereads Clausewitz against the overly rigid grid of power described by Foucault: "Power is bound by its very visibility" and "trickery is possible for the weak."[21] Neither ignoring the devastating possibilities of struggles for power as classically exercised, nor romanticizing the possibilities of little tricks, de Certeau retheorizes the "social"—what he punningly calls "*le propre*"—as the field in which both forms of practice may be legible, although through radically different modes of inscription, or rather, through both inscription and defacement.[22] But most critically, he demands a sharper evaluation of the proper in order to understand what it "sees," what falls beneath its sightlines.

De Certeau develops Derrida's point that there is a margin in which practices can occur that evade the "proper" as it delimits the forms of resistance which may occur in its sightlines.[23] Following Clausewitz, he

observes that strategies constitute a field of greater and lesser power in order to establish a hold in the proper, but forms of deception—tactics—have another sort of power precisely because they are, as it were, below the firing line of the proper. Thus, instead of proposing the superiority of strategies over tactics for, say, the "AIDS movement"—a plausible reading of arguments between various gay-community-based AIDS service organizations and ACT UP—it might make more sense to view each as engaging in forms of power which are sometimes linked through the common project of provoking a response from or through existing mechanisms for policy, care delivery, treatment, research, education, and so on.[24] The point of contestation between these two forces which sometimes are, or some think should be, allies, is less an issue of whether strategies of massing symbolic (credibility), economic, or governmental capital (staging claims through accepted political discourses, like minority rights, antidiscrimination based in handicaps, and so on) are better than disrupting the conduct of science and policy through street theater or through underground antiviral drug networks, but rather, how each form of engaging power constructs a hypostatized actant (the person living with AIDS, the ASO), while at the same time deconstructing the "proper" of public health policy and discourse. The critically undertheorized aspect of political interventions into the now massive and multiple fields of AIDS policy, research, activism, representation, and so on, is the space in which such actions occur: understanding the place of various strategies, tactics, and the actants they produce and which deploy them requires us to say more about the "context" or "stage" of performance/performativity.

But what seems most dangerous now is the shifting logic of the proper itself: the proper against which both ASOs and ACT UP instituted their strategies and tactics was framed by epidemiology and its homologs, the bodies visualized as "risk groups" or "targets of education." These mutually constitutive agents operate strategically in a field comprised of public health practices and bodily practices. Contestation occurs in and through epidemiology's (historical) disciplinary practices, bodies' appropriation of those discursive and extradiscursive practices, and epidemiology's appropriation of the bodies' terms and practices.

Because it is performative and unstable, epidemiology needs the bodies that resist it in order to constitute itself again, that is, in order to declare an epidemic for it to administer. Tropical medicine now threatens to secure the space of the proper with definitional pairs formed outside its own discourse and practices, drawing its agents from ZIP-coded spaces of dead bodies. There will no longer be any issue of risk groups to fight over, no need to debate the complexities of sexual practice versus identity. Tropical medicine operates through definitions secured elsewhere, refusing any dialogue with the bodies whose health it administers.

Responses to the epidemic have been produced during a period in which epidemiology was not so much an opponent as an alternate actant. Not only are the particular form and meaning of the bodies now discursively indicated contingent on the mutual constitution of "people at risk" and epidemiology, but the activisms engendered have affectivity only so long as those homologous features are present. If, for example, tropical medical discourse supersedes epidemiology, not only will epidemiology recede, but the homologous characters (gay men, people living with AIDS) will lose their ability to gain any power through strategic use of their names. Put bluntly, epidemiology can only manage categories it can scientifically produce, but tropical medicine can administer categories already in place through another discourse. If we disliked the necessity, under the performative logic of epidemiology, of responding from the position of "risk group," then we will find our placement as the already-discounted-native one from which it is even more difficult to engender forms of resistance. While epidemiology and bodies are mutually constitutive, virtually interdependent despite huge power differences, tropical medicine does not need bodies at all: potentially dangerous bodies are always and already somewhere else; border patrols—in the form of always-too-late education—will be seen as a sufficient response.

For a decade, AIDS activists have battled against epidemiology's misnomination of "risk groups." While the National Research Council report nods toward the "culturally sensitive" programs we have long sought, it does so for the wrong reasons. It does not accept June Osborn's description of an epidemic mismanaged and allowed to go "every-

where" because policy-makers could not bring themselves to let communities speak for and to themselves. The report promotes "targeting" out of a contention that the epidemic has largely stayed in one place, and cordons off the virus and the community ideologically constructed in relation to it by stabilizing the mistaken line that divides those who should from those who need not attend to the *techné* of safer sex and needle hygiene. While we take full advantage of the window of opportunity that this shift toward local specificity may afford in terms of funding, we must also arm ourselves for battle against a new, equally problematic discursive regime which uses locality to isolate instead of educate.

Thanks to the following people who provided excellent comments on early drafts or presentations of this material: Eve Kosofsky Sedgwick, Andrew Parker, Michèle Barale, Lisa Duggan, Benigno Sánchez-Eppler, Barbie Zelizer, Michael Shapiro, Jennifer Terry, and Jackie Urla.

NOTES

1. Gina Kolata, "Targeting Urged in Attack on AIDS," *New York Times* (March 7, 1993), p. 1. Further references will appear in parentheses after the citation.

2. I want to make clear at the outset that I am analyzing Kolata's construction of a story and her use of various kinds of "experts" as markers for larger positions and ideas in policy discourse. Indeed, I can imagine that many of the people cited in this particular article were horrified at the role they are made to play as characters in a dispute. I know personally several of those who are quoted by Kolata and, based on my knowledge of those individuals' longtime commitments and activities in policy debate, I believe that their quotations are so radically decontextualized as to render them nearly opposite the position the speakers might actually have taken.

3. For a further discussion of the modes through which other media and policy discourse on the epidemic attempts to defeat epidemiology's assault on heteronormativity, see my "Queer Peregrinations: Science and Travel," forthcoming in *Queer Diasporas: Sexualities on the Move,* ed. Cindy Patton and Benigno Sánchez (Durham, 1995). Here I describe the construction of homosexuality as, sometimes, a tropic space that bisexual men visit, while retaining heterosexuality as the figural "home."

4. Ronald Frankenberg, "The Other Who is Also the Same: The Relevance of

Epidemics in Space and Time for Prevention of HIV Infection," *International Journal of Health Services* 22 (1992), pp. 73–88.

5. Movement, the critical but inarticulate third term in the space-time nexus, is largely absent from theoretical consideration because it is difficult to render in the still-subject-centered model of self-other. In arguing here that the abstract logics of epidemiologic and of tropical medical discourse contain fundamentally contending notions of place and movement, one operating performatively to constitute the bodies subject to it, the other operating ostensively to deploy already secure markers of place and body, I am echoing, but will not specifically detail here, the recent work in "postmodern geography" which rethinks space against a perceived modernist tyranny of time. Edward Soja reviews this trend in his *Postmodern Geographies: The Reassertion of Space in Critical Social Theory* (London, 1989). See also Gilles Deleuze's reconsideration of Bergson's theory of time and the crucial role of movement in it, *Cinema 1: The Movement-Image* (Minneapolis, 1986), and *Bergsonism* (New York, 1992).

6. Frankenberg, p. 74.

7. Frankenberg, p. 74.

8. Frankenberg, p. 74.

9. Frankenberg, p. 74.

10. See especially my "Heterosexual AIDS Panic: A Queer Paradigm," *Gay Community News*, February 9, 1985. Although I continued to invoke this idea, I seem to have recognized its limits by the late 1980s, especially as I began to work internationally and to write about colonialism and AIDS. Even here, though, *colonial* otherings allowed me to revert to this self-other/margin-center metaphor. "The Gendered Geo-Politics of Space," in my *Last Served? Gendering the HIV Pandemic* (London, 1994), offers the most sustained analysis of AIDS research (on migration) which resists the othering maneuver.

11. Frankenberg, p. 74.

12. See, for example, Judith Butler, *Gender Trouble: Feminism and the Subversion of Identity* (New York, 1990) and Diana Fuss, *Essentially Speaking: Feminism, Nature and Difference* (New York, 1990).

13. For an excellent example of new social theory in queer theory, see Michael Warner, ed., *Fear of a Queer Planet* (Minneapolis, 1993).

14. Michel de Certeau, *The Practice of Everyday Life,* trans. Stephen F. Rendall (Berkeley, 1988).

15. de Certeau, p. 37.

16. Race is a crucial and shifting component in the incoherent field of AIDS policy. The United States identified "Haitians" as a "risk group" at the same time (around 1983) that Belgian and French researchers enumerated "Africans" in Europe as a "risk group." Under protest that the designation of "Haitians" was racist, the

Centers for Disease Control withdrew the category. Western Europeans never dropped "Africans" and indeed, by the late 1980s, the United States blood donor applications and some safe sex advice included among those at risk "people from Central Africa." The United States could not make an epidemiologic argument based on race or nationality, but the more tropical medically oriented French and Belgian policy systems could. In addition, as I have argued elsewhere, racial designations in the United States had to be reimported through the creation of an analogy of the urban ghetto with the specious category "African AIDS," a geographic designation promoted by the World Health Organization, itself underwritten by tropical medical epistemic structure. See my "Inventing African AIDS," in *Inventing AIDS* (New York, 1990), pp. 77–97, and "From Nation to Family: Containing 'African AIDS,'" in Andrew Parker *et al.*, ed., *Nationalisms and Sexualities* (New York, 1992), pp. 218–234.

The conflicting discourses of race as they appear and disappear between epidemiology and tropical medicine in the United States have weighed most tragically on the bodies of black women: statistically overrepresented in epidemiologic accounts—in effect, an epidemic within an epidemic and, thus, worthy of intensified prevention, care, and research—but also a long-standing signifier of difference which is easily mobilized in a discourse of blame, black women are in the position of being simultaneously unrepresented and overdetermined. Thus the media has only charted, and not promoted intervention into, the rapid dissemination of HIV among black women precisely because U.S. policy cannot deploy resources for effective prevention and health maintenance programs for black women.

17. Bruno Latour, *The Pasteurization of France* (Cambridge, 1988).

18. Donna Haraway, "The Biopolitics of Postmodern Bodies: Constitutions of Self in Immune System Discourse," *Simians, Cyborgs, and Women: The Reinvention of Nature* (New York, 1991), pp. 203–230.

19. Frankenberg, p. 74.

20. I thank Alex Juhasz and her student coproducers at Swarthmore College for the idea of a safe sex philosophy, a move toward planning and evaluating how to pursue one's sexuality before, or in the absence of, initiating sexual practices.

21. de Certeau, p. 37.

22. de Certeau, p. xix.

23. Jacques Derrida, *Positions,* trans. Alan Bass (Chicago, 1981).

24. See my *Inventing AIDS*, especially pp. 5–49 and 121–132.

JUDITH BUTLER

9

BURNING
ACTS
INJURIOUS
SPEECH

THE TITLE OF J. L. Austin's *How to Do Things with Words* poses the question of performativity as what it means to say that "things might be done with words." The problem of performativity is thus immediately bound up with a question of transitivity. What does it mean for a word not only to name, but also in some sense to perform and, in particular, to perform what it names? On the one hand, it may seem that the word—for the moment we do not know which word or which kind of word—enacts what it names; where the "what" of "what it names" remains distinct from the name itself and the performance of that "what." After all, Austin's title questions how to do things *with* words, suggesting that words are instrumentalized in getting things done. Austin, of course, distinguishes between illocutionary and perlocutionary acts of speech, between actions that are performed by virtue of words, and those that are performed as a consequence of words. The distinction is tricky, and not always stable. According to the perlocutionary view, words are instrumental to the accomplishment of actions, but they are not themselves the actions which they help to accomplish. This form of the performative suggests that the words and the things done are in no sense the same. But according to his view of the illocutionary speech act, the name performs *itself,*

and in the course of that performing becomes a thing done; the pronouncement is the act of speech at the same time that it is the speaking of an act. Of such an act, one cannot reasonably ask for a "referent," since the effect of the act of speech is not to refer beyond itself, but to perform itself, producing a strange enactment of linguistic immanence.

The title of Austin's manual, *How to Do Things With Words*, suggests that there is a perlocutionary kind of doing, a domain of things done, and then an instrumental field of "words," indeed, that there is also a deliberation that precedes that doing, and that the words will be distinct from the things that they do.

But what happens if we read that title with an emphasis on the illocutionary form of speech, asking instead what it might mean for a word "to do" a thing, where the doing is less instrumental than it is transitive. Indeed, what would it mean for a thing to be "done by" a word or, for that matter, for a thing to be "done in by" a word? When and where, in such a case, would such a thing become disentangled from the word by which it is done or done in, and where and when would that conjunction between word and thing appear indissoluble? If a word in this sense might be said to "do" a thing, then it appears that the word not only signifies a thing, but that this signification will also be an enactment of the thing. It seems here that the meaning of a performative act is to be found in this apparent coincidence of signifying and enacting.

And yet, it seems that this "act-like" quality of the performative is itself an achievement of a different order, and that de Man was clearly on to something when he asked whether a trope is not animated at the moment when we claim that language "acts," that language posits itself in a series of distinct acts, and that its primary function might be understood as this kind of periodic acting. Significantly, I think, the common translation of Nietzsche's account of the metaleptic relation between doer and deed rests on a certain confusion about the status of the "deed." For even there, Nietzsche will claim that certain forms of morality require a subject and institute a subject as the consequence of that requirement. This subject will be installed as prior to the deed in order to assign blame and accountability for the painful effects of a

certain action. A being is hurt, and the vocabulary that emerges to moralize that pain is one which isolates a subject as the intentional originator of an injurious deed; Nietzsche understands this, first, as the moralization by which pain and injury are rendered equivalent and, second, as the production of a domain of painful effects suffused with conjectured intention. At such a moment the subject is not only fabricated as the prior and causal origin of a painful effect that is recast as an injury, but the action whose effects are injurious is no longer an action, the continuous present of a doing, but is reduced to a "singular act."

The following citation from *On the Genealogy of Morals* is usually read with an emphasis on the retroactive positing of the doer prior to the deed; but note that simultaneous with this retroactive positing is a moral resolution of a continuous "doing" into a periodic "deed": "there is no 'being' behind doing, effecting, becoming; 'the doer' is merely a fiction added to the deed—the deed is everything." ". . . es gibt kein 'Sein' hinter dem Tun, Wirken, Werden; 'der Täter' ist zum Tun blos hinzugedichtet—das Tun ist alles." In the German, there is no reference to an "act"—*die Tat*—but only to *a doing*, "das Tun," and to the word for a culprit or wrong-doer, "der Tater," which translates merely as a "doer."[2] Here the very terms by which "doing" is retroactively fictionalized (*hinzugedichtet*) as the intentional effect of a "subject," establishes the notion of a "doer" primarily as a wrong-doer. Furthermore, in order to attribute accountability to a subject, an origin of action in that subject is fictively secured. In the place of a "doing" there appears the grammatical and juridical constraint on thought by which a subject is produced first and foremost as the accountable originator of an injurious deed. A moral causality is thus set up between the subject and its act such that both terms are separated off from a more temporally expansive "doing" that appears to be prior and oblivious to these moral requirements.

For Nietzsche, the subject appears only as a consequence of a demand for accountability; a set of painful effects is taken up by a moral framework that seeks to isolate the "cause" of those effects in a singular and intentional agent, a moral framework that operates through a certain economy of paranoid fabrication and efficiency.

The question, then, of who is accountable for a given injury precedes and initiates the subject, and the subject itself is formed through being nominated to inhabit that grammatical and juridical site.

In a sense, for Nietzsche, the subject comes to be only within the requirements of a moral discourse of accountability. The requirements of blame figure the subject as the "cause" of an act. In this sense, there can be no subject without a blameworthy act, and there can be no "act" apart from a discourse of accountability and, according to Nietzsche, without an institution of punishment.

But here it seems that Nietzsche's account of subject-formation in *On the Genealogy of Morals* exposes something of its own impossibility. For if the "subject" is first animated through accusation, conjured as the origin of an injurious action, then it would appear that the accusation has to come *from* an interpellating performative that precedes the subject, one that presupposes the prior operation of an efficacious speaking. Who delivers that formative judgment? If there is an institution of punishment within which the subject is formed, is there not also a figure of the law who performatively sentences the subject into being? Is this not, in some sense, the conjecturing by Nietzsche of a prior and more powerful subject? Nietzsche's own language elides this problem by claiming that the "'der Täter' is zum Tun blos hinzugedichtet." This passive verb formation, "hinzugedichtet," poetically or fictively added on to, appended, or applied, leaves unclear who or what executes this fairly consequential formation.

If, on the occasion of pain, a subject is belatedly attributed to the act as its origin, and the act then attributed to the subject as its effect, this double attribution is confounded by a third, namely, the attribution of an injurious consequence to the subject and its act. In order to establish injurious consequence within the domain of accountability, is it necessary not only to install a subject, but also to establish the singularity and discreteness of the act itself as well as the efficacy of the act to produce injury? If the injury can be traced to a specifiable act, it qualifies as an object of prosecution: it can be brought to court and held accountable. But this tracing of the injury to the act of a subject, and this privileging of the juridical domain as the site to

negotiate social injury, does this not unwittingly stall the analysis of how precisely discourse produces injury by taking the subject and its spoken deed as the proper place of departure? And when it is words that wound, to borrow Richard Delgado's phrase, how are we to understand the relation between the word and the wound? If it is not a causal relation, and not the materialization of an intention, is it perhaps a kind of discursive transitivity that needs to be specified in its historicity and its violence? What is the relation between this transitivity and the power to injure?

In Robert Cover's impressive essay, "Violence and the Word," he elaborates the violence of legal interpretation as "the violence that *judges* deploy as instruments of a modern nation-state."[3] "Judges," he contends, "deal pain and death," "for as the judge interprets, using the concept of punishment, she also acts—through others—to restrain, hurt, render helpless, even kill the prisoner" [note the unfortunate implication of liberal feminism when it decides to legislate the feminine as the universal]. Cover's analysis is relevant to the question of prosecuting hate speech precisely because it underscores the power of the *judiciary* to enact violence through speech. Defenders of hate speech prosecution have had to shift the analysis to acknowledge that agents other than governments and branches of government wield the power to injure through words. Indeed, an analogy is set up between state action and citizen action such that both kinds of actions are understood to have the power to deny rights and liberties protected by the Equal Protection Clause of the Constitution. Consequently, one obstacle to contemporary efforts to legislate against hate speech is that the "state action doctrine" qualifies recourse to the Equal Protection Clause in such instances, presuming as it does that only governments can be the agents of harmful treatment that results in a deprivation of rights and liberties.[4] To argue that citizens can effectively deprive *each other* of such rights and liberties through words that wound requires overcoming the restrictions imposed by the state action doctrine.[5]

Whereas Cover emphasizes the *juridical* power to inflict pain through language, recent jurisprudence has shifted the terms away from the interpretive violence enacted by nation-states and toward

the violence enacted by citizen-subjects toward members of minority groups. In this shift, it is not simply that citizens are said to act like states, but the power of the state is refigured as a power wielded by a citizen-subject. By "suspending" the state action doctrine, proponents of hate speech prosecution may also suspend a critical understanding of state power, relocating that power as the agency and effect of the citizen-subject. Indeed, if hate speech prosecution will be adjudicated by the state, in the form of the judiciary, the state is tacitly figured as a neutral instrument of legal enforcement. Hence, the "suspension" of the state action doctrine may involve both a suspension of critical insight into state power and state violence in Cover's sense, but also a displacement of that power onto the citizen, figured as a kind of sovereign, and the citizenry, figured as sovereigns whose speech now carries a power that operates like state power to deprive other "sovereigns" of fundamental rights and liberties.[6]

In shifting the emphasis from the harm done by the state to the harm done by citizens and non-state institutions against citizens, a reassessment of how power operates in and through discourse is also at work. When the words that wound are not the actions of the nation-state—indeed, when the nation-state and its judiciary are appealed to as the arbiter of such claims made by citizens against one another—how does the analysis of the violence of the word change? Is the violence perpetrated by the courts unwittingly backgrounded in favor of a politics that presumes the fairness and efficacy of the courts in adjudicating matters of hate speech? And to what extent does the potential for state violence become greater to the degree that the state action doctrine is suspended?

The subject as sovereign is presumed in the Austinian account of performativity; the figure for the one who speaks and, in speaking, per-, forms what she/he speaks, is the judge or some other representative of the law. A judge pronounces a sentence and the pronouncement is the act by which the sentence first becomes binding, as long as the judge is a legitimate judge and the conditions of felicity are properly met. The performative in Austin maintains certain commonalities with the Althusserian notion of interpellation, although interpellation is

never quite as "happy" or "effective" as the performative is sometimes figured in Austin. In Althusser, it is the police who hail the trespasser on the street: "Hey you there!" brings the subject into sociality through a life-imbueing reprimand. The doctor who receives the child and pronounces—"It's a girl"—begins that long string of interpellations by which the girl is transitively girled; gender is ritualistically repeated, whereby the repetition occasions both the risk of failure and the congealed effect of sedimentation. Kendall Thomas makes a similar argument that the subject is always "raced," transitively racialized by regulatory agencies from its inception.[7]

If performativity requires a power to effect or enact what one names, then who will be the "one" with such a power, and how will such a power be thought? How might we account for *the injurious word* within such a framework, the word that not only names a social subject, but constructs that subject in the naming, and constructs that subject through a violating interpellation? Is it the power of a "one" to effect such an injury through the wielding of the injurious name, or is that a power accrued through time which is concealed at the moment that a single subject utters its injurious terms? Does the "one" who speaks the term *cite* the term, thereby establishing his or herself as the author while at the same time establishing the derivative status of that authorship? Is a community and history of such speakers not magically invoked at the moment in which that utterance is spoken? And if and when that utterance brings injury, is it the utterance or the utterer who is the cause of the injury, or does that utterance perform its injury through a transitivity that cannot be reduced to a causal or intentional process originating in a singular subject?

Indeed, is iterability or citationality not precisely this: *the operation of that metalepsis by which the subject who "cites" the performative is temporarily produced as the belated and fictive origin of the performative itself*? The subject who utters the socially injurious words is mobilized by that long string of injurious interpellations: the subject achieves a temporary status in the citing of that utterance, in performing itself as the origin of that utterance. That subject-effect, however, is the consequence of that very citation; it is derivative, the effect of a belated metalepsis by

which that invoked legacy of interpellations is dissimulated as the subject as "origin" of its utterance. If the utterance is to be prosecuted, where and when would that prosecution begin, and where and when would it end? Would this not be something like the effort to prosecute a history that, by its very temporality, cannot be called to trial? If the function of the subject as fictive origin is to occlude the genealogy by which that subject is formed, the subject is also installed in order to assume the burden of responsibility for the very history that subject dissimulates; the juridicalization of history, then, is achieved precisely through the search for subjects to prosecute who might be held accountable and, hence, temporarily resolve the problem of a fundamentally unprosecutable history.

This is not to say that subjects ought not to be prosecuted for their injurious speech; I think that there are probably occasions when they should. But what is precisely being prosecuted when the injurious word comes to trial and is it finally or fully prosecutable?

That words wound seems incontestably true, and that hateful, racist, misogynist, homophobic speech should be vehemently countered seems incontrovertibly right. But does understanding from where speech derives its power to wound alter our conception of what it might mean to counter that wounding power? Do we accept the notion that injurious speech is attributable to a singular subject and act? If we accept such a juridical constraint on thought—the grammatical requirements of accountability—as a point of departure, what is lost from the political analysis of injury when the discourse of politics becomes fully reduced to juridical requirements? Indeed, when political discourse is fully collapsed into juridical discourse, the meaning of political opposition runs the risk of being reduced to the act of prosecution.

How is the analysis of the discursive historicity of power unwittingly restricted when the subject is presumed as the point of departure for such an analysis? A clearly theological construction, the postulation of the subject as the causal origin of the performative act is understood to generate that which it names; indeed, this divinely empowered subject is one for whom the name itself is generative.

According to the biblical rendition of the performative, "Let there be light!," it appears that by virtue of *the power of a subject or its will* a phenomenon is named into being. Although the sentence is delivered in the subjunctive, it qualifies as a 'masquerading' performative in the Austinian sense. In a critical reformulation of the performative, Derrida makes clear in relation to Austin that this power is not the function of an originating will but is always derivative:

> Could a performative utterance succeed if its formulation did not repeat a "coded" or iterable utterance, or in other words, if the formula I pronounce in order to open a meeting, launch a ship or a marriage were not identifiable as *conforming* with an iterable model, if it were not then identifiable in some way as a "citation"? . . . [i]n such a typology, the category of intention will not disappear; it will have its place, but from that place it will no longer be able to govern the entire scene and system of utterance [*l'énonciation*].[8]

To what extent does discourse gain the authority to bring about what it names through citing the linguistic conventions of authority, conventions that are themselves legacies of citation? Does a subject appear as the author of its discursive effects to the extent that the citational practice by which he/she is conditioned and mobilized remains unmarked? Indeed, could it be that the production of the subject as originator of his/her effects is precisely a consequence of this dissimulated citationality?

If a performative provisionally succeeds (and I will suggest that "success" is always and only provisional), then it is not because an intention successfully governs the action of speech, but only because that action echoes prior actions, and *accumulates the force of authority through the repetition or citation of a prior and authoritative set of practices*. It is not simply that the speech act takes place *within* a practice, but that the act is itself a ritualized practice. What this means, then, is that a performative "works" to the extent that *it draws on and covers over* the constitutive conventions by which it is mobilized. In this sense, no term or statement can function performatively without the accumulating and dissimulating historicity of force.

When the injurious term injures (and let me make clear that I think it does), it works its injury precisely through the accumulation and dissimulation of its force. The speaker who utters the racial slur is thus citing that slur, making linguistic community with a history of speakers. What this might mean, then, is that precisely the iterability by which a performative enacts its injury establishes a permanent difficulty in locating accountability for that injury in a singular subject and its act.

In two recent cases, the Supreme Court has reconsidered the distinction between protected and unprotected speech in relation to the phenomenon of "hate speech." Are certain forms of invidious speech to be construed as "fighting words," and if so, are they appropriately considered to be a kind of speech unprotected by the First Amendment? In the first case, *R.A.V. v. St. Paul*, 112 S. Ct. 2538, 120 L. Ed. 2d 305 (1992), the ordinance in question was one passed by the St. Paul City Council in 1990, and read in part as follows:

> Whoever places on public or private property a symbol, object, appellation, characterization or graffiti, including, but not limited to, a burning cross or Nazi swastika, which one knows or has reasonable grounds to know arouses anger, alarm, or resentment in others on the basis of race, color, creed, religion or gender commits disorderly conduct and shall be guilty of a misdemeanor.[9]

A white teenager was charged under this ordinance after burning a cross in front of a black family's house. The charge was dismissed by the trial court but reinstated by the Minnesota State Supreme Court; at stake was the question whether the ordinance itself was "substantially overbroad and impermissably content based." The defense contended that the burning of the cross in front of the black family's house was to be construed as an example of protected speech. The State Supreme Court overturned the decision of the trial court, arguing first that the burning of the cross could not be construed as

protected speech because it constituted "fighting words" as defined in
Chaplinsky v. New Hampshire, 315 U.S. 568, 572 (1942), and second,
that the reach of the ordinance was permissible considering the "com-
pelling government interest in protecting the community against
bias-motivated threats to public safety and order." *In Re Welfare of
R.A.V.*, 464 N.W.2d 507, 510 (Minn. 1991).

The United States Supreme Court reversed the State Supreme
Court decision, reasoning first that the burning cross was not an
instance of "fighting words," but an instance of a "viewpoint" with-
in the "free marketplace of ideas" and that such "viewpoints" are
categorically protected by the First Amendment.[10] The majority on
the High Court (Scalia, Rehnquist, Kennedy, Souter, Thomas) then
offered a *second* reason for declaring the ordinance unconstitutional,
a judicially activist contribution which took many jurists by surprise:
the justices severely restricted the doctrinal scope of "fighting words"
by claiming it unconstitutional to impose prohibitions on speech
solely on the basis of the "content" or "subjects addressed" in that
speech. In order to determine whether words are fighting words, there
can be no decisive recourse to the content and the subject matter of
what is said.

One conclusion on which the justices appear to concur is that the
ordinance imposed overbroad restrictions on speech, given that forms
of speech *not* considered to fall within the parameters of fighting words
would nonetheless be banned by the ordinance. But while the
Minnesota ordinance proved too broad for all the justices, Scalia,
Thomas, Rehnquist, Kennedy, and Souter took the opportunity of this
review to severely restrict any future application of the fighting words
doctrine. At stake in the majority opinion is not only when and where
"speech" constitutes some component of an injurious act such that it
loses its protected status under the First Amendment, but what con-
stitutes the domain of "speech" itself.

According to a rhetorical reading of this decision—distinguished
from a reading that follows established conventions of legal interpre-
tation—the court might be understood as asserting its state-sanctioned
linguistic power to determine what will and will not count as "speech"

and, in the process, enacting a potentially injurious form of juridical speech. What follows, then, is a reading which considers not only the account that the court gives of how and when speech becomes injurious, but considers as well the injurious potential of the account itself as "speech" considered in a broad sense. Recalling Cover's claim that legal decisions can engage the nexus of language and violence, consider that the adjudication of what will and will not count as protected speech will itself be a kind of speech, one which implicates the state in the very problem of discursive power that it is vested within the authority to regulate, sanction, and restrict such speech.

In the following, then, I will read the "speech" in which the decision is articulated against the version of "speech" officially circumscribed as protected content in the decision. The point of this kind of reading is not only to expose a contradictory set of rhetorical strategies at work in the decision, but to consider the power of that discursive domain which not only produces what will and will not count as "speech," but which regulates the political field of contestation through the tactical manipulation of that very distinction. Furthermore, I want to argue that the very reasons that account for the injuriousness of such acts, construed as speech in a broad sense, are precisely what render difficult the prosecution of such acts. Lastly, I want to suggest that the court's speech carries with it its *own* violence, and that the very institution that is invested with the authority to adjudicate the problem of hate speech recirculates and redirects that hatred in and as its own highly consequential speech, often by coopting the very language that it seeks to adjudicate.

The majority opinion, written by Scalia, begins with the construction of the act, the burning of the cross; and one question at issue is whether or not this act constitutes an injury, whether it can be construed as "fighting words" or whether it communicates a content which is, for better or worse, protected by first amendment precedents. The figure of burning will be repeated throughout the opinion, first in the context in which the burning cross is construed as the free expression of a viewpoint within the marketplace of ideas, and second, in the example of the burning of the flag, which could

be held illegal were it to violate an ordinance prohibiting outside fires, but which could not be held to be illegal if it were the expression of an idea. Later Scalia will close the argument through recourse to yet another fire: "Let there be no mistake about our belief that burning a cross in someone's front yard is reprehensible." "But," Scalia continues, "St. Paul has sufficient means at its disposal to prevent such behavior without adding the First Amendment to the fire." *R.A.V. v St. Paul*, 112 S. Ct. at 2550, 120 L. Ed. 2d at 326.

Significantly, Scalia here aligns the act of cross-burning with those who defend the ordinance, since both are producing fires, but whereas the cross-burner's fire is constitutionally protected speech, the ordinance maker's language is figured as the incineration of free speech. The analogy suggests that the ordinance itself is a kind of cross-burning, and Scalia then draws on the very destructive implications of cross-burning to underscore his point that the ordinance itself is destructive. The figure thus affirms the destructiveness of the cross-burning that the decision itself effectively denies, the destructiveness of the act that it has just elevated to the status of protected verbal currency within the marketplace of ideas.

The Court thus transposes the place of the ordinance and the place of the cross-burning, but also figures the First Amendment in an analogous relation to the black family and its home which in the course of the writing has become reduced to "someone's front yard." The stripping of blackness and family from the figure of the complainant is significant, for it refuses the dimension of social power that constructs the so-called speaker and the addressee of the speech act in question, the burning cross. And it refuses as well the racist history of the convention of cross-burning by the Ku Klux Klan which marked, targeted, and, hence, portended a further violence against a given addressee. Scalia thus figures himself as quenching the fire which the ordinance has lit, and which is being stoked with the First Amendment, apparently in its totality. Indeed, compared with the admittedly "reprehensible" act of burning a cross in "someone's" front yard, the ordinance itself appears to conflagrate in much greater dimensions, threatening to burn the book which it is Scalia's duty to uphold; Scalia

thus champions himself as an opponent of those who would set the constitution on fire, cross-burners of a more dangerous order.[11]

The lawyers arguing for the legality of the ordinance based their appeal on the fighting words doctrine. This doctrine, formulated in *Chaplinsky v. New Hampshire*, 315 U.S. 568, 572 (1942), argued that speech acts unprotected by the constitution are those which are not essential to the communication of ideas: "such utterances are no essential part of any exposition of ideas, and are of such slight social value as a step to truth that any benefit that may be derived from them is clearly outweighed by the social interest in order and morality." Scalia takes this phrasing to legitimate the following claim: "the unprotected features of the words are, despite their verbal character, essentially a 'nonspeech' element of communication." *R.A.V. v. St. Paul*, 112 S. Ct. at 2545, 120 L. Ed. 2d at 319. In his effort to protect all contents of communication from proscription, Scalia establishes a distinction between the content and the vehicle of that expression; it is the latter which is proscribable, and, the former which is not: he continues, "Fighting words are thus analogous to a noisy sound truck." *Id.* What is injurious, then, is the sound, but not the message; indeed, "the government may not regulate use based on hostility—or favoritism—towards the underlying message expressed." *Id.*

The connection between the signifying power of the burning cross and Scalia's regressive new critical distinction between what is and is not a speech element in communication is nowhere marked in the text.[12] Scalia assumes that the burning cross is a message, an expression of a viewpoint, a discussion of a "subject" or "content"; in short, that the act of burning the cross is fully and exhaustively translatable into a *constative* act of speech; the burning of the cross which is, after all, on the black family's lawn, is thus made strictly analogous—and morally equivalent—to an individual speaking in public on whether or not there ought to be a 50 cent tax on gasoline. Significantly, Scalia does not tell us what the cross would say if the cross could speak, but he does insist that what the burning cross is doing is expressing a viewpoint, discoursing on a content which is, admittedly, controversial, but for that very reason, ought not to be proscribed. Thus the defense of

cross-burning as free speech rests on an unarticulated analogy between that act and a public constation. This speech is not a doing, an action or an injury, even as it is the enunciation of a set of "contents" that might offend.[13] The injury is thus construed as one that is registered at the level of sensibility, which is to say that it is an offense that is one of the risks of free speech.

That the cross burns and thus constitutes an incendiary destruction is not considered as a sign of the intention to reproduce that incendiary destruction at the site of the house or the family; the historical correlation between cross-burning and marking a community, a family, or an individual for further violence is also ignored. How much of that burning is translatable into a declarative or constative proposition? And how would one know exactly what constative claim is being made by the burning cross? If the cross is the expression of a viewpoint, is it a declaration as in, "I am of the opinion that black people ought not to live in this neighborhood" or even, "I am of the opinion that violence ought to be perpetrated against black people," or is it a perlocutionary performative as in imperatives and commands which take the form of "Burn!" or "Die!"? Is it an injunction that works its power metonymically not only in the sense that the fire recalls prior burnings which have served to mark black people as targets for violence, but also in the sense that the fire is understood to be transferable from the cross to the target that is marked by the cross? The relation between cross-burning and torchings of both persons and properties is historically established. Hence, from this perspective, the burning cross assumes the status of a direct address and a *threat* and, as such, is construed either as the incipient moment of injurious action *or* as the statement of an intention to injure.[14]

Although Justice Stevens agreed with the decision to strike down the Minnesota ordinance, he takes the occasion to rebuke Scalia for restricting the fighting words doctrine. Stevens reviews special cases in which conduct may be prohibited by special rules. Note in the following quotation how the cross burning is nowhere mentioned, but the displacements of the figure of fire appear in a series of examples which effectively transfer the need for protection *from racist speech*, to

the need for protection *from public protest against racism*. Even within Steven's defense of proscribing conduct, a phantasmatic figure of a menacing riot emerges:

> Lighting a fire near an ammunition dump or a gasoline storage tank is especially dangerous; such behavior may be punished more severely than burning trash in a vacant lot. Threatening someone because of her race or religious beliefs may cause particularly severe trauma or touch off a riot, and threatening a high public official may cause substantial social disruption; such threats may be punished more severely than threats against someone based on, say, his support of a particular athletic team. *R.A.V. v. St. Paul*, 112 S. Ct. at 2561, 120 L. Ed. 2d at 340.

Absent from the list of fires above is the burning of the cross in question. In the place of that prior scene, we are asked first to imagine someone who would light a fire near a gas tank, and then to imagine a more innocuous fire in a vacant lot. But with the vacant lot, we enter the metaphor of poverty and property, which appears to effect the unstated transition to the matter of blackness[15] introduced by the next line, "threatening someone because of her race or religious beliefs . . .": *because* of her race is not the same as "on the basis of" her race and leaves open the possibility that the race causally induces the threat. The threat appears to shift mid-sentence as Stevens continues to elaborate a second causality: this threat "may cause particularly severe trauma or touch off a riot" at which point it is no longer clear whether the threat which warrants the prohibition on conduct refers to the "threatening someone because of her race or religious belief" or to the riot that might result therefrom. What immediately follows suggests that the limitations on rioters has suddenly become more urgent to authorize than the limitation on those who would threaten this "her" "because of her race . . ." After "or touch off a riot," the sentence continues, "and threatening a high official may cause substantial social disruption . . . ," as if the racially marked trauma had already led to a riot and an attack on high officials.

 This sudden implication of the justices themselves might be construed as a paranoid inversion of the original cross-burning narrative.

That original narrative is nowhere mentioned, but its elements have been redistributed throughout the examples; the fire which was the original "threat" against the black family is relocated first as a incendiary move against industry, then as a location in a vacant lot, and then reappears tacitly in the riot which now appears to follow from the trauma and threaten public officials. The fire which initially constituted the threat against the black family becomes metaphorically transfigured as the threat that blacks in trauma now wield against high officials. And though Stevens is on record as endorsing a construction of "fighting words" that would include cross-burning as *un*protected speech, the language in which he articulates this view deflects the question to that of the state's right to circumscribe conduct to protect itself against a racially motivated riot.[16]

The circumscription of content explicitly discussed in the decision appears to emerge through a production of semantic excess in and through the metonymic chain of anxious figuration. The separability of content from sound, for instance, or of content from context, is exemplified and illustrated through figures which signify in excess of the thesis which they are meant to support. Indeed, to the extent that, in the Scalia analysis, "content" is circumscribed and purified to establish its protected status, that content is secured through the production and proliferation of "dangers" from which it calls to be protected. Hence, the question of whether or not the black family in Minnesota is entitled to protection from public displays such as cross-burnings is displaced onto the question of whether or not the "content" of free speech is to be protected from those who would burn it. The fire is thus displaced from the cross to the legal instrument wielded by those who would protect the family from the fire, but then to the black family itself, to blackness, to the vacant lot, to rioters in Los Angeles who explicitly oppose the decision of a court and who now represent the incendiary power of the traumatized rage of black people who would burn the judiciary itself. But of course, that construal is already a reversal of the narrative in which a court delivers a decision of acquittal for the four policemen indicted for the brutal beating of Rodney King, a decision that might be said to "spark" a riot which calls into

question whether the claim of having been injured can be heard and countenanced by a jury and a judge who are extremely susceptible to the suggestion that a black person is always and only endangering, but never endangered. And so the High Court might be understood in its decision of June 22, 1992, to be taking its revenge on Rodney King, protecting itself against the riots in Los Angeles and elsewhere which appeared to be attacking the system of justice itself. Hence, the justices identify with the black family who sees the cross burning and takes it as a threat, but they substitute themselves for that family, and reposition blackness as the agency behind the threat itself.[17]

The decision enacts a set of metonymic displacements which might well be read as anxious deflections and reversals of the injurious action at hand; indeed, the original scene is successively reversed in the metonymic relation between figures such that the fire is lit by the ordinance, carried out by traumatized rioters on the streets of Los Angeles and threatens to engulf the justices themselves.

Mari Matsuda and Charles Lawrence also write of this text as enacting a rhetorical reversal of crime and punishment: "The cross burners are portrayed as an unpopular minority that the Supreme Court must defend against the power of the state. The injury to the Jones family is appropriated and the cross burner is cast as the injured victim. The reality of ongoing racism and exclusion is erased and bigotry is redefined as majoritarian condemnation of racist views."[18]

Significantly, the Justices revisited *R.A.V. v. St. Paul* in a more recent decision, *Wisconsin v. Mitchell*, 113 S. Ct. 2194, 14 L. Ed. 2d 436 (1993), in which the court unanimously decided that racist speech could be included as evidence that a victim of a crime was intentionally selected because of his/her race and could constitute one of the factors that come into play in determining whether an enhanced penalty for the crime is in order. *Wisconsin v. Mitchell* did not address whether racist speech is injurious, but only whether speech that indicates that the victim was selected on the basis of race could be brought to bear in determining penalty enhancement for a crime which is itself not a crime of speech, as it were. Oddly, the case at hand involved a group of young black men, including Todd Mitchell, who had just left the

film, "Mississippi Burning." They decided to "move on" some white people, and proceeded to beat a young white man who had approached them on the street. Rehnquist is quick to note that these young men were discussing a scene from the film, one in which "a white man beat a young black boy who was praying." Rehnquist then goes on to quote Mitchell whose speech will become consequential in the decision: "Do you all feel hyped up to move on some white people?" and later, "You all want to fuck somebody up? There goes a white boy: go get him." *Wisconsin v. Mitchell*, 113 S. Ct. at 2196–7, 120 L. Ed. 2d at 442 (citing Brief for Petitioner). Now, the irony of this event, it seems, is that the film narrates the story of three civil rights workers (two white and one black) who are murdered by Klansmen who regularly threaten with burning crosses and firebombs any townspeople who appear to help the Justice Department in their search for the bodies of the slain civil rights activists and then their murderers. The court system is first figured within the film as sympathetic to the Klan, refusing to imprison the murdering Klansmen, and then as setting improper restraints on the interrogation. Indeed, the Justice Department official is able to entrap the Klansman only by acting against the law, freely brutalizing those he interrogates. This official is largely regarded as rehabilitating masculinity on the side of what is right over and against a liberal "effem-inization" represented by judicial due process. But perhaps most important, while the effective official acts in the name of the law, he also acts against the law, and purports to show that his unlawfulness is the only efficacious way to fight racism. The film thus appeals to a widespread lack of faith in the law and its proceduralism, reconstructing a lawless white masculinity even as it purports to curb its excesses.

In some ways, the film shows that violence is the consequence of the law's failure to protect its citizens, and in this way allegorizes the reception of the judicial decisions. For if the film shows that the court will fail to guarantee the rights and liberties of its citizens, and only violence can counter racism, then the street violence that literally follows the film reverses the order of that allegory. The black men who leave the film and embark upon violence in the street find themselves in a court that not only goes out of its way to indict the film—which

is, after all, an indictment of the courts—but implicitly goes on to link the street violence to the offending representation, and effectively to link the one through the other.

The court seeks to decide whether or not the selection of the target of violence is a racially motivated one by quoting Todd Mitchell's speech. This speech is then taken to be the consequence of having watched the film, indeed, to be the very extension of the speech that constitutes the text of the film. But the court itself is implicated in the extended text of the film, "indicted" by the film as complicit with racial violence. Hence, the punishment of Mitchell and his friends— and the attribution of racially selective motives to them—reverses the "charges" that the film makes against the court. In *R.A.V. v. St. Paul*, the court makes a cameo appearance in the decision as well, reversing the agency of the action, substituting the injured for the injurer, and figuring itself as a site of vulnerability.

In each of these cases, the court's speech exercises the power to injure precisely by virtue of being invested with the authority to adjudicate the injurious power of speech. The reversal and displacement of injury in the name of "adjudication" underscores the particular violence of the "decision," one which becomes both dissimulated and enshrined once it becomes word of law. It may be said that all legal language engages this potential power to injure, but that insight supports only the argument that it will be all the more important to gain a reflective understanding of the specificities of that violence. It will be necessary to distinguish between those kinds of violence that are the necessary conditions of the binding character of legal language, and those kinds which exploit that very necessity in order to redouble that injury in the service of injustice.

The arbitrary use of this power is evidenced in the contrary use of precedents on hate speech to promote conservative political goals and thwart progressive efforts. Here it is clear that what is needed is not a better understanding of speech acts or the injurious power of speech, but the strategic and contradictory uses to which the court puts these various formulations. For instance, this same court has been willing to countenance the expansion of definitions of obscenity, and

to use the very rationale proposed by some arguments in favor of hate crime legislation to augment its case to exclude obscenity from protected speech.[19] Scalia refers to *Miller v. California* (1973) as the case which installs obscenity as an exception to the categorical protection of content through recourse to what is "patently offensive," and then remarks that in a later case, *New York v. Ferber*, 458 U.S. 747 (1982), in exempting child pornography from protection, there was no "question here of censoring a particular literary theme." *R.A.V. v. St. Paul*, 112 S. Ct. at 2543, 120 L. Ed. 2d at 318. What constitutes the "literary" is thus circumscribed in such a way that child pornography is excluded from both the literary and the thematic. Although it seems that one must be able to recognize the genre of child pornography, to identify and delimit it in order to exempt it from the categorical protection of content, the identifying marks of such a product can be neither literary nor thematic. Indeed, the court appears in one part of its discussion to accept the controversial position of Catharine MacKinnon, which claims that certain verbal expressions constitute sex discrimination, when it says "sexually derogatory 'fighting words' . . . may produce a violation of Title VII's general prohibition against sexual discrimination in employment practices" *Id.* at 2546, 120 L. Ed. 2d at 321. But here the court is clear that it does not prohibit such expressions on the basis of their content, but only on the basis of the effects that such expressions entail. Indeed, I would suggest that the contemporary conservative sensibility exemplified by the court and right-wing members of Congress is also exemplified in the willingness to expand the domain of obscenity and, to that end, to enlarge the category of the pornographic and to claim the unprotected status of both, and so, potentially, to position obscenity to become a species of "fighting words," that is, to accept that graphic sexual representation is injurious. This is underscored by the rationale used in *Miller v. California* in which the notion of "appealing to prurience" is counterposed to the notion of "literary, artistic, political, or scientific value." Here the representation that is deemed immediately and unobjectionably injurious is excluded from the thematic and the valuable and, hence, from protected status. This same rationale has been taken

up by Jesse Helms and others to argue that the National Endowment for the Arts is under no obligation to fund obscene materials, and then to argue that various lesbian performers and gay male photographers produce work that is obscene and lacking in literary value. Significantly, it seems, the willingness to accept the nonthematic and unobjectionably injurious quality of graphic sexual representations, when these representations cannot be said to leave the page or to "act" in some obvious way, must be read against the unwillingness to countenance the injuriousness of the burning cross in front of the black family's house. That the graphic depiction of homosexuality, say, can be construed as nonthematic or simply prurient, figured as a sensuousness void of meaning, whereas the burning of the cross, to the extent that it communicates a message of racial hatred, might be construed as a sanctioned point in a public debate over admittedly controversial issues, suggests that the rationale for expanding the fighting words doctrine to include unconventional depictions of sexuality within its purview has been strengthened, but that the rationale for invoking fighting words to outlaw racist threats is accordingly weakened. This is perhaps a way in which a heightened sexual conservatism works in tandem with an increasing governmental sanction for racist violence, but in such a way that whereas the "injury" claimed by the viewer of graphic sexual representation is honored as fighting words, the injury sustained by the black family with the burning cross out front, not unlike the injury of Rodney King, proves too ambiguous, too hypothetical to abrogate the ostensible sanctity of the First Amendment.[20] And it is not simply that prohibitions against graphic sexual representation will be supported by this kind of legal reasoning, whereas racist injury will be dignified as protected speech, but that racially marked depictions of sexuality will be most susceptible to prosecution, and those representations that threaten the pieties and purities of race and sexuality will become most vulnerable.

Two remarks of qualification: first, some critical race theorists such as Charles Lawrence will argue that cross burning is speech, but that not all speech is to be protected, indeed, not all speech is protected, and that racist speech conflicts with the Equal Protection Clause because

it hinders the addressed subject from exercising his/her rights and liberties. Other legal scholars in critical race studies, such as Richard Delgado, will argue for expanding the domain of the "fighting words" restriction on First Amendment rights. Matsuda and MacKinnon, following the example of sex discrimination jurisprudence, will argue that it is impossible to distinguish between conduct and speech, that hateful remarks are injurious actions. Oddly enough, this last kind of reasoning has reappeared in the recent policy issued on gays in the military, where the statement "I am a homosexual" is considered to be a "homosexual act." The word and the deed are one, and the claim "I am a homosexual" is considered to be not only a homosexual act, but a homosexual offense.[21] According to this policy, the act of coming out is effectively construed as fighting words. Here it seems that one must be reminded that the prosecution of hate speech in a court runs the risk of giving that court the opportunity to impose a further violence of its own. And if the court begins to decide what is and is not violating speech, that decision runs the risk of constituting the most binding of violations.

For, as in the case with the burning cross, it was not merely a question of whether the court knows how to read the threat contained in the burning cross, but whether the court itself signifies along a parallel logic. For this has been a court that can only imagine the fire engulfing the First Amendment, sparking the riot which will fray its own authority. And so it protects itself against the imagined threat of that fire by protecting the burning cross, allying itself with those who would seek legal protection from a spectre wrought from their own fantasy. Thus the court protects the burning cross as free speech, figuring those it injures as the site of the true threat, elevating the burning cross as a deputy for the court, the local protector and token of free speech: with so much protection, what do we have to fear?

POSTSCRIPT

MacKinnon herself understands this risk of invoking state power, but in her recent book, *Only Words* (1993), she argues that state power is

on the side of the pornographic industry, and that the construction of
women within pornography in subordinate positions is, effectively, a
state-sanctioned construction.

MacKinnon has argued that pornography is a kind of hate speech,
and that the argument in favor of restricting hate speech ought to be
based on the argument in favor of restricting pornography. This anal-
ogy rests upon the assumption that the visual image in pornography
operates as an imperative, and that this imperative has the power to
realize that which it dictates. The problem, for MacKinnon, is *not* that
pornography reflects or expresses a social structure of misogyny, but
that it is an institution with the performative power to bring about
that which it depicts. She writes that pornography not only substitutes
for social reality, but that that substitution is one which creates a social
reality of its own, the social reality of pornography. This self-fulfilling
capacity of pornography is, for her, what gives sense to the claim that
pornography *is* its own social context. She writes,

> Pornography does not simply express or interpret experience; it substitutes for it.
> Beyond bringing a message from reality, it stands in for reality. . . . To make visu-
> al pornography, and to live up to its imperatives, the world, namely women, must
> do what the pornographers want to 'say.' Pornography brings its conditions of pro-
> duction to the consumer. . . . Pornography makes the world a pornographic place
> through its making and use, establishing what women are said to exist as, are seen
> as, are treated as, constructing the social reality of what a woman is and can be
> in terms of what can be done to her, and what a man is in terms of doing it.

In the first instance, pornography substitutes for experience, implying
that there is an experience which is supplanted, and supplanted thor-
oughly, through pornography. Hence, pornography takes the place of an
experience and thoroughly constitutes a new experience, understood as
a totality; by the second line, this second-order experience is rendered
synonymous with a second order "reality," which suggests that in this
universe of pornography there is no distinction between an experience
of reality and reality, although MacKinnon herself makes clear that this
systemic conflation of the two takes place within a reality which is itself

a mere substitution for another reality, one which is figured as more original, perhaps one which furnishes the normative or utopian measure by which she judges the pornographic reality that has taken its place. This visual field is then figured as speaking, indeed, as delivering imperatives, at which point the visual field operates as a subject with the power to bring into being what it names, to wield an efficacious power analogous to the divine performative. The reduction of that visual field to a speaking figure, an authoritarian speaker, rhetorically effects a different substitution than the one that MacKinnon describes. She substitutes a set of linguistic imperatives for the visual field, implying not only a full transposition of the visual into the linguistic, but a full transposition of visual depiction into an efficacious performative.

When pornography is then described as "constructing the social reality of what a woman is," the sense of "construction" needs to be read in light of the above two transpositions: for that construction can be said to work, that is, "to produce the social reality of what a woman is," only if the visual can be transposed into the linguistically efficacious in the way that she suggests. Similarly, the analogy between pornography and hate speech works to the extent that the pornographic image can be transposed into a set of efficacious spoken imperatives. In MacKinnon's paraphrase of how the pornographic image speaks, she insists that that image says, "do this," where the commanded act is an act of sexual subordination, and where, in the doing of that act, the social reality of woman is constructed precisely as the position of the sexually subordinate. Here "construction" is not simply the doing of the act—which remains, of course, highly ambiguous in order perhaps to ward off the question of an equivocal set of readings—but *the depiction* of that doing, where the depiction is understood as the dissimulation and fulfillment of the verbal imperative, "do this." For MacKinnon, no one needs to speak such words because the speaking of such words already functions as the frame and the compulsory scripting of the act; in a sense, to the extent that the frame orchestrates the act, it wields a performative power; it is conceived by MacKinnon as encoding the will of a masculine authority, and compelling a compliance with its command.

But does the frame impart the will of a preexisting subject, or is the frame something like the derealization of will, the production and orchestration of a phantasmatic scene of willfulness and submission? I don't mean to suggest a strict distinction between the phantasmatic and the domain of reality, but I do mean to ask, to what extent does the operation of the phantasmatic within the construction of social reality render that construction more frail and less determinative than MacKinnon would suggest? In fact, although one might well agree that a good deal of pornography is offensive, it does not follow that its offensiveness consists in its putative power to construct (unilaterally, exhaustively) the social reality of what a woman is. To return for a moment to MacKinnon's own language, consider the way in which the hypothetical insists itself into the formulation of the imperative, as if the force of her own assertions about the force of pornographic representation tends toward its own undoing: "pornography establish[es] . . . what women are said to exist *as*, are seen *as*, are treated *as* . . . " Then, the sentence continues: "constructing the social reality of what a woman is"; here to be treated as a sexual subordinate is to be constructed as one, and to have a social reality constituted in which that is precisely and only what one is. But if the "as" is read as the assertion of a likeness, it is not for that reason the assertion of a metaphorical collapse into identity. Through what means does the "as" turn into an "is," and is this the doing of pornography, or is it the doing of the very *depiction* of pornography that MacKinnon provides? For the "as" could also be read as "as if," "as if one were," which suggests that pornography neither represents nor constitutes what women are, but offers an allegory of masculine willfulness and feminine submission (although these are clearly not its only themes), one which repeatedly and anxiously rehearses its own *un*realizability. Indeed, one might argue that pornography depicts impossible and uninhabitable positions, compensatory fantasies that continually reproduce a rift between those positions and the ones that belong to the domain of social reality. Indeed, one might suggest that pornography is the text of gender's unreality, the impossible norms by which it is compelled, and in the face of which it perpetually fails. The imperative "do this" is less deliv-

ered than "depicted," and if what is depicted is a set of compensatory ideals, hyperbolic gender norms, then pornography charts a domain of unrealizable positions that hold sway over the social reality of gender positions, but do not, strictly speaking, constitute that reality; indeed, it is their failure to constitute it that gives the pornographic image the phantasmatic power that it has. In this sense, to the extent that an imperative is "depicted" and not "delivered," it fails to wield the power to construct the social reality of what a woman is. This failure, however, is the occasion for an allegory of such an imperative, one that concedes the unrealizability of that imperative from the start, and which, finally, cannot overcome the unreality that is its condition and its lure. My call, as it were, is for a feminist reading of pornography that resists the literalization of this imaginary scene, one which reads it instead for the incommensurabilities between gender norms and practices that it seems compelled to repeat without resolution.

In this sense, it makes little sense to figure the visual field of pornography as a subject who speaks and, in speaking, brings about what it names; its authority is decidedly less divine; its power, less efficacious. It only makes sense to figure the pornographic text as the injurious act of a speaker if we seek to locate accountability at the prosecutable site of the subject. Otherwise our work is more difficult, for what pornography delivers is what it recites and exaggerates from the resources of compensatory gender norms, a text of insistent and faulty imaginary relations that will not disappear with the abolition of the offending text, the text that remains for feminist criticism relentlessly to read.

NOTES

1. I greatly appreciate the thoughtful readings given to this paper in an earlier form by Wendy Brown, Robert Gooding-Williams, Morris Kaplan, Robert Post, and Hayden White. Any inaccuracies and all misreadings are, of course, my responsibility alone. I thank Jane Malmo for help with preparing the manuscript.

2. This criminal sense of an actor is to be distinguished both from the commercial and theatrical terms (*Händlerin* and *Schauspielerin*, respectively).

3. Robert M. Cover, "Violence and the Word," 95 *Yale Law Journal* 1595, 1601 n I (1986).

4. "The [state action] doctrine holds that although someone may have suffered harmful treatment of a kind that one might ordinarily describe as a deprivation of liberty or a denial of equal protection of the laws, that occurrence excites no constitutional concern unless the proximate active perpetrators of the harm include persons exercising the special authority or power of the government of a state." Frank Michelman, "Conceptions of Democracy in American Constitutional Argument: The Case of Pornography Regulation," 56 *Tennessee Law Review* 291, 306 (1989).

5. Charles Lawrence III, "If He Hollers Let Him Go: Regulating Racist Speech on Campus," in *Words that Wound: Critical Race Theory, Assaultive Speech and the First Amendment*, ed. Mari J. Matsuda, Charles R. Lawrence III, Richard Delgado, and Kimberlè Williams Crenshaw (Boulder, 1993), p. 65.

6. I thank Robert Post for this last analogy, suggested to me in conversation.

7. Kendall Thomas, University of Virginia Law Review, forthcoming.

8. Jacques Derrida, "Signature, Event, Context," in *Limited Inc.*, ed. Gerald Graff, tr. Samuel Weber and Jeffrey Mehlman (Evanston, 1988), p. 18.

9. St. Paul Bias Motivated Crime Ordinance, Section 292.02 Minn. Legis. Code (1990).

10. Charles R. Lawrence III argues that "it is not just the prevalence and strength of the idea of racism that make the unregulated marketplace of ideas an untenable paradigm for those individuals who seek full and equal personhood for all. The real problem is that the idea of the racial inferiority of nonwhites infects, skews, and disables the operation of a market" in "If He Hollers Let Him Go: Regulating Racist Speech on Campus," in *Words that Wound*, p. 77.

11. The lawyers defending the application of the ordinance to the cross burning episode made the following argument:

> ... we ask the Court to reflect on the 'content' of the 'expressive conduct' represented by a 'burning cross.' It is no less than the first step in an act of racial violence. It was and unfortunately still is the equivalent of [the] waving of a knife before the thrust, the pointing of a gun before it is fired, the lighting of the match before the arson, the hanging of the noose before the lynching. It is not a political statement, or even a cowardly statement of hatred. It is the first step in an act of assault. It can be no more protected than holding a gun to a victim['s] head. It is perhaps the ultimate expression of 'fighting words.'

R.A.V. v. St. Paul, 112 S. Ct. at 2569–70, fn. 8, 120 L. Ed. 2d at 320 (App. to Brief for Petitioner).

12. The new critical assumption to which I refer is that of the separable and fully formal unity that is said to characterize a given text.

13. All of the justices concur that the St. Paul ordinance is overbroad because it isolates "subject-matters" as offensive, and (a) potentially prohibits discussion of such subject-matters even by those whose political sympathies are with the ordinance, and (b) fails to distinguish between the subject-matter's injuriousness and the context in which it is enunciated.

14. Justice Stevens, in a decision offered separately from the argument offered by the majority, suggests that the burning cross is precisely a threat, and that whether a given "expression" is a threat can only be determined *contextually*. Stevens bases his conclusion on *Chaplinsky*, which argued that "one of the characteristics that justifies" the constitutional status of fighting words is that such words "by their very utterance inflict injury or tend to incite an immediate breach of the peace." *Chaplinsky v. New Hampshire*, 315 U.S. 568, 572 (1942).

Here Stevens argues, first, that certain kinds of contents have always been proscribable, and, second, that the fighting words doctrine has depended for its very implementation on the capacity to discriminate among kinds of contents (i.e., political speech is more fully protected than obscene speech, etc.), but also, third, that fighting words that are construed as a threat are in themselves injurious, and that it is this injurious character of speech, and not a separable "content" that is at issue. As he continues, however, Stevens is quick to point out that whether or not an expression is injurious is a matter of determining the force of an expression within a given context. This determination will never be fully predictable, precisely because, one assumes, contexts are also not firmly delimitable. Indeed, if one considers not only historical circumstance, but the historicity of the utterance itself, it follows that the demarcation of relevant context will be as fraught as the demarcation of injurious content.

Stevens links content, injurious performativity, and context together when he claims, objecting to both Scalia and White, that there can be no categorical approach to the question of proscribablity: "few dividing lines in First Amendment laws are straight and unwavering, and efforts at categorization inevitably give rise only to fuzzy boundaries . . . the quest for doctrinal certainty through the definition of categories and subcategories is, in my opinion, destined to fail." *R.A.V. v. St. Paul*, 112 S. Ct. at 2561, 120 L. Ed. 2d, at 346. Furthermore, he argues, "the meaning of any expression and the legitimacy of its regulation can only be determined in context." *Id.*

At this point in his analysis, Stevens cites a metaphoric description of "the word" by Justice Holmes, a term which stands synecdochally for "expression" as it is broadly construed within First Amendment jurisprudence: the citation from Holmes runs as follows: "a word is not a crystal, transparent and unchanged, it is the skin of a living thought and may vary greatly in color and content according to the circumstances

and the time in which it is used" (11–12). We might consider this figure not only as a racial metaphor which describes the "word" as a "skin" that varies in "color," but also in terms of the theory of semantics it invokes. Although Stevens believes that he is citing a figure which will affirm the historically changing nature of an "expression's" semantic "content," denoted by a "skin" that changes in color and content according to the historical circumstance of its use, it is equally clear that the epidermal metaphor suggests a living and disembodied thought which remains dephenomenalized, the noumenal quality of life, the living spirit in its skinless form. Skin and its changing color and content thus denote what is historically changing, but they also are, as it were, the signifiers of historical change. The racial signifier comes to stand not only for changing historical circumstances in the abstract, but for the specific historical changes marked by explosive racial relations.

15. Toni Morrison remarks that poverty is often the language in which black people are spoken about.

16. The above reading raises a series of questions about the rhetorical status of the decision itself. Kendall Thomas and others have argued that the figures and examples used in judicial decisions are as central to its semantic content as the explicit propositional claims that are delivered as the conclusions of the argumentation. In a sense, I am raising two kinds of rhetorical questions here, one has to do with the "content" of the decision, and the other with the way in which the majority ruling, written by Scalia, itself delimits what will and will not qualify as the content of a given public expression in light of the new restrictions imposed on fighting words. In asking, then, after the rhetorical status of the decision itself, we are led to ask how the rhetorical action of the decision presupposes a theory of semantics that undermines or works against the explicit theory of semantics argued for and in the decision itself.

Specifically, it seems, the decision itself draws on a distinction between the verbal and non-verbal parts of speech, those which Scalia appears to specify as "message" and "sound." *R.A.V. v. St. Paul*, 120 L. Ed. 2d 305, 319–21. For Scalia, only the sound of speech is proscribable or, analogously, that sensuous aspect of speech deemed inessential to the alleged ideality of semantic content. Although Justice Stevens rejects what he calls this kind of "absolutism," arguing instead that the proscribability of content can only be determined in context, he nevertheless preserves a strict distinction between the semantic properties of an expression and the context, including historical circumstance, but also conditions of address. For both Scalia and Stevens, then, the "content" is understood in its separability from both the non-verbal and the historical, although in the latter case, determined in relation to it.

17. The decision made in the trial of the policemen in Simi Valley relied on a similar kind of reversal of position, whereby the jury came to believe that the

policemen, in spite of their graphic beating of King, were themselves the endangered party in the case.

18. Matsuda and Lawrence, "Epilogue," *Words that Wound*, p. 135.

19. *Chaplinsky* makes room for this ambiguity by stipulating that some speech loses its protected status when it constitutes "no essential part of any exposition of ideas." This notion of an inessential part of such an exposition forms the basis of a 1973 ruling, *Miller v. California*, 413 U.S. 15, extending the unprotected status of obscenity. In that ruling the picture of a model sporting a political tattoo, construed by the court as "anti-government speech," is taken as *un*protected precisely because it is said, "taken as a whole to lack serious literary, artistic, political, or scientific value." Such a representation, then, is taken to be "no essential part of any exposition of ideas." But here, you will note that "no essential part" of such an exposition has become "no valuable part." Consider then Scalia's earlier example of what remains unprotected in speech, that is, the noisy sound truck, the semantically void part of speech which, he claims, is the "nonspeech element of communication." Here he claims that only the semantically empty part of speech, its pure sound, is unprotected, but that the "ideas" which are sounded in speech most definitely are protected. This loud street noise, then, forms no essential part of any exposition but, perhaps more poignantly, forms no valuable part. Indeed, we might speculate that whatever form of speech is unprotected will be reduced by the justices to the semantically empty sounding title of "pure noise." Hence, the film clip of the ostensibly nude model sporting an anti-government tattoo would be nothing but pure noise, not a message, not an idea, but the valueless soundings of street noise.

20. Kimberlé Crenshaw marks this ambivalence in the law in a different way, suggesting that the courts will discount African-American forms of artistic expression as artistic expression and subject such expression to censorship precisely because of racist presumptions about what counts as artistic. On the other hand, she finds the representation of women in these expressions to be repellent, and so feels herself to be "torn" between the two positions. See "Beyond Racism and Misogyny: Black Feminism and 2 Live Crew," in *Words That Wound*.

21. Note the subsumption of the declaration that one is a homosexual under the rubric of offensive conduct: "Sexual orientation will not be a bar to service unless manifested by homosexual conduct. The military will discharge members who engage in homosexual conduct, which is defined as a homosexual act, a statement that the member is homosexual or bisexual, or a marriage or attempted marriage to someone of the same gender." "The Pentagon's New Policy Guidelines on Homosexuals in the Military," *The New York Times* (July 20, 1993), p. A14.

BIBLIOGRAPHY

Abdulla, Adnan K. *Catharsis in Literature*. Bloomington, 1985.

Adorno, T. W. *Aesthetic Theory*, trans. C. Lenhardt. London and New York, 1984.

Appiah, Kwame Anthony. *In My Father's House: Africa in the Philosophy of Culture*. New York and Oxford, 1992.

Arac, Jonathan. *Critical Genealogies: Historical Situations for Postmodern Literary Studies*. New York, 1987.

Artaud, Antonin. *The Theater and its Double*, trans. M. C. Richards. New York, 1958.

Auslander, Philip. *Presence and Resistance: Postmodernism and Cultural Politics in Contemporary American Performance*. Ann Arbor, 1992.

Austin, J. L. *How to Do Things with Words*. 2nd. ed., ed. Marina Sbisa and J. O. Urmson. Cambridge, MA, 1975.

———. *Philosophical Papers*. 3rd ed., ed. J. O. Urmson and G. J. Warnock. Oxford, 1979.

Baker, Houston A., Jr. *Blues, Ideology, and Afro-American Literature: A Vernacular Theory*. Chicago, 1984.

Barba, Eugenio, and Nicola Savarese. *A Dictionary of Theatre Anthropology: The Secret Art of the Performer*. New York, 1991.

Barish, Jonas. *The Antitheatrical Prejudice*. Berkeley, 1981.

Belfiore, Elizabeth. *Tragic Pleasures: Aristotle on Plot and Emotion*. Princeton, NJ, 1992.

Benjamin, Walter. *Reflections: Essays, Aphorisms, Autobiographical Writings*, trans. Edmund Jephcott. New York, 1986.

———. *Understanding Brecht*, trans. Anna Bostock. London, 1973.

Bennington, Geoffrey. *Lyotard: Writing the Event*. New York, 1988.

Benston, Kimberly. "Being There: Performance as Mise-en-Scène, Abscene, Obscene and Other Scene." *PMLA* 107:3 (May 1982), pp. 434-449.

———. "Performing Blackness: Re/Placing Afro-American Poetry." In *Afro-American Literary Study in the 1990s,* ed. Houston A. Baker and Patricia Redmond. Chicago, 1989, pp. 164–193.

Berger, Fred. "Bringing Hate Crime into Focus: The Hate Crime Statistics Act of 1990." *Harvard Civil Rights and Civil Liberties Review* 26:1 (Winter 1991), pp. 261-294.

———. *Freedom, Rights, and Pornography*. Boston, 1991

Bettelheim, Judith, and John W. Nunley. *Caribbean Festival Arts: Each and Every Bit of Difference*. St. Louis, 1988.

Bigsby, C. W. E. "A View from East Anglia." *American Quarterly* 41:1 (March 1989), pp. 128–132.

Black American Literature Forum 25:1 (Spring 1991).

Blau, Herbert. *Blooded Thought: Occasions of Theater*. New York, 1982.

———. *The Audience*. Baltimore, 1990.

Bourdieu, Pierre. *Distinction: A Social Critique of the Judgement of Taste,* trans. Richard Nice. Cambridge, MA, 1984.

———. "The Social Space and the Genesis of Groups." *Social Science Information* 24:2 (1985), pp. 195–220.

Bourdieu, Pierre, and J.-C. Passeron. *Reproduction: In Education, Society and Culture,* trans. R. Nice. London and Beverly Hills, 1977.

Brecht, Bertholt. *Brecht on Theater,* trans. John Willet. New York, 1964.

Bret, Philip, Sue-Ellen Case, and Susan Leigh Foster, ed. *Cruising the Performative*. Bloomington, 1995.

Bryant-Jackson, Paul K., and Lois M. Overbeck, ed. *Intersecting Boundaries: The Theatre of Adrienne Kennedy*. Minneapolis, 1992.

Buck-Morss, Susan. *The Origin of Negative Dialectics*. New York, 1977.

Buerkle, Jack Vincent, and Danny Barker. *Bourbon Street Black: The New Orleans Black Jazzman*. New York, 1973.

Butler, Judith. *Bodies that Matter: On the Discursive Limits of "Sex."* New York, 1993.

———. "Critically Queer." *GLQ* 1:1 (1993), pp. 17–32.

———. *Gender Trouble: Feminism and the Subversion of Identity*. New York, 1990.

———. "The Lesbian Phallus and the Morphological Imaginary." *differences* 4:1 (Spring 1992), pp. 131–171.

Cadden, Michael. "Rewriting Literary History." *American Quarterly* 41:1 (March 1989), pp. 133–137.

Calder, Angus. *Revolutionary Empire: The Rise of the English-Speaking Empires from the Fifteenth Century to the 1780s*. New York, 1981.

Carter, Steven R. *Hansberry's Drama*. Urbana, 1991.

Caruth, Cathy, ed. *Trauma: Explorations in Memory*. Baltimore, 1995.

———. "Unclaimed Experience: Trauma and the Possibility of History." *YFS* 79 (1991), pp. 181–192.

Caruth, Cathy, and Deborah Esch, ed. *Critical Encounters: Reference and Responsibility in Deconstructive Writing*. New Brunswick, 1994.

Case, Sue-Ellen, ed. *Performing Feminisms: Feminist Critical Theory and Theatre.* Baltimore, 1990.

Case, Sue-Ellen, and Janelle Reinelt, ed. *The Performance of Power.* Iowa City, 1991.

Castelvetro, Lodovico. *Poetica d'Aristotele vulgarizzata, et sposta.* Basel, 1576.

Cavell, Stanley. *The Claim of Reason.* Oxford, 1979.

———. *Conditions Handsome and Unhandsome.* Chicago, 1990.

———. *Philosophical Passages.* Cambridge, MA, 1995.

———. *A Pitch of Philosophy.* Cambridge, MA, 1994.

———. "Politics as Opposed to What?" *Critical Inquiry* 9:1 (1982), pp. 157–188.

Clark, Vèvè. "Developing Diaspora Literacy and *Marasa* Consciousness." In *Comparative American Identities: Race, Sex, and Nationality in the Modern Text,* ed. Hortense J. Spillers. New York, 1991, pp. 40–61.

Clifford, James. *The Predicament of Culture: Twentieth-Century Ethnography, Literature and Art.* Cambridge, MA, 1988.

Coffin, Tristram, and Hennig Cohen, ed. *Folklore in America.* Garden City, 1966.

Cohen, Ted. "Illocutions and Perlocutions." *Foundations of Language* 9 (1973).

Cole, Thomas. *The Origins of Rhetoric in Ancient Greece.* Baltimore and London, 1991.

Connerton, Paul. *How Societies Remember.* New York, 1989.

Cornell, Drucilla. *The Philosophy of the Limit.* New York, 1992.

Cover, Robert. "Violence and the Word." *The Yale Law Journal* 95 (1986), pp. 1601–1629.

Crane, R. S., ed. *Critics and Criticism: Ancient and Modern.* Chicago, 1952.

Crimp, Douglas. "Mourning and Militancy." *October* 51 (Winter 1989), pp. 3–18.

David-Menard, Monique. *Hysteria from Freud to Lacan,* trans. Catherine Porter. Ithaca, 1989.

Davis, Gerald. *I Got the Word in Me and I Can Sing It, You Know: A Study of the Performed African-American Sermon.* Philadelphia, 1985.

de Certeau, Michel. *The Practice of Everyday Life,* trans. Stephen F. Rendall. Berkeley, 1988.

Deleuze, Gilles. *Cinema 1: Movement-Image,* trans. Hugh Tomlinson and Barbara Habberjam. Minneapolis, 1986.

de Man, Paul. *Allegories of Reading: Figural Language in Rousseau, Nietzsche, Rilke, and Proust.* New Haven, 1979.

Denores, Giason. *Discorso intorno à que' principii, cause, et accrescimenti, che la comedia, la tragedia, et il poema heroico ricevono dalla philosophia . . .* Padua, 1586.

Derrida, Jacques. *La carte postale: de Socrate à Freud et au-delà.* Paris, 1980.

———. *Limited Inc.,* ed. Gerald Graff, trans. Samuel Weber and Jeffrey Mehlman. Evanston, 1988.

————. *Margins of Philosophy,* trans. Alan Bass. Chicago, 1982.

————. *Points de suspension: Entretiens.* Paris, 1992.

————. *Positions.*, trans. Alan Bass. Chicago, 1981.

Diamond, Elin, "Realism and Hysteria: Notes Toward a Feminist Mimesis." *Discourse* 13:1 (Fall-Winter 1990–1991), pp. 59–92.

Drewal, Henry John. "Performing the Other: Mami Wata Worship in Africa." *TDR* 32:2 (T118) (Summer 1988), pp. 160–185.

Drewal, Margaret Thompson. *Yoruba Ritual: Performers, Play, Agency.* Bloomington, 1992.

Else, Gerald. *Aristotle's Poetics: The Argument.* Cambridge, MA, 1963.

Emery, Lynne Fauley. *Black Dance, From 1619 to Today.* Salem, 1988.

Euba, Femi. *Archetypes, Imprecators and Victims of Fate.* New York, 1989.

Fabre, Geneviève. *Drumbeats, Masks and Metaphor.* Cambridge, 1983.

Feldstein, Richard, and Judith Roof, ed. *Feminism and Psychoanalysis.* Ithaca, 1984.

Felman, Shoshana. *The Literary Speech Act,* trans. Catherine Porter. Ithaca, 1983.

Fliegelman, Jay. *Declaring Independence: Jefferson, Natural Language, and the Culture of Performance.* Stanford, 1993.

Flynn, Joyce. "A Complex Causality of Neglect." *American Quarterly* 41:1 (March 1989), pp. 123–127.

Foucault, Michel. *Discipline and Punish: The Birth of the Prison,* trans. Alan Sheridan. New York, 1979.

————. *The History of Sexuality, Vol. 1: An Introduction,* trans. Robert Hurley. New York, 1978.

Frankenberg, Ronald. "The Other Who is Also the Same: The Relevance of Epidemics in Space and Time for the Prevention of HIV Infection." *International Journal of Health Services* 22 (1992), pp. 73–88.

Freud, Sigmund. *The Standard Edition of the Complete Psychological Works,* trans. and ed. James Strachey. London, 1953.

Fried, Michael. *Absorption and Theatricality: Painting and Beholder in the Age of Diderot.* Berkeley, 1980.

Fuss, Diana. *Essentially Speaking: Feminism, Nature and Difference.* New York, 1990.

Gallop, Jane. *Reading Lacan.* New York, 1985.

Garber, Marjorie. *Vested Interests: Cross-Dressing and Cultural Anxiety.* New York, 1993.

Gates, Henry Louis, Jr., ed. *Black Literature and Literary Theory.* New York, 1984.

————, ed. *Reading Black, Reading Feminist: A Critical Anthology.* New York, 1990.

————. *The Signifying Monkey: A Theory of Afro-American Literary Criticism.* New York, 1988.

Gellrich, Michele. *Tragedy and Theory: The Problem of Conflict Since Aristotle.* Princeton, NJ, 1988.

Gennari, John. "Jazz Criticism: Its Development and Ideologies." *Black American Literature Forum* 25:3 (Fall 1991), pp. 449–523.

Gentile, Bruno. *Poetry and Its Public in Ancient Greece: From Homer to the Fifth Century,* trans. and introduction by A.T. Cole. Baltimore and London, 1988.

Giacomini, Lorenzo. *Sopra la purgazione della tragedia* . . . (1586). In *Prose Florentine.* Part 2, vol. 4., pp. 212–250. Florence, 1729.

Gilroy, Paul. *'There Ain't No Black in the Union Jack': Cultural Politics of Race and Nation.* Chicago, 1987.

Goodwin, Sarah Webster, and Elisabeth Bronfen, ed. *Death and Representation.* Baltimore, 1993.

Gould, Timothy. "Where the Action Is." In *The Senses of Stanley Cavell,* ed. Richard Fleming and Michael Payne. Lewisburg, 1989.

———. "What Makes the Pale Criminal Pale? Nietzsche and the Image of the Deed." *Soundings* 68:4 (Winter 1985), pp. 510–536.

Grotowski, Jerzy. *Towards a Poor Theatre,* trans. T. K. Wiewiorowski. New York, 1969.

Guarini, Battista. *Il Verato.* Ferrara, 1588.

Guillory, Elizabeth Brown. *Their Place on the Stage: Black Women Playwrights in America.* New York, 1988.

Gunther, Gerald, and Charles Lawrence III. "Speech that Harms: An Exchange." *Academe: Bulletin of the AAUP* 76:6 (November 1990), pp. 10–14.

Halbwachs, Maurice. *On Collective Memory,* ed. Lewis A. Coser. Chicago, 1992.

Hall, Gwendolyn Midlo. *Africans in Cultural Louisiana: The Development of Afro-Creole Culture in the Eighteenth Century.* Baton Rouge, 1992.

Halliwell, Stephen. *Aristotle's Poetics.* London, 1986.

Haraway, Donna J. *Simians, Cyborgs, and Women: The Reinvention of Nature.* New York, 1991.

Harrison, Daphne Duval. *Black Pearls: Blues Queens of the 1920s.* New Brunswick, 1990.

Harrison, Paul Carter. "Introduction: Black Theater in Search of a Source." In *Kuntu Drama: Plays of the African Continuum.* New York, 1974, pp. 5–29.

Hart, Lynda, ed. *Making a Spectacle: Feminist Essays on Contemporary Women's Theatre.* Ann Arbor, 1989.

Hart, Lynda and Peggy Phelan, ed. *Acting Out: Feminist Performances.* Ann Arbor, 1993.

Hazzard-Gordon, Katrina. *Jookin': The Rise of Social Dance Formations in African American Culture.* Philadelphia, 1990.

Heins, Marjorie. "Banning Words: A Comment on 'Words that Wound.'" *Harvard Civil Rights–Civil Liberties Law Review* 18 (1983), pp. 585–592.

Herington, John. *Poetry into Drama: Early Tragedy and the Greek Poetic Tradition.* Berkeley, 1985.

Hernadi, Paul, ed. *What is Literature?* Bloomington, 1978.

Hill, Eroll, ed. *The Theatre of Black Americans.* Englewood Cliffs, 1980, rpt. 1987.

hooks, bell. *Black Looks: Race and Representation.* Boston, 1993.

Houston, Hollis. *The Actor's Instrument: Body, Theory, Stage.* Ann Arbor, 1992.

Huntington, Richard, and Peter Metcalf. *Celebrations of Death: The Anthropology of Mortuary Ritual.* Cambridge and New York, 1979.

Hutton, James. *Aristotle's Poetics Translated with an Introduction and Notes.* New York, 1982.

Huyssen, Andreas. *After the Great Divide: Modernism, Mass Culture, Postmodernism.* Bloomington, 1986.

Irigaray, Luce. *Speculum of the Other Woman*, trans. Gillian C. Gil. Ithaca, 1985.

Jones, LeRoi. "Revolutionary Theatre." *Home: Social Essays.* New York, 1966.

Jost, Kenneth. "Hate Crimes." *The CQ Researcher* 3:1 (January 8, 1993), pp. 1–24.

Kirshenblatt-Gimblett, Barbara. "Objects of Ethnography." In *The Poetics and Politics of Museum Display,* ed. Evan Karp and Steven D. Lavine. Washington and London, 1991.

Kristeva, Julia. *Powers of Horror: An Essay on Abjection*, trans. Leon S. Roudiez. New York, 1982.

Kronik, John W. "Editor's Note." *PMLA* 107 (1992), p. 425.

Kubiak, Anthony. *Stages of Terror: Terrorism, Ideology, and Coercion as Theatre History.* Bloomington, 1991.

Lacan, Jacques. *The Four Fundamental Concepts of Psychoanalysis*, trans. Alan Sheridan. New York, 1981.

Lacoue-Labarthe, Philippe. "Theatrum Analyticum." *Glyph* 2 (1977), pp. 122–143.

La Pin, Diedre. "Story, Medium and Masque: The Idea and Art of Yoruba Storytelling." Ph.D. diss., University of Wisconsin, Madison, 1977.

Latour, Bruno. *The Pasteurization of France.* Cambridge, 1988.

Lear, Jonathan. "Kartharsis." *Phronesis* 33 (1988), pp. 327–344.

Lifton, Robert Jay. *The Broken Connection.* New York, 1979.

Locke, Alain. "Negro Youth Speaks." *The New Negro.* New York, 1925; rpt. 1968.

Lott, Eric. "Love and Theft: The Racial Unconscious of Blackface Minstrelsy." *Representations* 39 (1992), pp. 23–50.

———. "The Seeming Counterfeit: Racial Politics and Early Blackface Minstrelsy." *American Quarterly* 43:2 (June 1991), pp. 223–254.

Lukacher, Ned. "Anamorphic Stuff: Shakespeare, Catharsis, Lacan." *SAQ* 88:4 (Fall 1989), pp. 863–898.

Lyotard, Jean-François. *The Postmodern Condition: A Report on Knowledge,* trans. Geoffrey Bennington and Brian Massumi. Minneapolis, 1984.

MacAloon, John J. *Rite, Drama, Festival, Spectacle: Rehearsals Toward a Theory of Cultural Performance.* Philadelphia, 1984.

McKay, Nellie. "Black Theater and Drama in the 1920s: Years of Growing Pains." *Massachusetts Review* 28:4 (Winter 1987), pp. 615–626.

MacKinnon, Catharine A. *Towards a Feminist Theory of the State.* Cambridge, MA, 1989.

———. *Only Words.* Cambridge, MA, 1993.

Matsuda, Mari J. "Voices of America." *The Yale Law Journal* 100 (1991), pp. 1329–1407.

———. "Public Response to Racist Speech." *Michigan Law Review* 87 (1989), pp. 2320–2381.

Matsuda, Mari J., Charles R. Lawrence III, Richard Delgado, and Kimberlè Williams Crenshaw, ed. *Words that Wound: Critical Race Theory, Assaultive Speech and the First Amendment.* Boulder, 1993.

Michelman, Frank. "Conceptions of Democracy in American Constitutional Argument: The Case of Pornography Regulation." 56 *Tennessee Law Review* 291 (1989).

Miller, J. Hillis. *Tropes, Parables, Performatives: Essays on Twentieth-Century Literature.* Durham, 1991.

Mintz, Sidney. *Sweetness and Power: The Place of Sugar in Modern History.* New York, 1985.

Molette, Barbara and Carlton. *Black Theater: Premise and Presentation.* Bristol, IN, 1986, rpt. 1992.

Murray, Albert. *The Omni-Americans: Black Experience and American Culture.* New York, 1970.

Nadel, Alan, ed. *May All Your Fences Have Gates.* Iowa City, 1994.

Nietzsche, Friedrich. *On the Genealogy of Morals,* trans. Walter Kaufmann. New York, 1967.

———. *Werke in Drei Bände, Band II.* Munich, 1981.

Nussbaum, Martha. *The Fragility of Goodness: Luck and Ethics in Greek Tragedy and Philosophy.* Cambridge, 1986.

Orgel, Stephen. "The Poetics of Spectacle." *New Literary History* 2:3 (Spring 1971), pp. 367–389.

———. "Shakespeare and the Kinds of Drama." *Critical Inquiry* 6:1 (Autumn 1979), pp. 107–124.

Parker, Andrew. "Unthinking Sex: Marx, Engels, and the Scene of Writing." In *Fear of a Queer Planet: Queer Politics and Social Theory*, ed. Michael Warner. Minneapolis, 1993, pp. 19–41.

Patton, Cindy. "Inventing African AIDS." In *Nationalisms and Sexualities*, ed. Andrew Parker *et al.* New York, 1992, pp. 218–234.

――――. *Inventing AIDS*. New York, 1990.

――――. *Last Served? Gendering the HIV Pandemic*. London, 1994.

Penley, Constance. *The Future of an Illusion: Film, Feminism, and Psychoanalysis*. Minneapolis, 1989.

Phelan, Peggy. *Unmarked: The Politics of Performance*. New York, 1993.

Pickard-Cambridge, A. W. *The Dramatic Festival of Athens*, 2nd ed. rev. by J. Gould and D. M. Lewis. Oxford, 1988.

Post, Robert C. "Racist Speech, Democracy, and the First Amendment." 32 *William and Mary Law Review* 267 (1991).

――――. "Cultural Heterogeneity and Law: Pornography, Blasphemy, and the First Amendment." *California Law Review* 76 (March 1988), pp. 297–335.

Rayner, Alice. "The Audience: Subjectivity, Community and the Ethics of Listening." *Journal of Dramatic Theory and Criticism* 8:2 (Spring 1993), pp. 3–24.

Reinelt, Janelle, and Joseph Roach, ed. *Critical Theory and Performance*. Ann Arbor, 1992.

Richards, Sandra L. "African American Women Playwrights and Shifting Canons." Accepted for publication in *Feminist Theatres for Social Change*, ed. Susan Bennet, Tracy Davis and Kathleen Forman.

――――. "Under the 'Trickster's' Sign: Towards a Reading of Ntozake Shange and Femi Osofisan." In *Critical Theory and Performance*, ed. Janelle Reinelt and Joseph Roach. Ann Arbor, 1992, pp. 65–78.

Roach, Joseph. "Mardi Gras Indians and Others: Genealogies of American Performance." *Theatre Journal* 44:4 (1992), pp. 461–483.

――――. "Slave Spectacles and Tragic Octoroons: A Cultural Genealogy of Antebellum Performance." *Theatre Survey* 33:2 (1992), pp. 167–187.

Robin, Claude C. *Voyage to Louisiana*, trans. Stuart O. Landry. New Orleans, 1966.

Robortello, Francesco. *Aristotelis de arte poetica explicationes*. Florence, 1548.

Rorty, Amelie O., ed. *Essays on Aristotle's Poetics*. Princeton, 1992.

Rose, Jacqueline. *Why War? —Psychoanalysis, Politics, and the Return to Melanie Klein*. Oxford, 1993.

Sanders, Leslie Catherine. *The Development of Black Theater in America: From Shadows to Selves*. Baton Rouge, 1988.

Sayre, Henry M. *The Object of Performance: The American Avant-Garde since 1970*. Chicago, 1989.

Schafer, William J. and Richard B. Allen. *Brass Bands and New Orleans Jazz*. Baton Rouge, 1977.

Schechner, Richard. *Between Theater and Anthropology*. Philadelphia, 1985.

———. *Essays on Performance Theory*. New York, 1977.

Scott, James C. *Domination and the Arts of Resistance: Hidden Transcripts*. New Haven, 1990.

Sedgwick, Eve Kosofsky. *Epistemology of the Closet*. Berkeley, 1991.

———. "Queer Performativity: Henry James's *The Art of the Novel*." *GLQ* 1:1 (1993), pp. 1–16.

———. "Socratic Ruptures, Socratic Raptures." In *English Inside and Out: The Places of Literary Criticism,* ed. Susan Gubar and Jonathan Kamholtz. New York, 1993, pp. 122–136.

Shapiro, Gary, ed. *After the Future: Postmodern Times and Places*. Albany, 1990.

Shengold, Leonard. *"Father, Don't You See I'm Burning?" Reflections on Sex, Narcissism, Symbolism, and Murder: From Everything to Nothing*. New Haven, 1991.

Sidney, Philip. *An Apology for Poetry,* ed. Forrest G. Robinson. New York and London, 1970.

Smith, Susan Harris. "Generic Hegemony: American Drama and the Canon." *American Quarterly* 41:1 (March 1989), pp. 112–122.

Soja, Edward W. *Postmodern Geographies: The Reassertion of Space in Critical Social Theory*. London, 1989.

Sparshott, Francis. "The Riddle of *Katharsis*." In *Centre and Labyrinth: Essays in Honor of Northrop Frye,* ed. E. Cook. Toronto, 1983, pp. 14–37.

Stearns, Jean and Marshall. *Jazz Dance: The Story of American Vernacular Dance*. New York, 1968.

Steiner, George. *The Death of Tragedy*. New York, 1963.

Sunstein, Cass. "Pornography and the First Amendment." *Duke Law Journal* (1986).

Taplin, Oliver. *Greek Tragedy in Action*. Berkeley, 1978.

Taussig, Michael. *Mimesis and Alterity*. New York, 1993.

Thompson, Robert Farris. "An Aesthetic of the Cool." In *The Theater of Black Americans,* ed. Eroll Hill. Englewood Cliffs, 1980, pp. 99–111.

Traylor, Eleanor. "Two Afro-American Contributions to Dramatic Form." In *Theater of Black Americans,* ed. Eroll Hill. Englewood Cliffs, 1980, pp. 45–60.

Turner, Victor. *The Anthropology of Performance*. Baltimore, 1985.

———. *Celebration: Studies in Festivity and Ritual*. Washington, DC, 1982.

———. *Schism and Continuity: A Study of Ndembu Village Life*. Manchester, 1957.

Walker, Thomas. "Ciaccona and Passacaglia: Remarks on Their Origin and Early History." *Journal of the American Musicological Society* 21 (1968), pp. 300–320.

Weinberg, Bernard. *A History of Literary Criticism in the Italian Renaissance.* Chicago, 1961.

Williams, Mance. *Black Theatre in the 1960s and 70s.* Westport, CT, 1985.

Williams, Raymond. *Keywords: A Vocabulary of Culture and Society.* Oxford, 1983.

Winkler, John J. "The Ephebes' Song: *Tragôedia* and *Polis.*" *Representations* 11 (1985), pp. 26–62.

Woll, Allen. *Black Musical Theatre: From Coontown to Dreamgirls.* Baton Rouge, 1989.

Wright, George R. *The Future of Free Speech Law.* New York, 1990.

Žižek, Slavoj. *The Sublime Object of Ideology.* New York, 1989.

Zumthor, Paul. *Oral Poetry: An Introduction,* trans. Kathryn Murphy-Judy. Minneapolis, 1990.

CONTRIBUTORS

JUDITH BUTLER is Professor of Rhetoric and Comparative Literature at University of California, Berkeley. She is the author of *Bodies that Matter* and *Gender Trouble: Feminism and the Subversion of Identity*.

CATHY CARUTH is Associate Professor of English at Emory University. She is the author of *Empirical Truths and Critical Fictions: Locke, Wordsworth, Kant, Freud* and *Unclaimed Experience: Trauma, Narrative, and History;* editor of *Trauma: Explorations in Memory;* and coeditor of *Critical Encounters: Reference and Responsibility in Deconstructive Writing.*

ELIN DIAMOND is Associate Professor of English at Rutgers University, New Brunswick. Her articles on feminist and theater theory have appeared in *ELH, Theater Journal, Kenyon Review, TDR, Modern Drama,* and the recent *Critical Theory and Performance,* and have been reprinted in several anthologies. Author of *Pinter's Comic Play*, she is now completing *Unmaking Mimesis: Feminist Stagings* for Routledge.

ANDREW FORD teaches Classics at Princeton University. He has worked on the history of Greek Criticism, as in *Homer: The Poetry of the Past,* and is currently writing a study of the origins of literary criticism in Classical Greece.

TIMOTHY GOULD teaches philosophy at Metro State College in Denver. He has written about the persistence of Kantian, Romantic, and Gothic issues in the projects of philosophy and criticism. He has completed a manuscript entitled *Traces of Freedom: An Archeology of Kant's Aesthetics.*

STEPHEN ORGEL is the Jackson Eli Reynolds Professor of Humanities at Stanford University. His books include *The Jonsonian Masque, The Illusion of Power,* and *Inigo Jones: The Theatre of the Stuart Court* (in collaboration with Sir Roy Strong). He has edited Ben Jonson's

masques, Christopher Marlowe's poems and translations, The Oxford Authors *John Milton* (in collaboration with Jonathan Goldberg), and Shakespeare's *The Tempest* for the Oxford Shakespeare. His edition of *The Winter's Tale* is forthcoming.

ANDREW PARKER, Professor of English and Women's and Gender Studies at Amherst College, is the author of the forthcoming *Re-Marx* and coeditor of *Nationalisms and Sexualities.*

CINDY PATTON is an Assistant Professor at Temple University. She is the author of *Inventing AIDS* and *Last Served? Gendering the HIV Pandemic.* The essay in this volume is part of a larger project on the globalization of AIDS discourse in the 1990s.

SANDRA L. RICHARDS is an Associate Professor of African American Studies and Theatre at Northwestern University. Her essays include "African American Women Playwrights and Shifting Canons," which will appear in *Feminist Theatres for Social Change* (edited by Susan Bennet, *et al.*) and "Under the 'Trickster's' Sign: Towards a Reading of Ntozake Shange and Femi Osofisan," which appeared in Janelle Reinelt and Joseph Roach's collection, *Critical Theory and Performance.*

JOSEPH ROACH is Professor of English at Tulane University. He is the author of *The Player's Passion: Studies in the Science of Action* and, with Janelle Reinelt, *Critical Theory and Performance.*

EVE KOSOFSKY SEDGWICK is the Newman Ivey White Professor of English at Duke University, and author of *The Coherence of Gothic Conventions, Between Men: English Literature and Male Homosocial Desire, Epistemology of the Closet, Tendencies,* and *Fat Art, Thin Art.*